weldon**owen**

President & Publisher • *Roger Shaw*
SVP, Sales & Marketing • *Amy Kaneko*
Associate Publisher • *Mariah Bear*
Creative Director • *Kelly Booth*
Art Director • *Allister Fein*
Production Director • *Michelle Duggan*
Imaging Manager • *Don Hill*

CAMERON + COMPANY
Publisher • *Chris Gruener*
Creative Director & Designer • *Iain R. Morris*
Managing Editor • *Jan Hughes*
Editorial Assistant • *Mason Harper*

TWENTIETH CENTURY FOX
CBO, Theatrical Franchise Team • *Beth Goss*
Theatrical Franchise Team • *Steve Tzirlin*
Theatrical Franchise Team • *Nicole Perez*
Consumer Products • *Carol Roeder*
Consumer Products • *Nicole Spiegel*
Theatrical Creative Advertising • *Ely Orias*
Theatrical Production • *Kira Goldberg*
Theatrical Photo Dept. • *Bill Mona*
Theatrical Photo Dept. • *Ariell Brown*

Chernin Entertainment • *Tonia Davis*
Chernin Entertainment • *Jenno Topping*
Michele Schweitzer

Weldon Owen is a division of
Bonnier Publishing USA
1045 Sansome Street, Suite 100,
San Francisco, CA 94111
www.weldonowen.com

Library of Congress Control Number
on file with the publisher

ISBN: 978-1-68188-373-1

10 9 8 7 6 5 4 3 2 1
2017 2018 2019 2020

Printed in Canada by Friesens

FRONT ENDPAPERS: *Concept art by Craig Sellars*
PAGE 1: *P.T. Barnum at the opening number*
"Greatest Show"
PAGES 2–3: *Barnum and Charity running away*
from home to begin their life together
PAGES 4–5: *Concept art for "A Million*
Dreams," by Jamie Jones
PAGES 8–9: *Crowd reaction at a show*
PAGE 10: *Barnum and Charity make up*
PAGES 12–13: *Concept art by Craig Sellars*

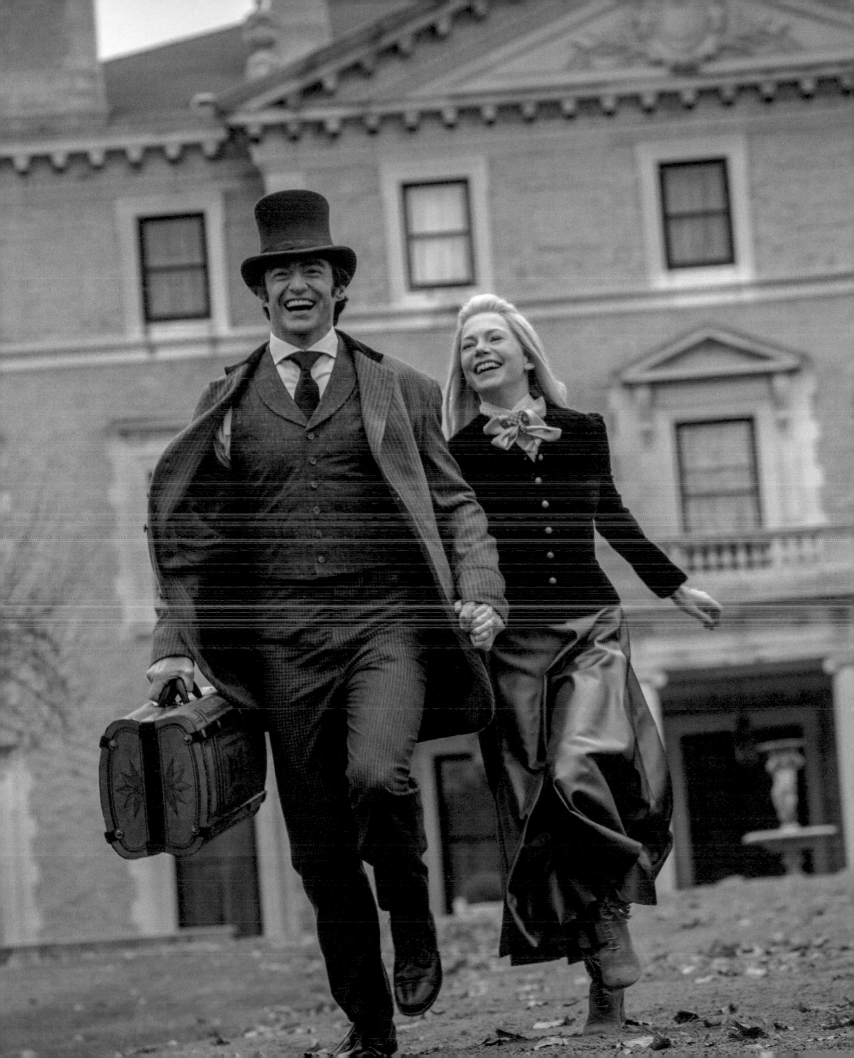

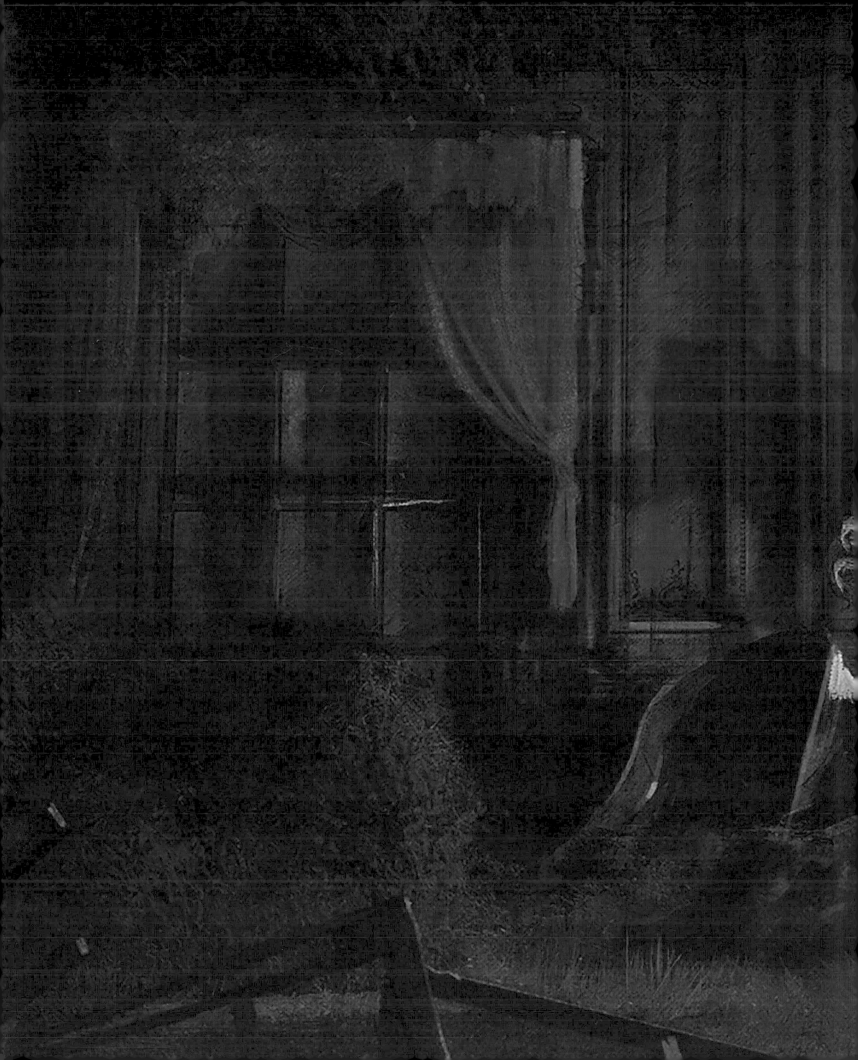

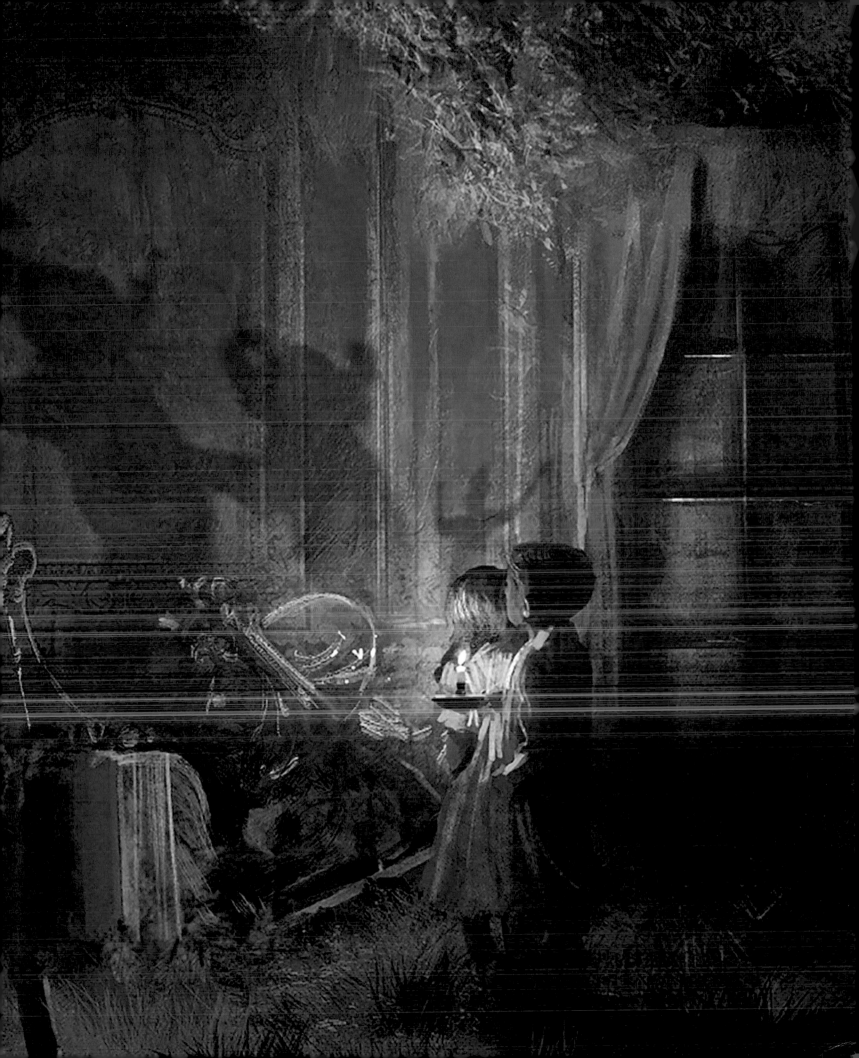

THE ART & MAKING OF

THE GREATEST SHOWMAN

SIGNE BERGSTROM

weldonowen

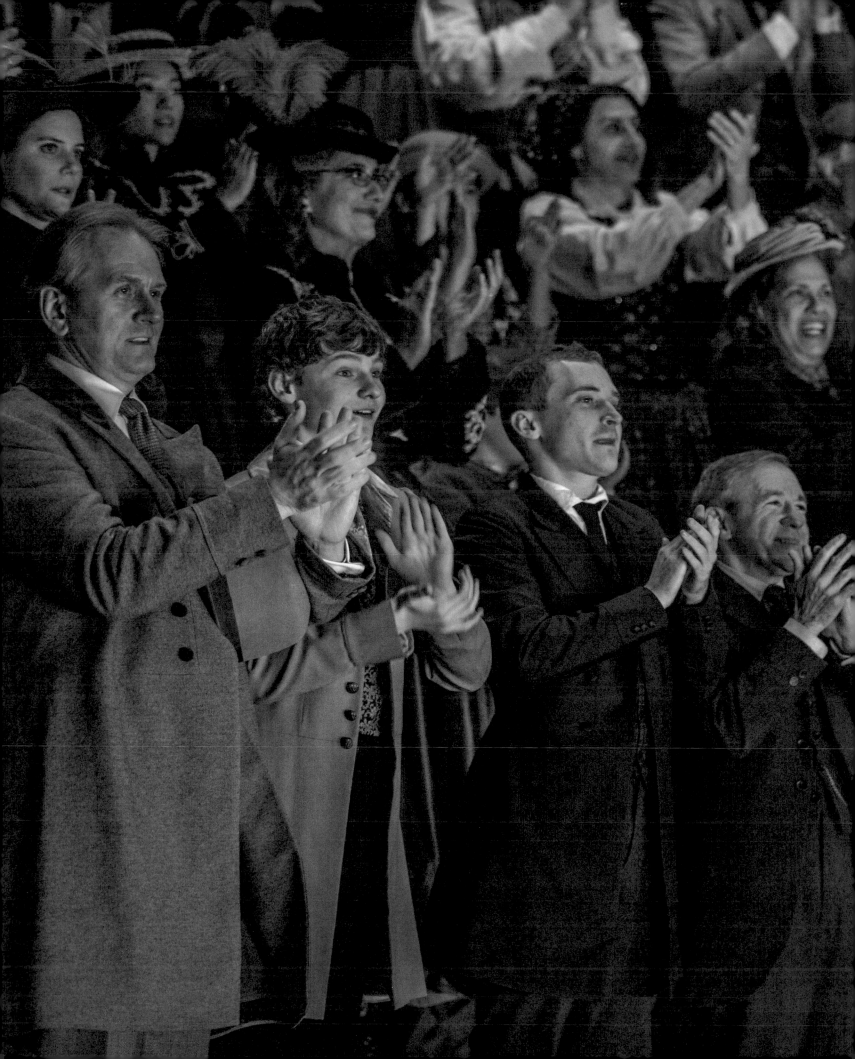

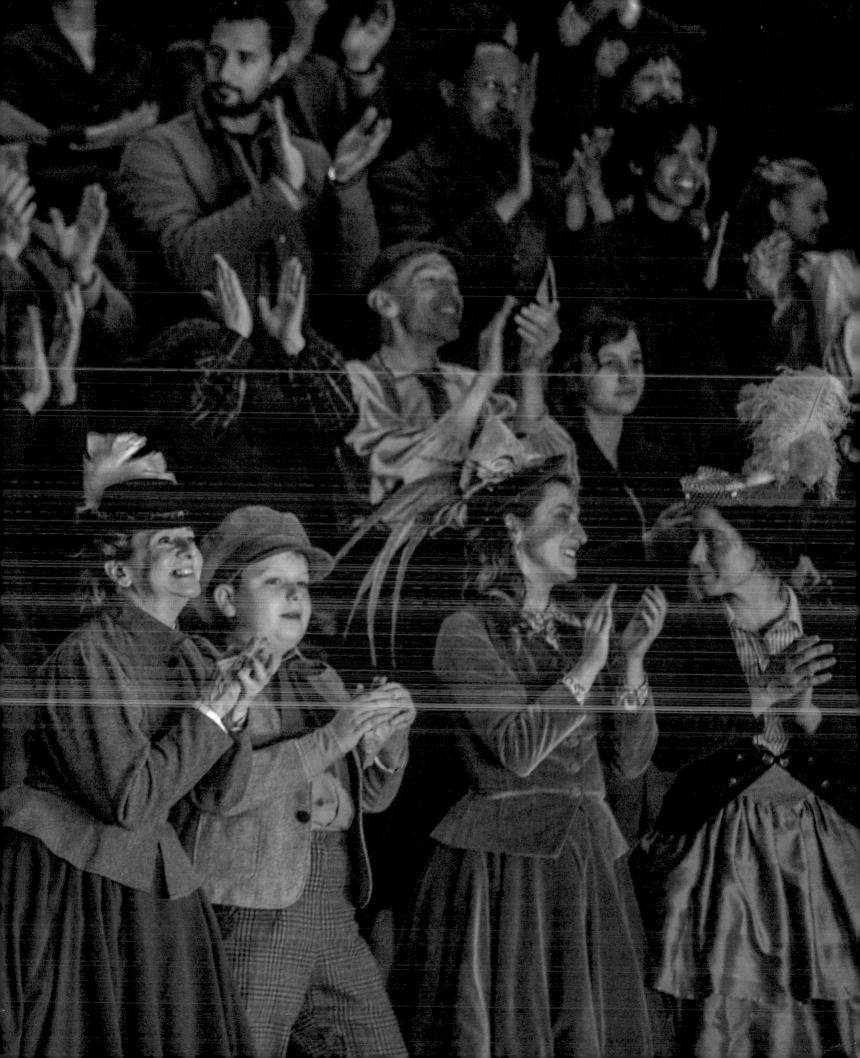

CONTENTS

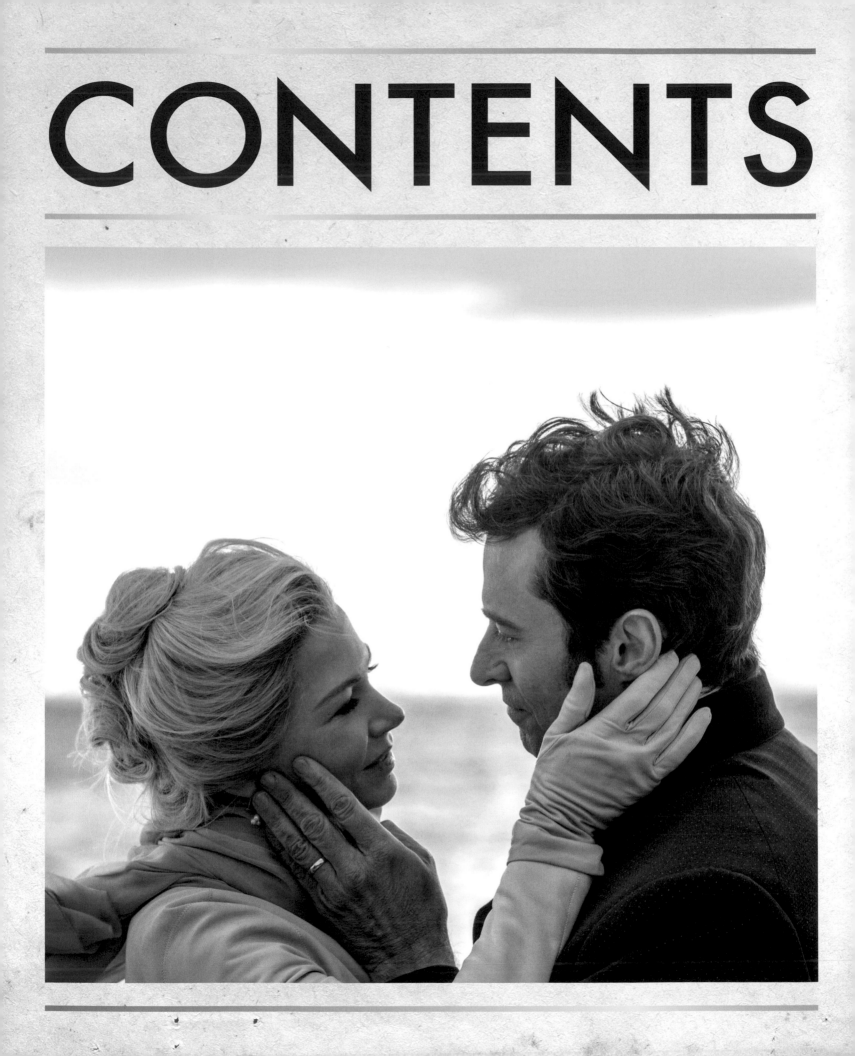

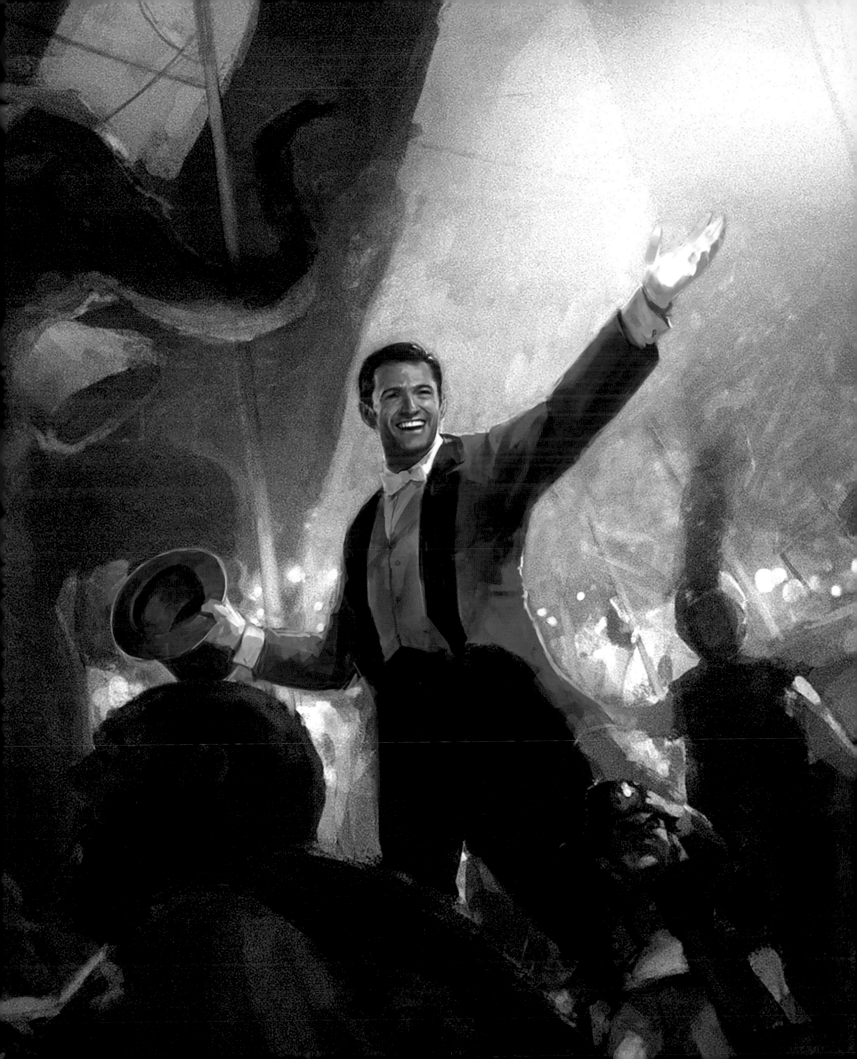

PHINEAS T. BARNUM'S THE
GREATEST SHOW ON EARTH
CELEBRATED LIFE BY RECOGNIZING
THE HUMAN APPETITE FOR
WONDER AND DELIGHT THAT
transcends class, race or physicality. Thanks to the
tireless work of an incredible cast and crew, our
film, *The Greatest Showman* depicts Barnum's life as
only Barnum would have done it – full of spectacle,
magic and heart.

This book is stamped with the passion and
commitment of every person involved. For me, it's
a true testament to making the impossible possible
and the magic that comes from surrounding yourself
with truly extraordinary individuals. In that sense,
it was life imitating art.

For P.T. Barnum, the only thing that separated
dreams from reality was belief. My greatest joy would
be that *The Greatest Showman* inspires people to
believe in their dreams once more.

Michael Gracey, Director

INTRODUCTION

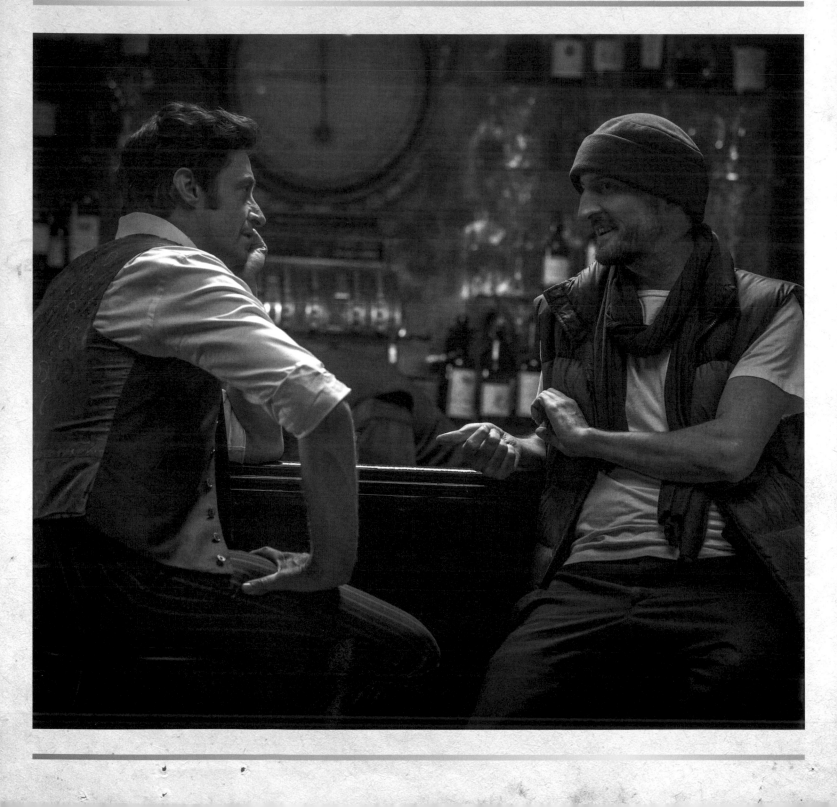

"This movie has spectacle."—ZAC EFRON

THE GREATEST SHOWMAN, A FILM THAT TOOK ITS DEDICATED CAST AND CREW SEVEN YEARS OF PRE-PRODUCTION, DEVELOPMENT, and planning to create, is a light-hearted, fictional portrayal of one of America's larger-than-life personas—P.T. Barnum. Starring Hugh Jackman as P.T. Barnum, Michelle Williams as his wife, Charity, and other stellar performers, including Zac Efron, Zendaya, and Rebecca Ferguson among them, the film is as epic as it is visually stunning—a family-friendly original movie musical sure to inspire childlike wonder and amazement. Tracing the evolution of show business itself—from Barnum's early days as a young boy growing up in Connecticut to his arrival in New York City as a man with a head full of dreams and a sense of adventure to his creation of the American Museum and, later, the tented circus—*The Greatest Showman* is a raucous celebration of the spirit of imagination and a testament to the idea that anything is possible.

THE SHOWMAN

"I was watching Hugh Jackman do what Hugh Jackman does better than anybody in the world, which is take the stage, and thought, 'Wow. . . . And I literally thought of P.T. Barnum.'"
—Producer Larry Mark

To create the visually cinematic spectacle, the film first needed a showman, someone who could embody the flair of a ringmaster, the finesse of a dancer, and the vocal pipes of a leading Broadway star. Enter Hugh Jackman.

"Believe it or not, *The Greatest Showman* started about two weeks after I hosted the Oscars in 2009," Jackman says. "Producer Larry Mark said, 'No one's ever seen you do anything like that [singing and dancing] on film. We should do a movie musical

about P.T. Barnum.' . . . I'll be honest, the chances of it actually being made at that point, I thought, were about twenty percent." After the Academy Awards, however, pre-production moved at a fairly clipped pace: A rough draft of the script came together quickly and some studios expressed general interest in the project, though nothing was firmly set in stone. The film desperately needed a front man—a director—to steer everything into place. As Jackman says, "For me, doing a movie musical is one of the hardest things you can pull off in the business. And it's really about the director." While the film had found its showman in Jackman, it still required its leading visionary. Jackman says, "So I'm working with [director] Michael Gracey on a commercial, and on the last day of filming, we wrapped, gave high-fives, hugs, and I said, 'We should do a film together.' And he looked at me—he's an Aussie and we know each other well—and he goes, 'Yeah, whatever, Jackman.' I said, 'Oh, fine, you don't have to do a movie with me if you don't want to.' Six months later Larry Mark came to me with this idea and we had a script, I sent it to him."

THE STORYTELLER AND THE PITCH

"And the real Barnum of this story—I know I get credited playing him—but it's really Michael Gracey because without him, we wouldn't be here today. He had to drive this thing the entire way."
—Hugh Jackman

Cast and crew admit that no one is able to pitch a story quite like Michael Gracey. Jackman says, "When Michael does a pitch, honestly, he's better than I've ever been playing P.T. Barnum." A "typical" Gracey pitch lasts forty-five minutes, is accompanied with beautiful, four-color renderings of concept art and, for this film, happened to include three songs, all of which were

OPPOSITE: *Hugh Jackman and Michael Gracey* • OVERLEAF: *Concept art by Joel Chang of young P.T. and Charity in "A Million Dreams"*

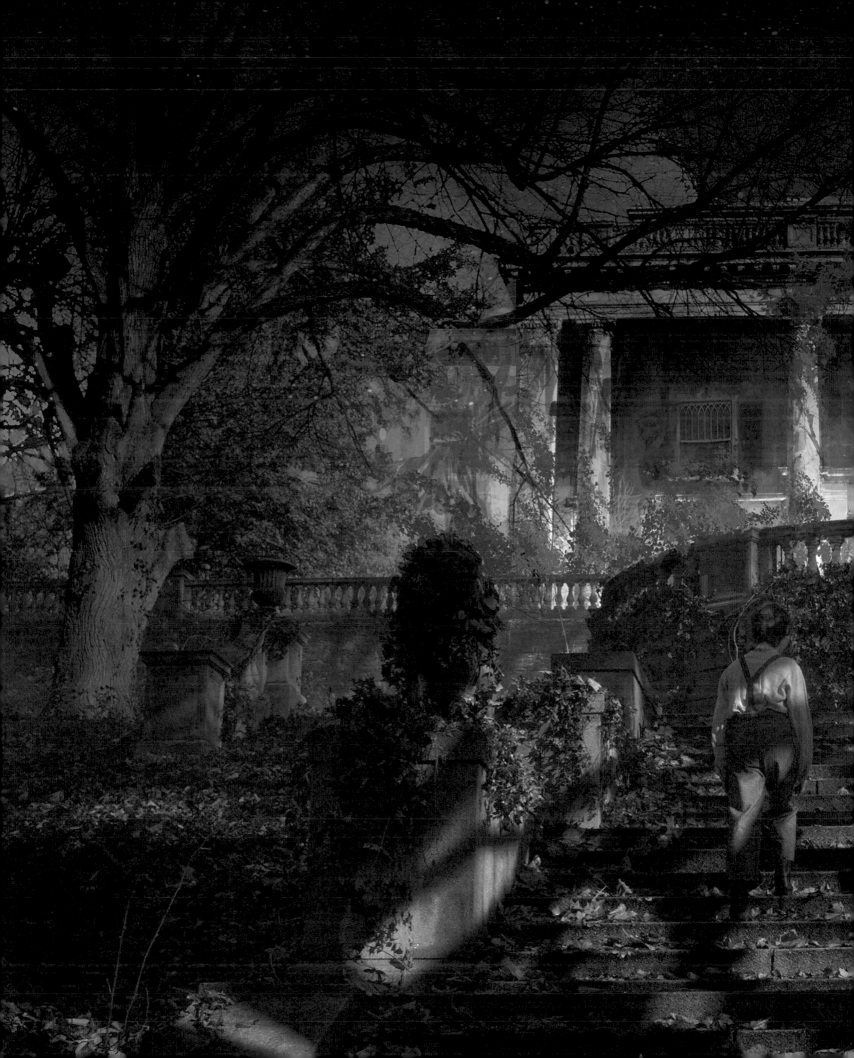

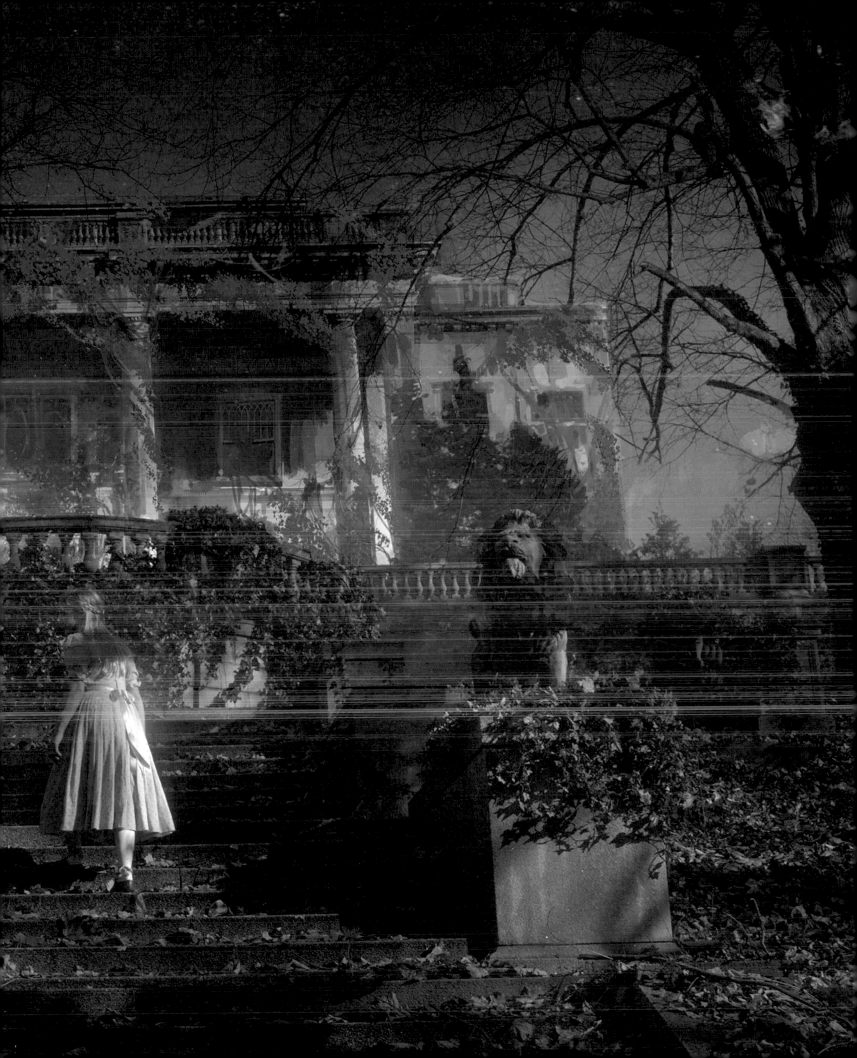

"I don't feel like there are different stations in this film where you have the art department and the director and the actors and the music. Everyone is involved, and I think that creates magic on set."
—REBECCA FERGUSON

arranged before anyone had officially signed to the project. Gracey pitched Barnum's story to anyone who would listen—producers, musicians, studio heads, actors—and anyone he thought might help get the movie made. "And there was not one person he pitched to, who didn't buy in after their forty-five minutes," Jackman says. One person Gracey won over in this manner was actress Zendaya.

For their first meeting, Zendaya says, "He literally explained the entire movie from the first

to the last shot to me. . . . He had these beautiful illustrations of what he wanted the circus to look like." Every shot in the film was painstakingly thought out by Gracey, some several years prior to production. The scene, for example, in which Zendaya's Anne Wheeler falls in love with Zac Efron's Phillip Carlyle was worked out by Gracey and fellow storyboard artist Joel Chang years before filming commenced, and even in those early drawings, Anne has cotton-candy-pink hair.

For Gracey, the visual artwork he does with Chang goes hand-in-hand with his storytelling; the art informs the story and vice versa. Once Gracey is happy with the general narrative arc, he works out its intricacies—even the shots themselves—on page with Chang. It's a creative process Gracey lives by. He later incorporates Chang's drawings into his formal pitches, and they become, in essence, a visual blueprint for the art and production teams, as well as a calling card for the actors, and a directorial guidebook that Gracey references throughout filming.

THE STORYBOARD AND PRE-PRODUCTION

"The very first step, the way that we start working from script to screen, how everything's going to look, and how we're going to stage scenes . . . all of those conversations are had ahead of [production] time."
—Director Michael Gracey

Michael Gracey and artist Joel Chang have worked together on every project, large and small, that the director has taken on. For *The Greatest Showman*, they worked first in black and white, with Chang doing a set of impressionistic paintings for every shot in the film. Chang's paintings are different from

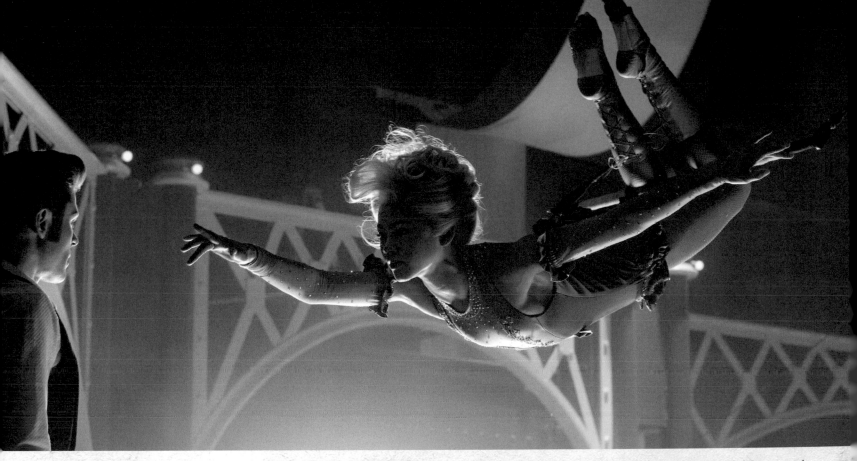

OPPOSITE: *Concept art by Brian Estanislao* • ABOVE: *Phillip Carlyle and Anne Wheeler lock eyes when they meet for the first time* • BELOW: *Barnum and family inspect the museum* • PAGE 20: *Concept art by Joel Chang of New York City* (TOP), *"A Million Dreams"* (MIDDLE), *and "Come Alive"* (BOTTOM) • PAGE 21: *Director Michael Gracey*

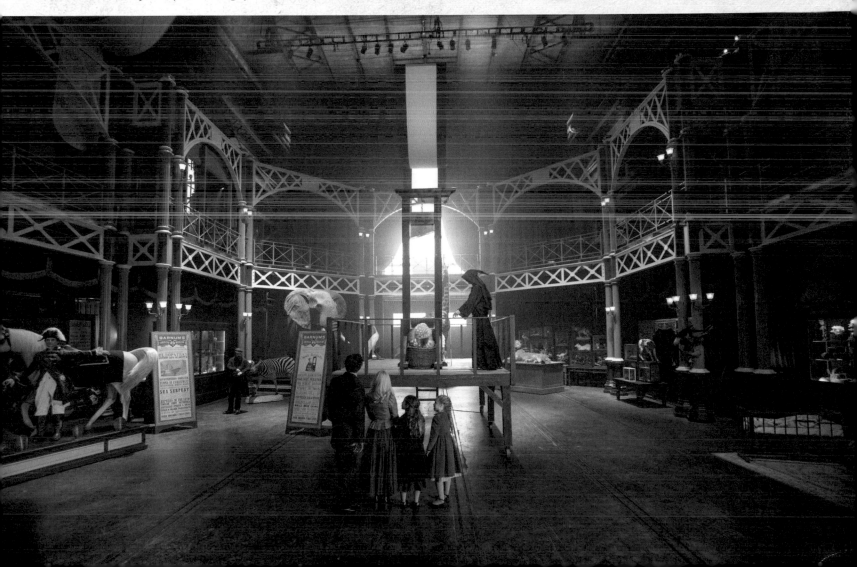

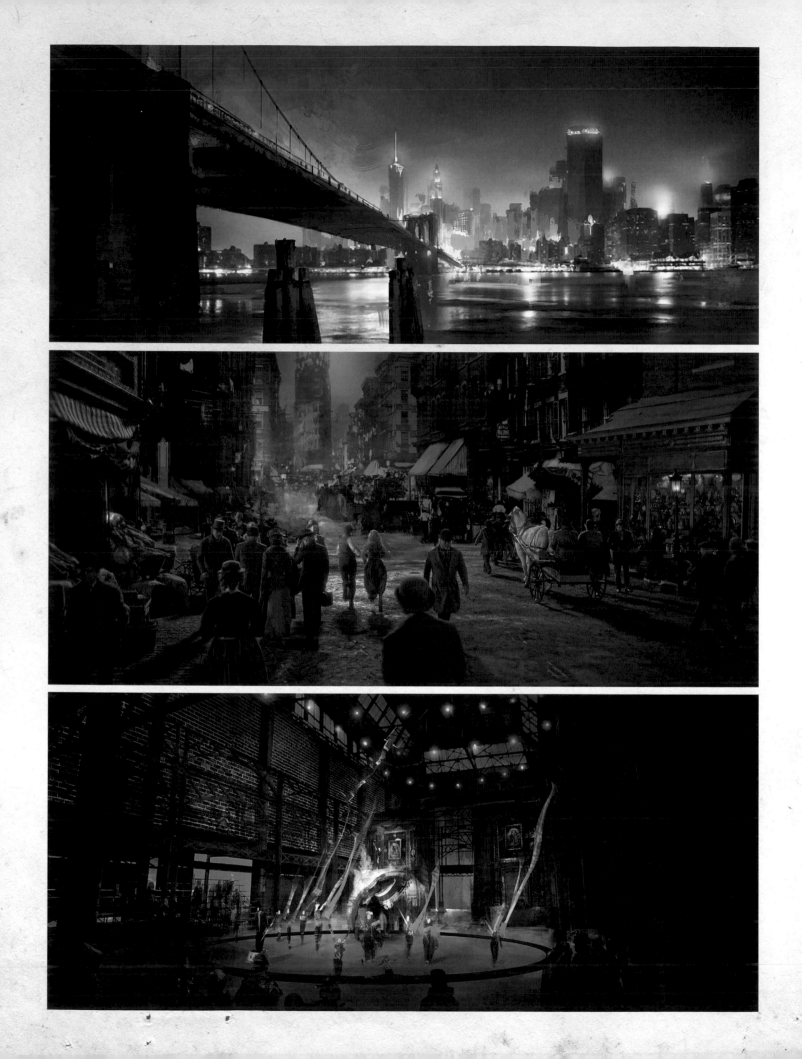

standard storyboards because, as Gracey says, they have a sense of character and lighting. Instead of being flat, Chang's artwork is fully realized and lush. His layout is often much looser than a typical storyboard, which gives Gracey the flexibility of mind to think about the shots in a more cinematic way. Once Gracey and Chang have worked out the film in black and white, Chang goes back and renders a pass in color, and those images become the basis on which Production Designer Nathan Crowley, Cinematographer Seamus McGarvey, and just about everyone else models their work. When Gracey related the film's story to Zendaya—along with several other cast members—those drawings functioned as a visual aid. "It's a wonderful way for everyone to get on the same page because it's what's in my head," Gracey explains. The rest is a matter of execution.

Beyond storyboarding, many other details were worked out before formal shooting. Prior to committing to shooting on the studio lots, for example, the cast worked small scale and blocked out many of the film's scenes, videotaping them in Gracey's office and, in effect, creating a rough sketch for the production team to later follow. Not only did the art and production teams have a wealth of visual information to draw from before the formal shooting actually commenced, but the cast was also able to get in a ton of rehearsal time—from dancing to actual scene work to walk-throughs, rewrites, improvisation, and character studies. While the actors prepped, trained, and rehearsed, the art and production teams readied the sets.

When the cast stepped onto the set of the American Museum for the first time, they found that it looked almost exactly like Chang's storyboard illustrations they had seen two years prior. Every detail was lovingly intact. The result, says Zendaya, was magical. "Michael," she says, "found a way for it to really come to life." Remarkably, too, the film feels fresh and resonates for today's audiences, despite it being, technically speaking, a period piece.

While the film's action and story takes place during the 1800s in America, Gracey didn't want it to feel or look dated. A contemporary vibe runs throughout *The Greatest Showman* and is present in everything from its music and vibrantly colored costumes to the energy level of the performers themselves, several of whom infuse aerial stunts, back flips, and intricate, modern-day dance moves with their stellar acting and singing. The film, despite its old-timey narrative backdrop, feels related and relevant to today, and for good reason. The cast and crew expertly straddled two worlds, infusing light and color, modern-day movement and music with period elements of 1800s Americana.

Cinematographer Seamus McGarvey says, "We're consciously using camera movement that you might not see in very many period films. We're working with digital. . . . We're embracing the saturation and the vivacity of the sets and the wonderful costumes, and running with it and will continue to push and extend when we do the final digital intermediate." The result? "A very distinct look . . . and one that wholeheartedly embraces color."

A bit like the character of P.T. Barnum himself, Gracey, together with a talented cast and crew guided by the energy and enthusiasm of leading man Hugh Jackman, transformed the seemingly ordinary into the extraordinary. The greatest show indeed.

"This is truly a film that you have to see on the big screen. I mean, honestly, the bigger the better. It has heart."—HUGH JACKMAN

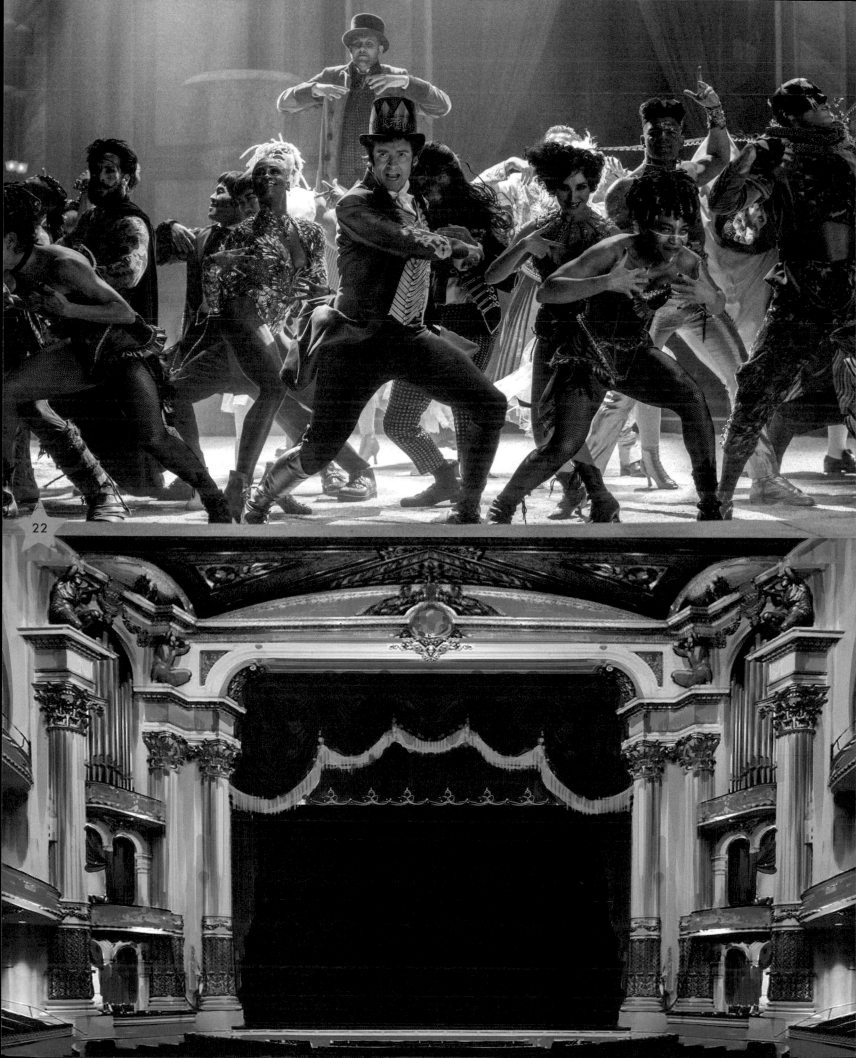

OPPOSITE: *P.T. Barnum in "Come Alive"* (TOP), *concept art by Joel Chang of Jenny Lind proscenium* (BOTTOM) • ABOVE: *Circus poster props*

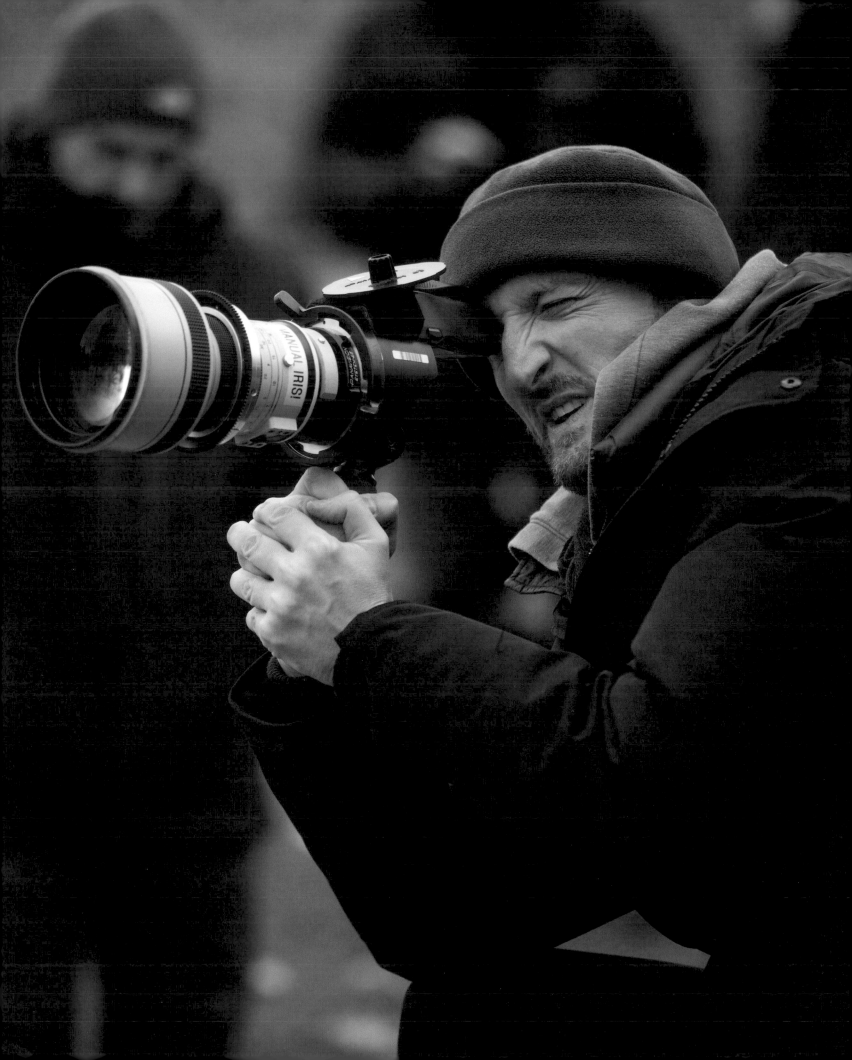

A WORLD OF WONDER
THE DIRECTOR'S
NOTEBOOK

"It was such a privilege and joy to come to set." —DIRECTOR MICHAEL GRACEY

DEPENDING ON WHO'S SPEAKING, *THE GREATEST SHOWMAN* HAD SEVERAL STARTING POINTS. IN 2009, PRODUCER LARRY MARK WATCHED HUGH JACKMAN TAKE the stage as host of the Academy Awards and envisioned the actor as P.T. Barnum. For Jackman, the project began when he read the first draft of the script. Keala Settle felt the spark when she sang "This Is Me" for the first time. Zendaya knew the film was magical the moment she soared through the sky, her costume sparkling in the spotlight. Zac Efron knew the fantasy was real when he saw several taxidermied creatures dotting the set of Barnum's American Museum. For Director Michael Gracey, however, *The Greatest Showman* began much, much earlier.

"A child's imagination is limitless," he says, "and one of the saddest moments in any child's life is when they learn the word 'impossible' because before that, everything is possible." P.T. Barnum was an adult when he created his show and world of wonder yet he was able to do so, in part, because he never lost his childlike imagination. "Children see things differently," Gracey says. Barnum knew that, too, and, sooner than most, he also understood the value of children's laughter and amazement: It's liquid gold.

As a young boy with limited financial means, Barnum is forced to rely on his imagination: It's the sum total of his survival. As an adult, it becomes his means of success, financial and otherwise. That character trait isn't lost on Gracey, a man who also depends on his own sense of creative adventure and risk-taking for his livelihood. The underlying story of *The Greatest Showman*—the source of its universal appeal—extends to one's childhood and the idea that dreams are, or have the potential to become, real. As Gracey says, "Barnum creates these living dreams and he does so as an adult. Parents—and other adults—have that capacity, too: They reawaken their own imagination because they see the way that children look at the world." *The Greatest Showman*, for Gracey, is a tale as old as human imagination, and it's one of the reasons the film starts with Barnum as a wild-eyed, creative young boy. "It's a beautiful thing for audiences to see this boy who has an imagination beyond his means," Gracey says. "Barnum loses his way over the course of the film, but he still taps into that childlike imagination." Having an imagination is one thing, of course, and having a good script is another.

"Getting a script right is a challenge unto itself," Gracey says. He continues, "In a narrative sense, in musical theatre, you need to be able to tell a story through song. That's the trait of musical theater. But, for *The Greatest Showman*, I also wanted those hooks that you have in pop songs where a tune just gets stuck in your head. And so, if musical theater is here and pop music is there, we wanted to sit somewhere in the middle. . . . Balance was everything." The lyrics not only have to tell the right story but the music itself has to engage the audience. The fact that Tony-Award-

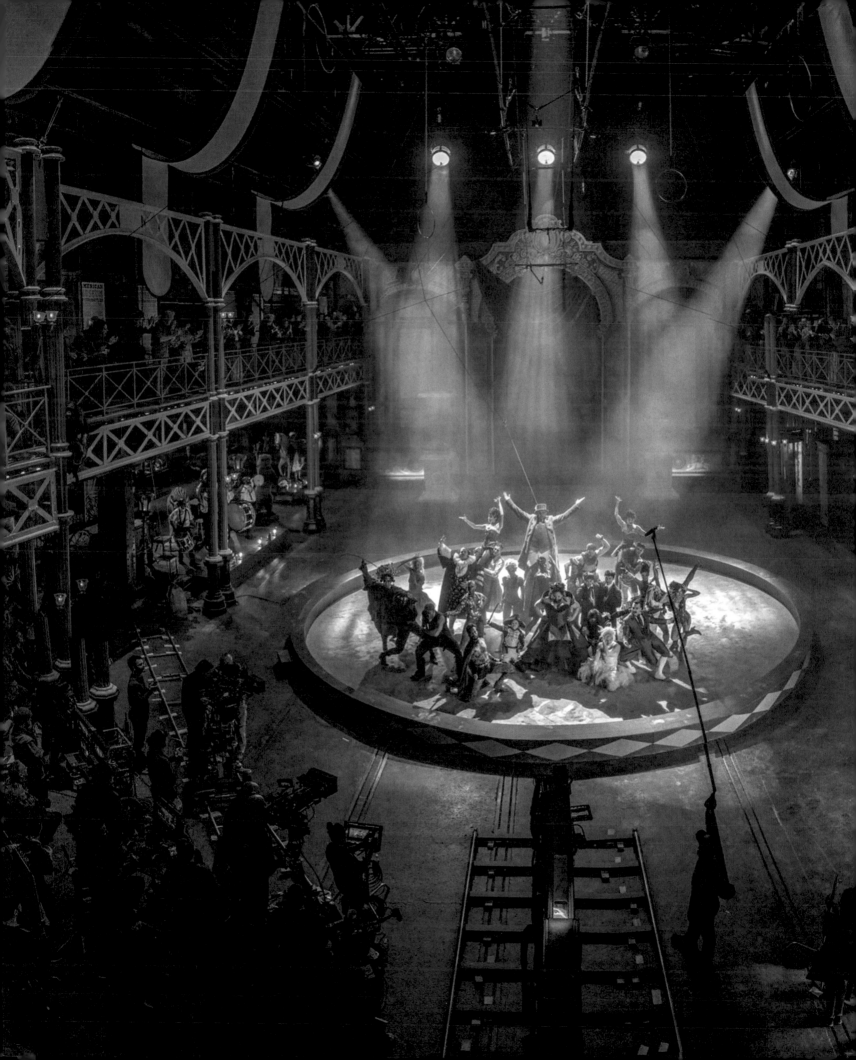

winning songwriters Benj Pasek and Justin Paul ended up composing the film's songs was a bit of serendipity, as Gracey tells it. The duo was at Fox Studio in Los Angeles doing a batch of meetings when a studio exec casually mentioned that there was someone down the hall doing an original musical. That "someone" was Gracey and, unusually for him, he also happened to be in the studio that day. From that chance encounter, Pasek and Paul wrote two songs for the film and the rest is history. "This is the best work they've ever done," Gracey says. "It's the heart and soul of the film."

While the film may have had several different starting points, it was undoubtedly Gracey's vision and direction that established the foundation upon which every department—from songwriting and choreography to cinematography and production design to costumes and hair and make up, to name a few—built. Gracey helped create the sense of family spirit that pervaded the set, and the cast and crew responded in kind. On a typical film, cast and crew work together for thirty, sixty, sometimes one hundred days, and then go their separate ways. *The Greatest Showman*, however, was unique in that it labored through seven years of pre-production, a phase that forged several close-knit creative partnerships and feelings of camaraderie . . . and this, prior to one scene being filmed. Rehearsals themselves were intense and brought together a tremendous amount of talent. The film's production was, in a sense, a kind of family circus: high-spirited, sometimes emotionally depleting, adrenaline-inducing moments that, when combined, brought the best out of everyone. And that, perhaps, is the film's greatest message of all. As Gracey says, "The message is very similar to *It's a Wonderful Life*. And that is, your real wealth is the people you surround yourself with, and the people who love you." Barnum discovers this truth by the end of the film; Gracey discovered it during its making. "The ability to work with people this talented was just a thrill," he says. No doubt they would say the same about their one-and-only ringleader.

27

I WANTED TO BE MORE THAN I WAS.

—P.T. BARNUM

THE GREATEST SHOWMAN

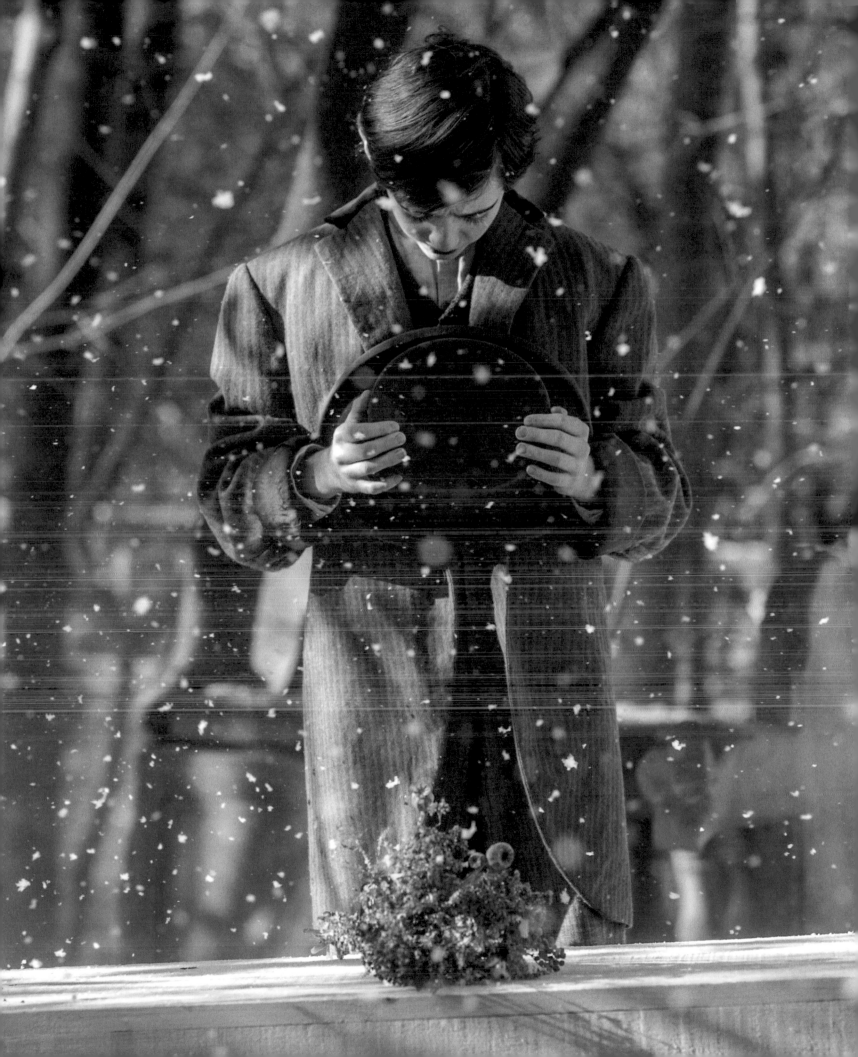

I N THE FILM *THE GREATEST SHOWMAN*, P.T. BARNUM IS THE SON OF A TAILOR BORN OF HUMBLE MEANS IN BETHEL, CONNECTICUT. AS AN ADULT, BARNUM ATTEMPTS TO HOLD DOWN STEADY EMPLOYMENT BUT SOON FINDS THAT HIS PROPENSITY FOR

daydreaming, concocting fun, and laying elaborate moneymaking schemes proves too distracting for a day job. Having little else to his name, Barnum depends on his ability to see the spectacular in the most ordinary of circumstances. His power of imagination is not only keen, it's also his most defining characteristic, one that will, later in his life, both set the stage for Jenny Lind and help set the course for the future of American entertainment. Before Barnum becomes the world's greatest showman, however, he first woos the attention of his childhood sweetheart, a young woman named Charity Hallett.

Barnum, as portrayed by Hugh Jackman, dazzles Charity, played by Michelle Williams, by turning everyday objects into seemingly magical phenomena. The slow flicker of a light splayed against the shadows of a large mansion dances across the walls and, much to Charity's delight, illuminates a menagerie of imaginary figures: a lion, acrobats, and trapeze artists. Barnum, despite being poor, is rich in imagination, enterprise, and character.

In the film, Charity risks her personal reputation and her wealthy family's sense of propriety when she marries Barnum. An adventurous soul herself, Charity recognizes that Barnum can give her something wealth and priveledge never could–freedom. The two lovebirds chart a path for New York City, the only place outsized enough for a man like Barnum to be challenged. Intent on making the most of himself and his ambition, Barnum pledges his commitment to Charity in "A Million Dreams," a song that swells with the hope and the promise of the magical becoming real. For Barnum, anything is possible. For Barnum, one dream becomes a million, and in Charity, he finds a partner for life when she sings: "However big, however small / Let me be part of them all / Share your dreams with me."

32

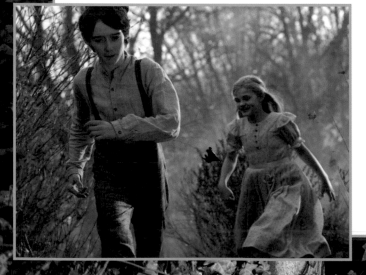

PAGE 31: *A young P.T. Barnum in mourning over his father's grave* • THIS SPREAD AND INSET: *Scenes from "A Million Dreams"* • PAGE 34: *Barnum and Charity look over an abandoned mansion* • PAGE 35: *Concept art by Jamie Jones* (TOP AND MIDDLE) *of Barnum and Charity before she leaves (the scene with the tree was cut from the film), and concept art by Jamie Jones of a scene cut from the movie* (BOTTOM)

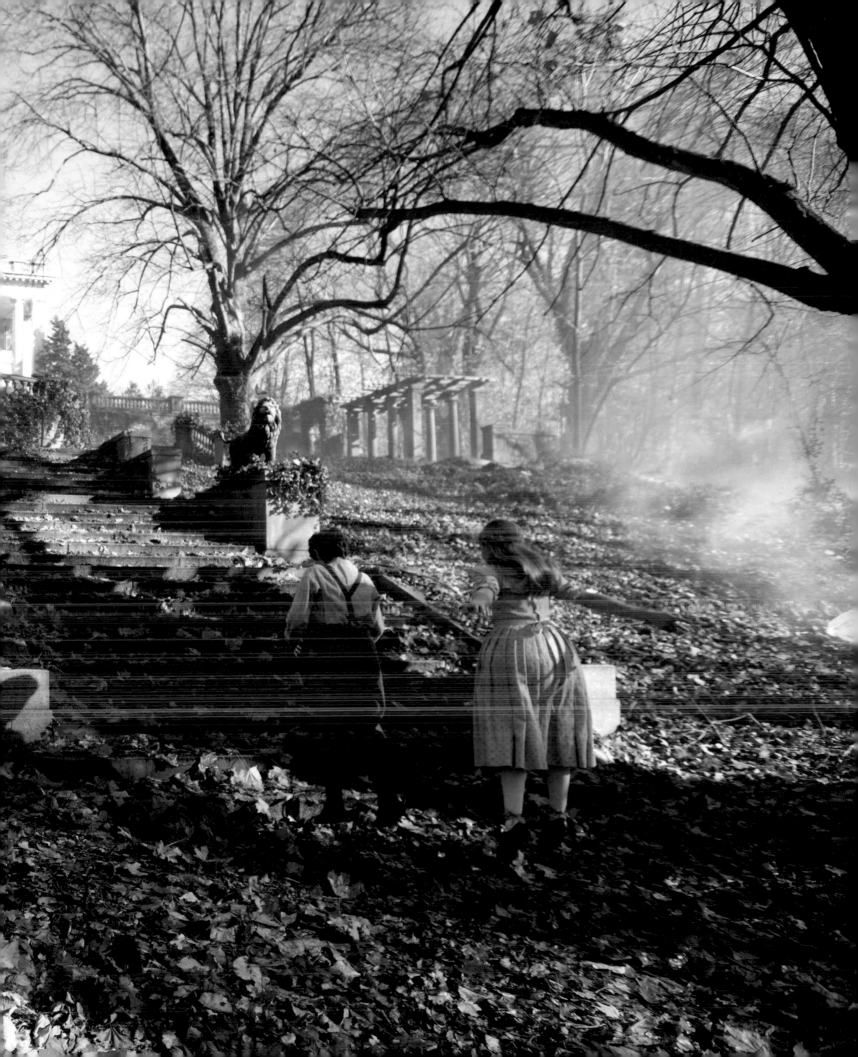

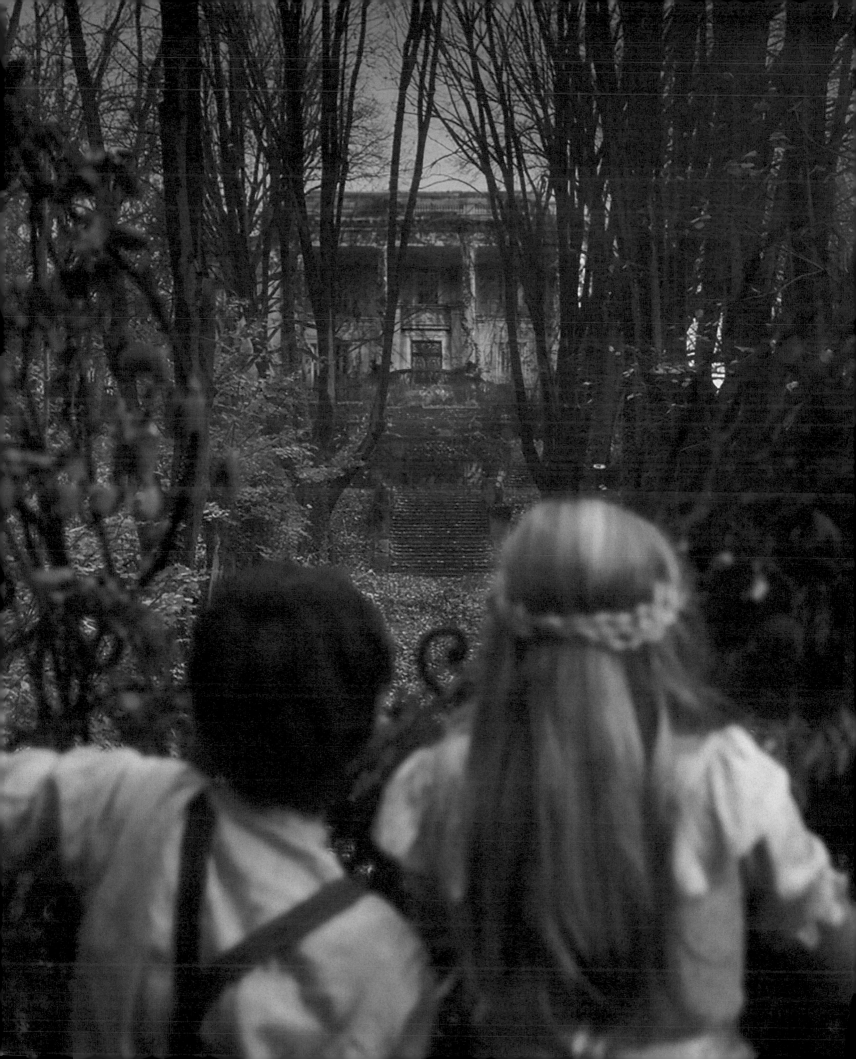

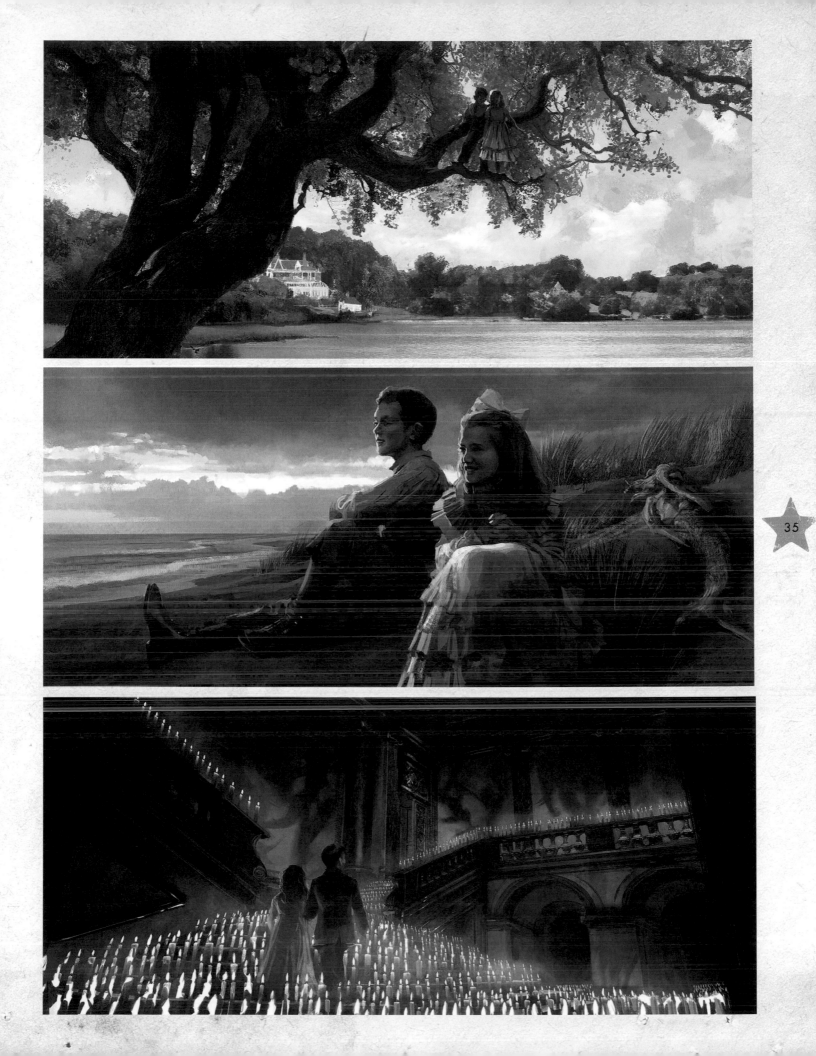

HUGH JACKMAN AS
P.T. BARNUM

> "It wasn't lost on Hugh that he was performing a role where he literally, by the very nature of the title, is claiming he is the greatest showman. But I think he wears that title so perfectly."
>
> —DIRECTOR MICHAEL GRACEY

DIRECTOR MICHAEL GRACEY ADMITS THAT THE MAIN REASON HE SIGNED UP FOR THE PROJECT AND TOOK TO CHAMPIONING IT AS HE did was because of Jackman. As a musical, the film plays to the actor's key strengths. "On stage," Gracey says, "Jackman stands about ten feet tall." He assumes a larger-than-life persona—a trait that characterizes P.T. Barnum as well.

Gracey was familiar with Jackman's work long before the two paired up on this passion project. "I grew up in Australia," he says, "watching Hugh on stage in plays like *Sunset Boulevard*, *Oklahoma*, and *Beauty and the Beast*. He was the leading man in the world of musical theater." While Gracey and Jackman have worked with each other before on television

commercials, this film marks their first movie-making endeavor together. It's also Gracey's directorial debut. "Once Gracey was on board," Jackman says, "things really started to kick into gear."

From the get-go and in speaking with Jackman and Producer Larry Mark, Gracey envisioned the world of P.T. Barnum as an original movie musical. Knowing that Jackman would star in the titular role only solidified that vision. "I wanted this to be a musical," Gracey says, "because the idea of Hugh singing and dancing like he does on film was so exciting. I mean, there's not many people who can pull that off. In fact, there's kind of no one who can pull that off like Hugh." It isn't enough, however, for Jackman to simply sing and dance. He must also ground the musical experience in an emotional reality. As Gracey says, "You need a really great

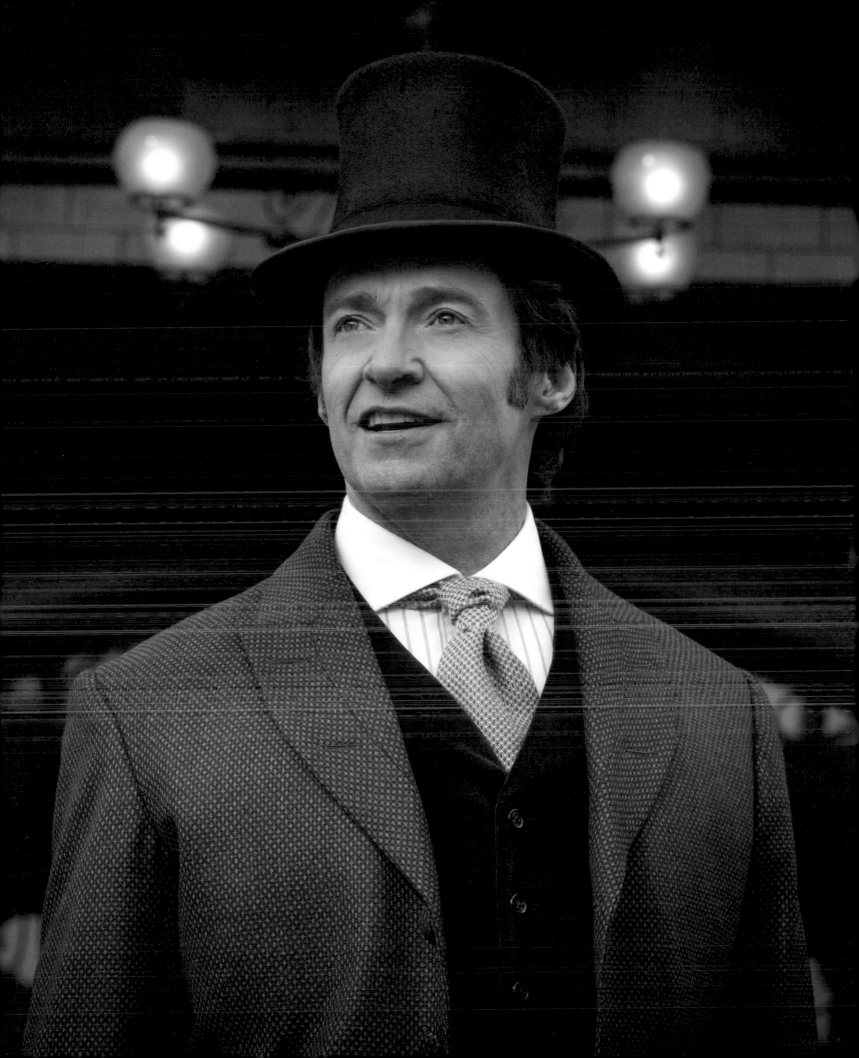

actor who can take you up to those moments where words no longer suffice and then they start to sing. And to me, those emotional high points and low points should be the songs of the film." With several years' experience doing both film and musical theater, Jackman fluidly combines both genres with the greatest of ease.

As Jackman portrays him, the character of Barnum is a man with larger-than-life ambitions and dreams; a jokester who always has a twinkle in his eye and a mischievous smile at the ready; a sentimental who wears his heart on his sleeve, all too ready and willing to fight for who and what he believes in. Jackman admits there's a contrarian side to the character as well. "Barnum is what we would describe now as a disruptor, an outlier," Jackman says. "He thought life was about fun, imagination, hard work. Think of his quote, 'Life is what you choose to make it.'" Barnum wasn't constrained by rules or convention; he was a free-thinking, risk-taking provocateur. And the life that Barnum chose to make was one of fantastic color and imagination, a place where audiences could be entertained and leave the doldrums of the everyday . . . something Jackman knows a thing or two about, being a world-renowned entertainer himself.

On set, Gracey couldn't help but draw parallels between Jackman, the performer, and Barnum, the

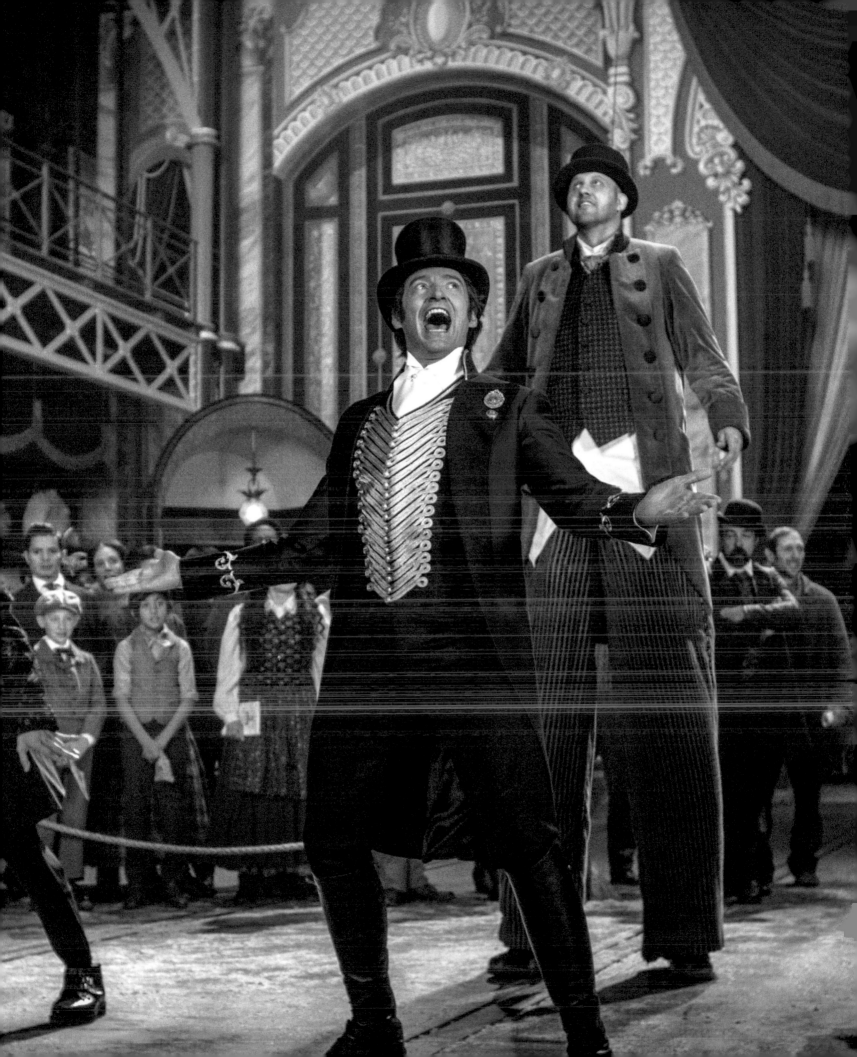

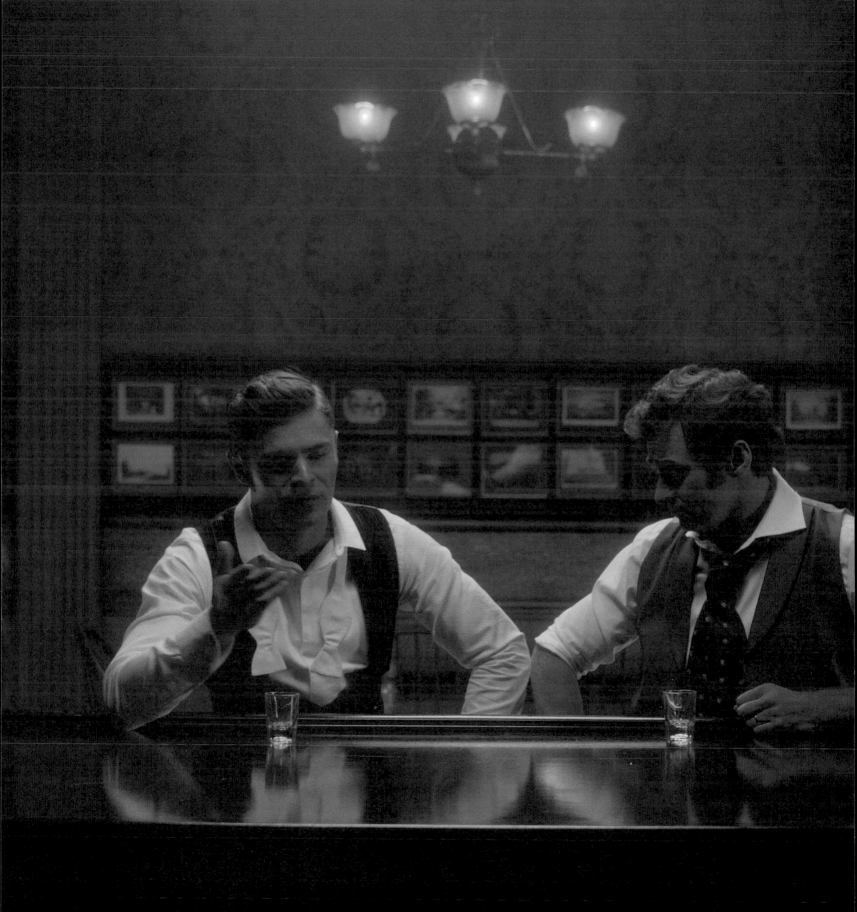

showman. "He got people together because he wanted to create a successful show," Gracey says. Though he was speaking of Barnum's sense of spirit, the same could be said about Jackman. "He [Jackman] elevates every single person on set from the cast to the crew," Gracey says, "and he works harder than anyone, putting in a hundred and fifty percent every take." Jackman's Barnum-esque sense of dedication inspires and drives everyone to elevate their performance. "And, on take forty-three, that's really important," Gracey says. Jackman himself admits that he relates to some of Barnum's characteristics, saying, "Nothing anybody said would stop him. He followed his own path. And any setback he had, he managed to literally turn that setback into a positive. So many things I aspire to in my life are embodied in this one character."

For Jackman, Barnum's story is distinctly American. He says, "I always think of Barnum as being the birth of modern-day America. Everyone around the world knows of America being the land of opportunity and possibility, and if you work hard and you have talent, you have imagination, you can do anything. But that actually wasn't the case in 1850 in America. . . . There were barriers drawn by class, by race, by many, many different things. And Barnum kind of broke down many of those walls. . . . He believed that what makes you different actually makes you special. That message resonates today, particularly with young kids. The theme of this movie is all about empowering people to be themselves. That it's actually cool to be yourself. . . . It's the only path, ultimately, that brings you true happiness."

"At the heart of it," says Jackman, "this film is about taking risks, following your dreams, and celebrating what makes each and every one of us unique. It's a rags-to-riches story about a dreamer who turned the everyday into the extraordinary. . . . Barnum knew that if people left his show happier, elevated, smiling from ear to ear, then he was happy and he'd done his job." Sage advice from one showman to another.

41

PAGE 37: *Hugh Jackman as P.T. Barnum* • PREVIOUS SPREAD: *Concept art by Brian Estanislao* (LEFT), *Barnum in "Come Alive"* (RIGHT) • LEFT: *Barnum and Phillip having drinks*

THE AUSSIE CONNECTION

"I didn't tell them that I didn't know Hugh Jackman."
—Director Michael Gracey

MICHAEL GRACEY AND HUGH JACKMAN WERE FAST FRIENDS: THE TWO MEN MET WHILE PREPPING A commercial. Gracey and Jackman had never met one another before but, because both are Australian, people assumed that they had. Gracey was vying to direct the commercial, and when Jackman saw him, he exclaimed, "Michael!" in front of the client and staff from the ad agency. Gracey says, "And then he hugs me and whispers in my ear, 'They think I know you, so just go along with it.' So that was the first time I met Hugh and for that entire shoot, we pretended we were best friends."

By the time they had finished shooting the commercial, Gracey and Jackman had formed a legitimate friendship, but when Jackman suggested they make a film together, Gracey was nonplussed. He explains, saying, "I'd been shooting commercials for about fifteen years and every time you work with a film star, that's what they say during the wrap party." A few months later, however, Jackman sent Gracey the script for *The Greatest Showman*.

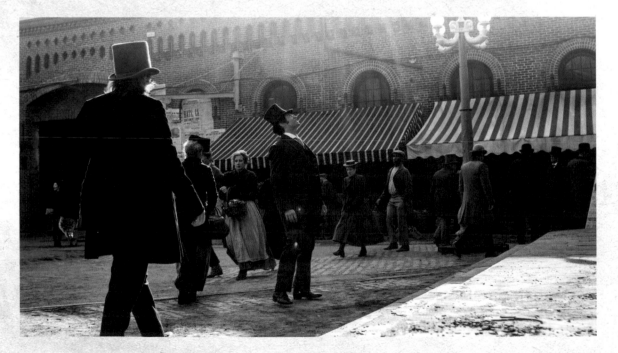

ABOVE: *P.T. Barnum admires the signs of his new show* • OPPOSITE: *Barnum and Charity in walkway* (TOP); *adult Barnum showing Charity the home he bought for them* (MIDDLE); *concept art by Alex Mandra of Barnum's big top* (BOTTOM) • OVERLEAF: *Concept art by Craig Sellars of P.T. Barnum and Phillip Carlyle*

42

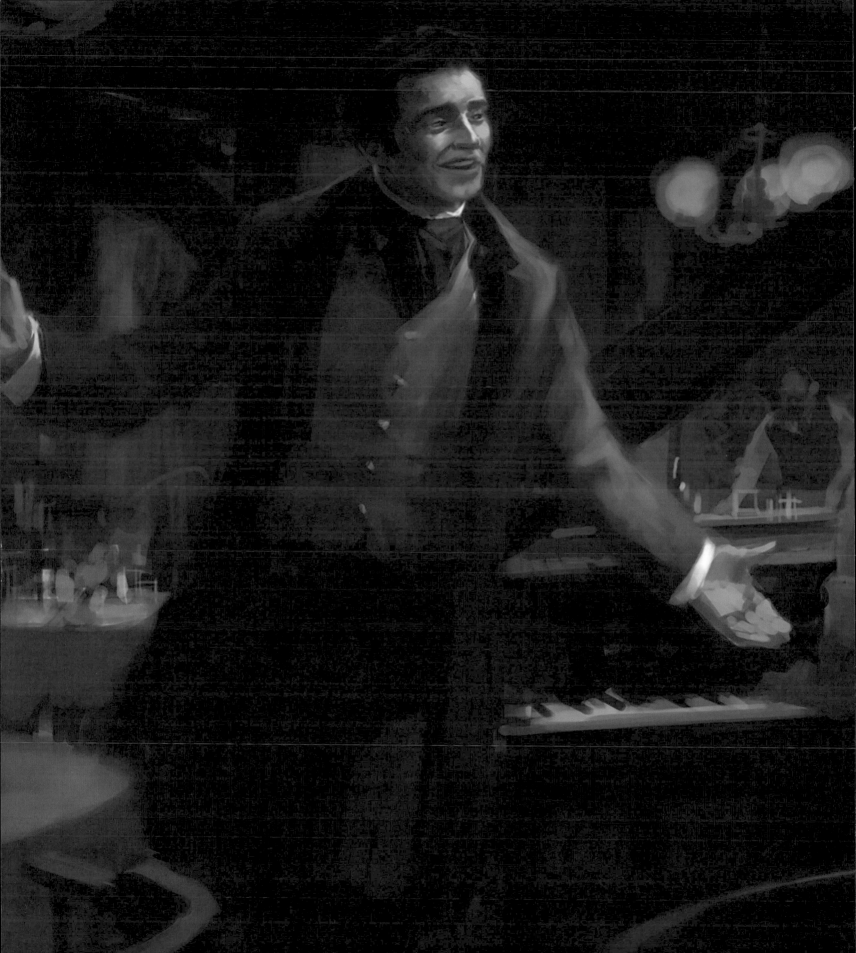

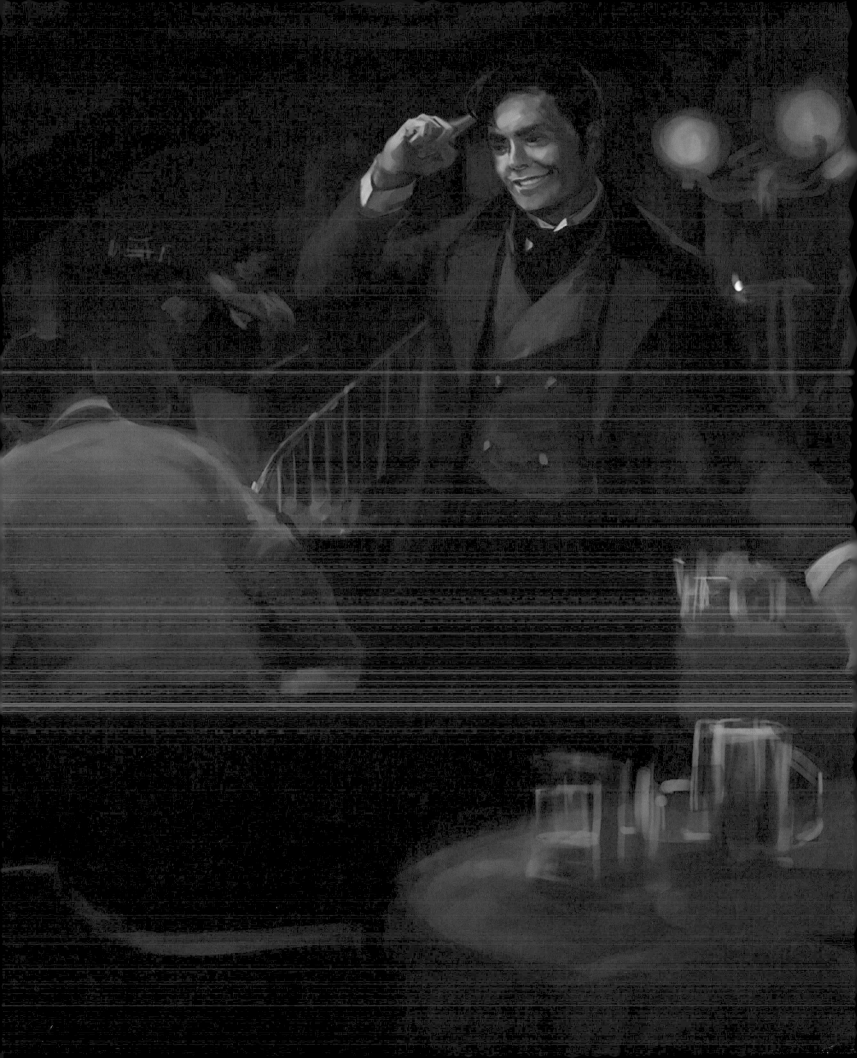

MICHELLE WILLIAMS AS
CHARITY HALLETT

"I wish for happiness. For you. And you. And for your father." —CHARITY HALLETT

PLAYING THE PART OF BARNUM'S WIFE IS NO EASY TASK. BARNUM'S LARGER-THAN-LIFE SHOWMANSHIP COULD EASILY OVERWHELM a lesser character. Michelle Williams, however, grounds Charity Hallett, both in song and in dialogue, and lets audiences know that she's the best thing in Barnum's life—she is, along with her daughters, the greatest show Barnum's got going. Gracey says, "Michelle Williams is an incredible actress . . . it's very difficult to go from scene to song but for those songs to have impact, you have to deliver the dramatic moments. You have to believe the scene that led up to the characters having to sing. . . . And Williams can convey all of it in a single look that tells you everything."

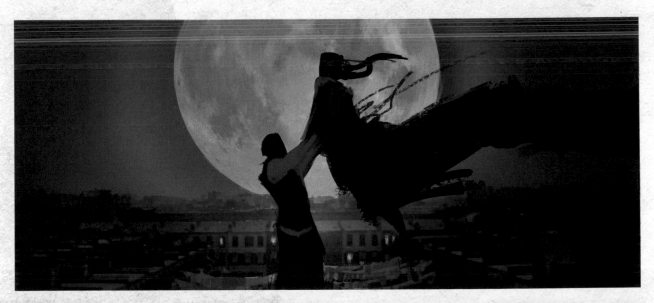

OPPOSITE: *Michelle Williams as Charity Hallett* • ABOVE: *Concept art by Joel Chang of "A Million Dreams"* • OVERLEAF: *Behind-the-scenes shot from "A Million Dreams"*

48

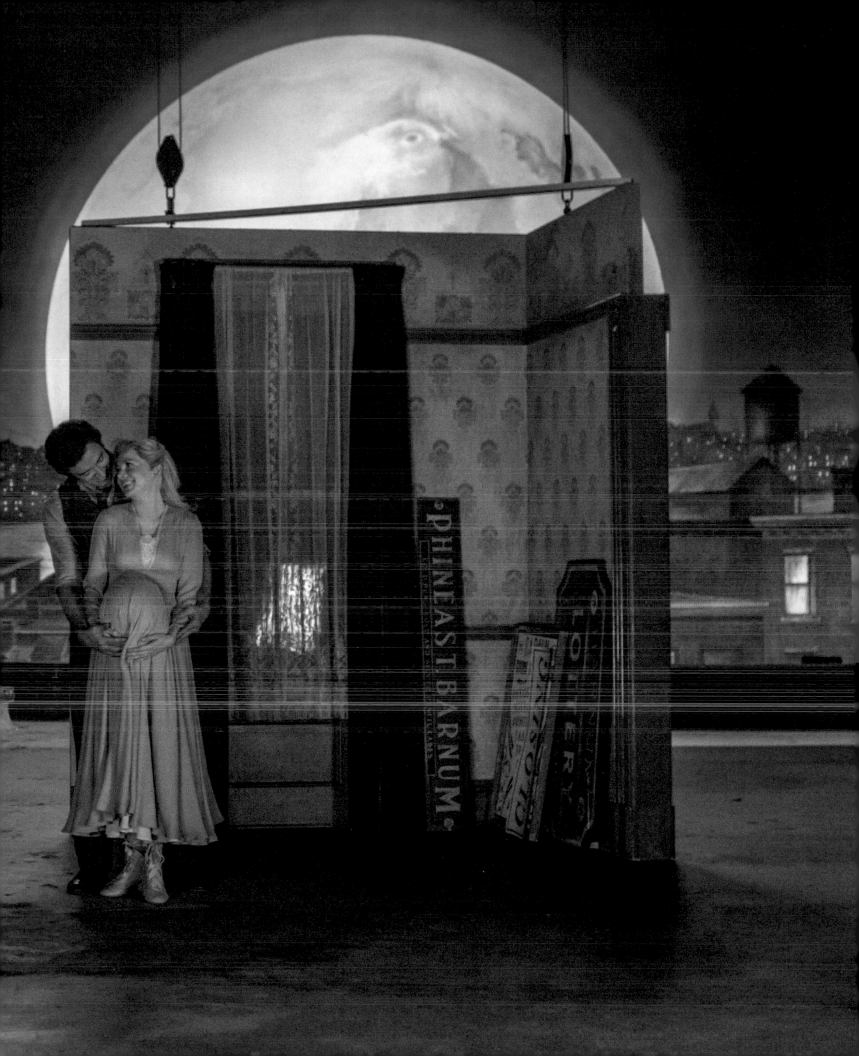

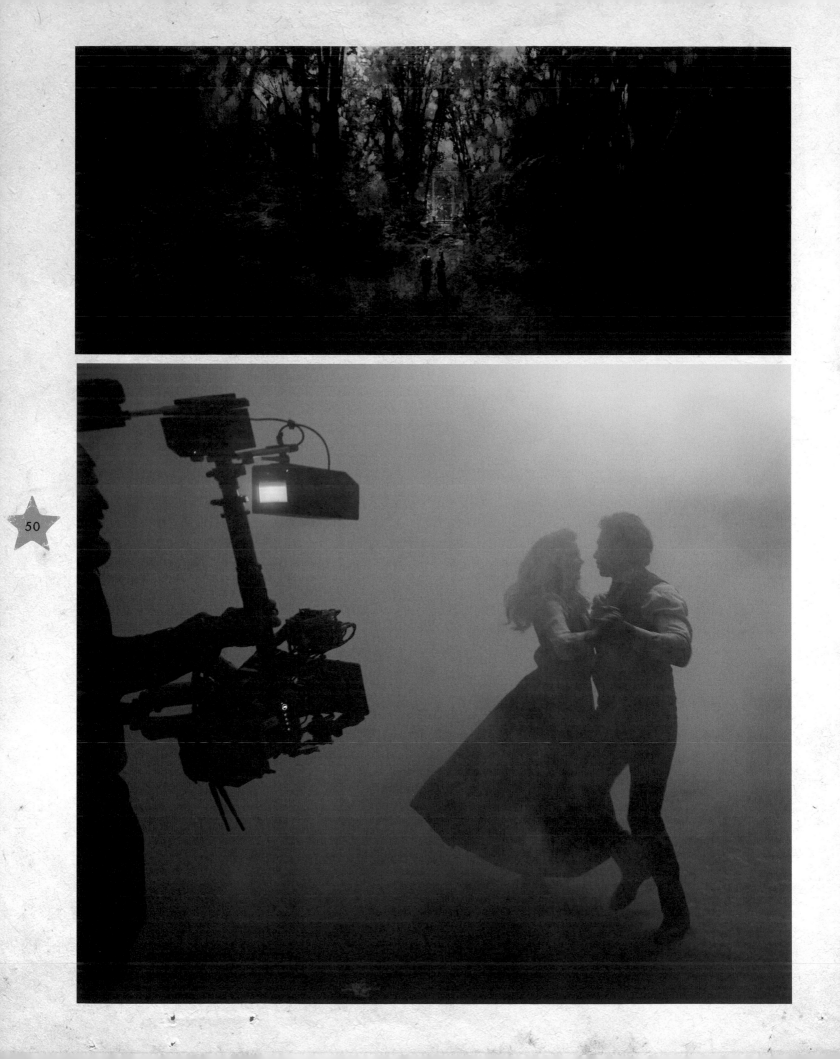

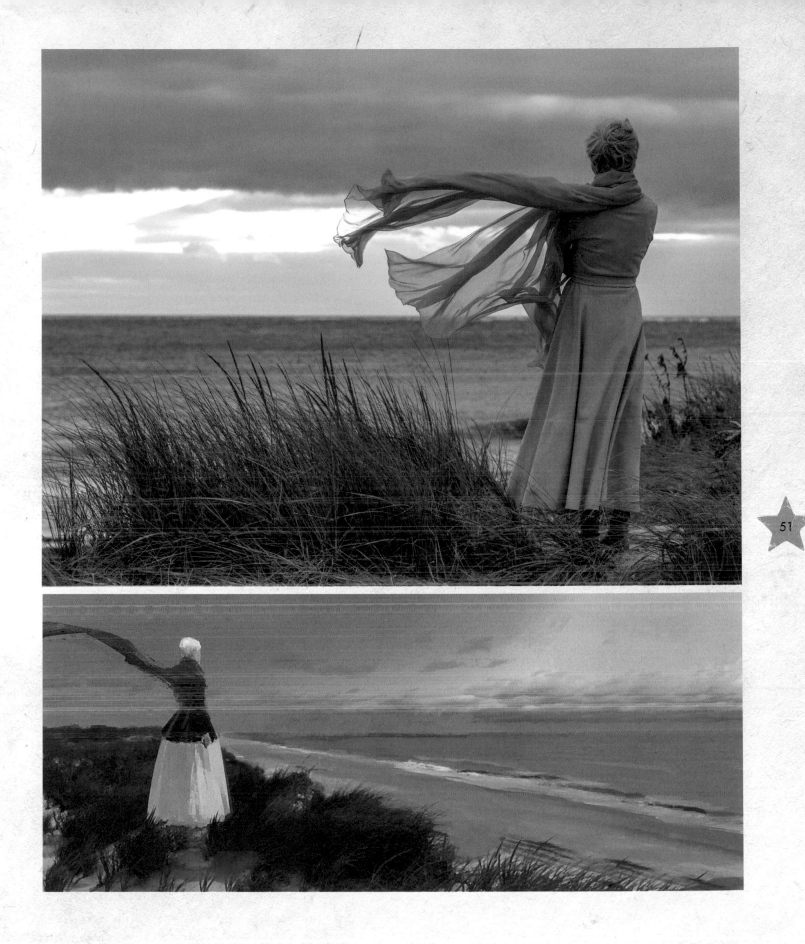

51

OPPOSITE: *Concept art by Joel Chang and a behind-the-scenes shot from "A Million Dreams"* • THIS PAGE: *A scene and concept art by Joel Chang from "From Now On"* • OVERLEAF: *Concept art by Jamie Jones of P.T. and Charity before she leaves for finishing school*

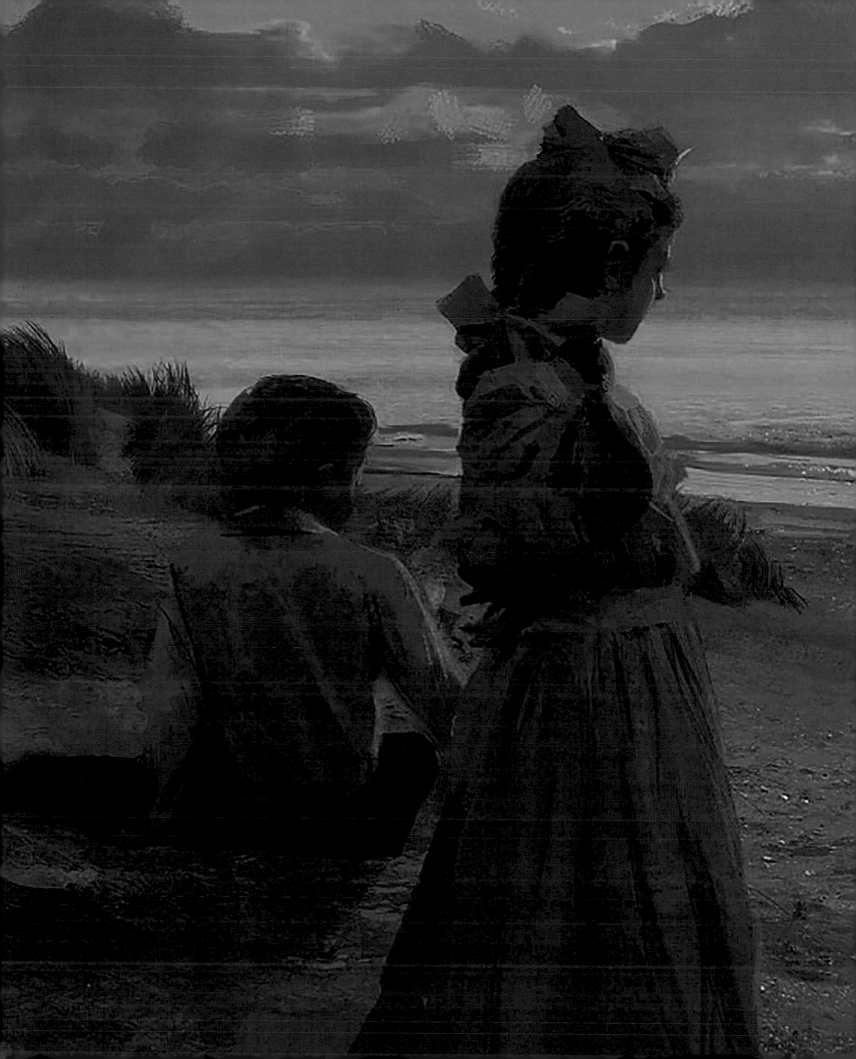

IT'S A PLACE
TO BE TRANSPORTED!
A PLACE WHERE
PEOPLE CAN SEE THINGS
THEY'VE NEVER
SEEN BEFORE!

—P.T. BARNUM

DESCRIBING HIS AMERICAN MUSEUM OF CURIOSITIES

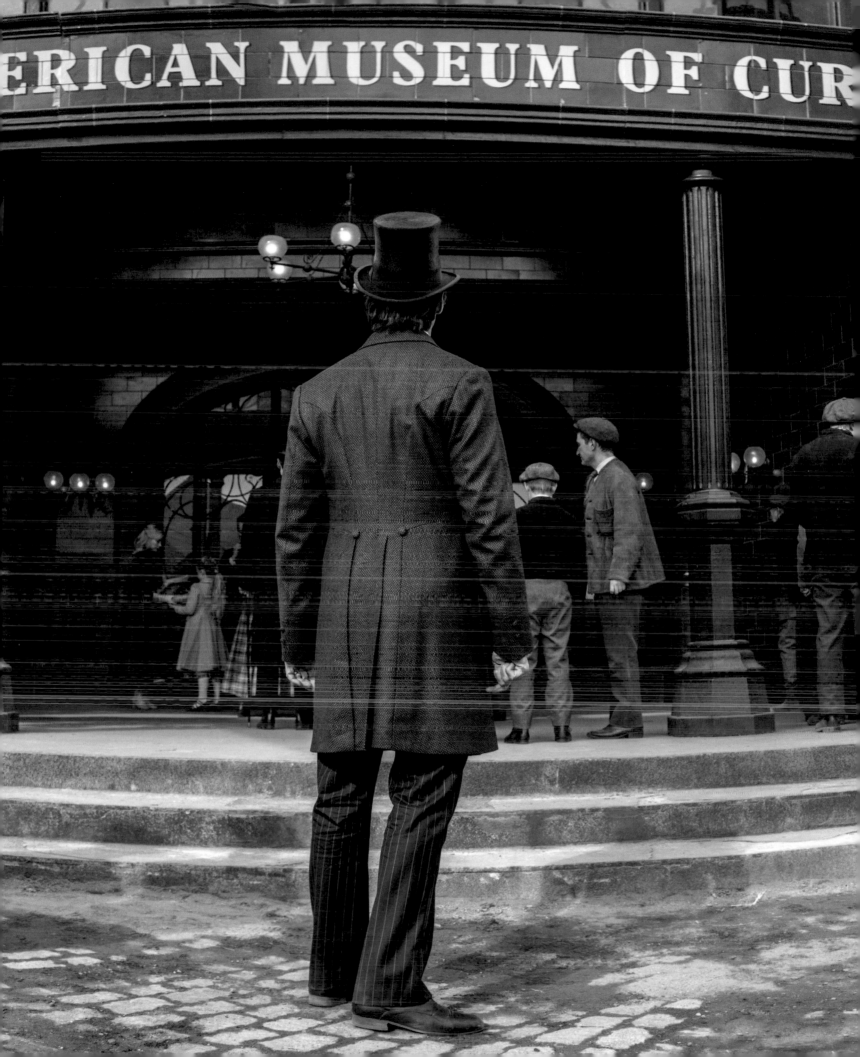

IN *THE GREATEST SHOWMAN,* DIRECTOR MICHAEL GRACEY SHEDS LIGHT ON THE DULLNESS OF NEW YORK CITY JUST BEFORE THE INDUSTRIAL REVOLUTION. UNLIKE THE PERIOD OF PROFOUND EXCITEMENT IN AMERICAN INNOVATION, INGENUITY, and democracy that was The Industrial Revolution — Barnum's imagination was set against the social forces of a world scarred by the civil war, slavery, and economic depression. Regardless, Barnum, a true innovator, set up his first museum in the Big Apple during this time. At the brink of the Industrial Revolution, Barnum taught a generation of Americans how to dream. However, Gracey was keen on capturing the spirit of Barnum as inspired by the later technological, cultural, and artistic advances of the Industrial Revolution, which corresponded with the showman's sense of zeal and seemingly outlandish ideas. There was only one problem: Barnum — the dreamer who escaped from the provincial life of Connecticut to set the big city ablaze with his charisma and imagination — was going nowhere… fast.

When film audiences next catch up to Barnum, he's leading a relatively predictable and humdrum life: He's supporting two children and a wife paycheck to paycheck, subsisting on one dead-end job after another. Instead of making any one of his million dreams come true, he's just one among the other millions of people scraping together a life in the rough-and-tumble city. Still, Barnum's pretty sure Charity didn't sign up for a boring life when she married him. Casting about his surroundings while charming his daughters with a homemade toy—a pencil holder rigged up to illuminate glowing shapes—he wonders, "Is this all?". As Barnum—and movie-going audiences—soon discover, even New York City is too small for P.T. Barnum's determination and appetite for success.

PAGE 57: *Barnum in front of his American Museum of Curiosities* • THIS SPREAD: *Concept art by Joel Chang of the museum* • INSET: *Barnum shows his family the museum*

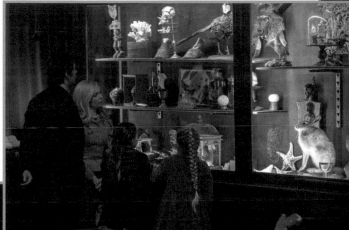

58

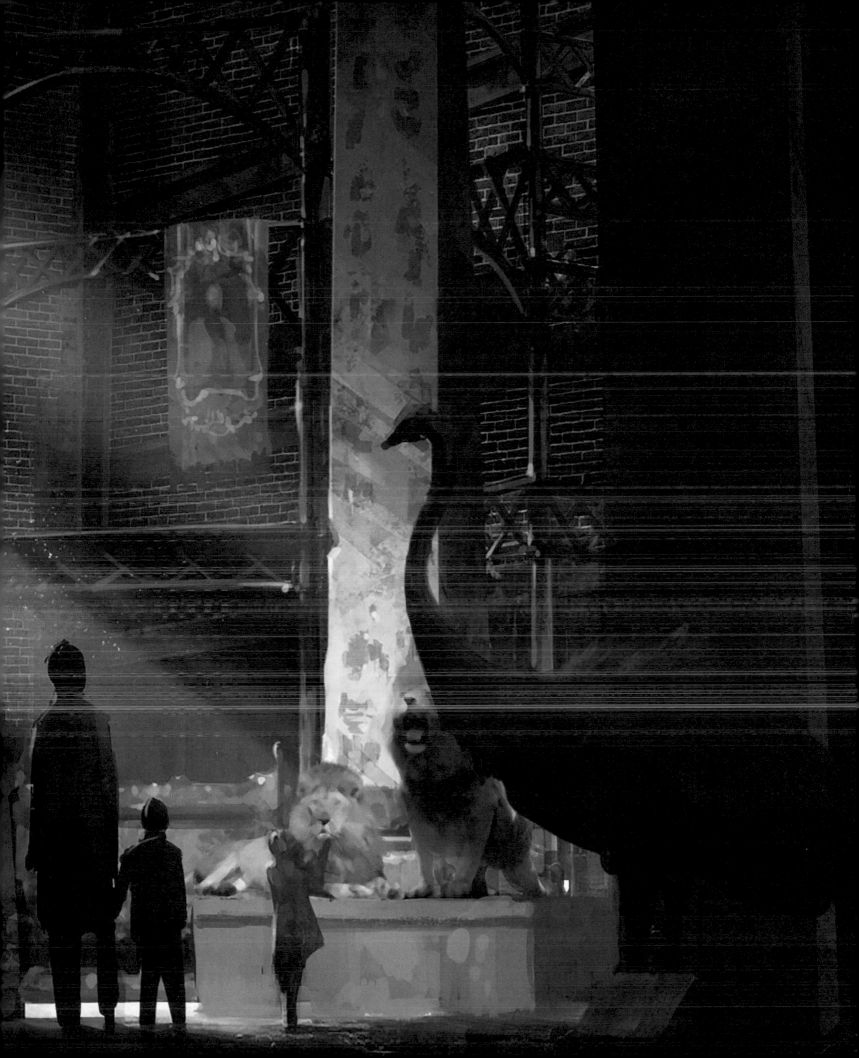

CITY OF DREAMS

"New York is the city of dreams, I think,
more than anywhere else on the planet."
—HUGH JACKMAN

THE GREATEST SHOWMAN WAS FILMED IN AND AROUND NEW YORK CITY, BOTH ON LOCATION AND AT Steiner Studios. In real life, the City had been P.T. Barnum's stomping ground, so it's fitting that the movie was made there, too. New York City is widely recognized as being the historical epicenter of show business—home to the early vaudeville circuit, and countless theaters on Broadway, Times Square, Lincoln Center, Carnegie Hall . . . the list goes on and on. A host of top-notch performers are either from the Big Apple or made their marquee names there. Jackman says, "It's also the epicenter of dreams or making dreams come true. And it does not matter where you come from. It does not matter what school you went to. [New York] City is filled with people with a dream and a desire to make it. . . . Barnum's first circus, which was the Museum of Curiosities, was literally on Broadway. That's where he made his living and where he spent much of his life, so the locations are absolutely perfect for us." More than the locations, though, New Yorkers themselves

made the difference in filming. "It's the spirit," Jackman explains. "The spirit of New York is encapsulated by the cast. I mean, we have so many people playing very small roles who are ridiculously talented, who you could only find in New York, who can sing and dance. . . . I don't think we could have done it anywhere else."

To prepare for the musical numbers and to claim some of that inimitable New Yorker spirit and grit for themselves, Jackman and Efron attended several Broadway shows a week. "Every chance we get," Efron says, "we're out seeing something new or experiencing something vibrant that I would never see in California. I don't think it gets any better than New York." As Gracey says, "New York has the spectacle. . . . Shooting there had an amazing effect of sort of making the impossible real." Some of the buildings featured in the film are standing structures dating from the late 1800s, a fact not lost on the cast and crew. Might Barnum have visited some of these himself? There's no way to know for sure but, surely, Barnum would have approved.

OPPOSITE: *Concept art by Joel Chang of New York City streets*

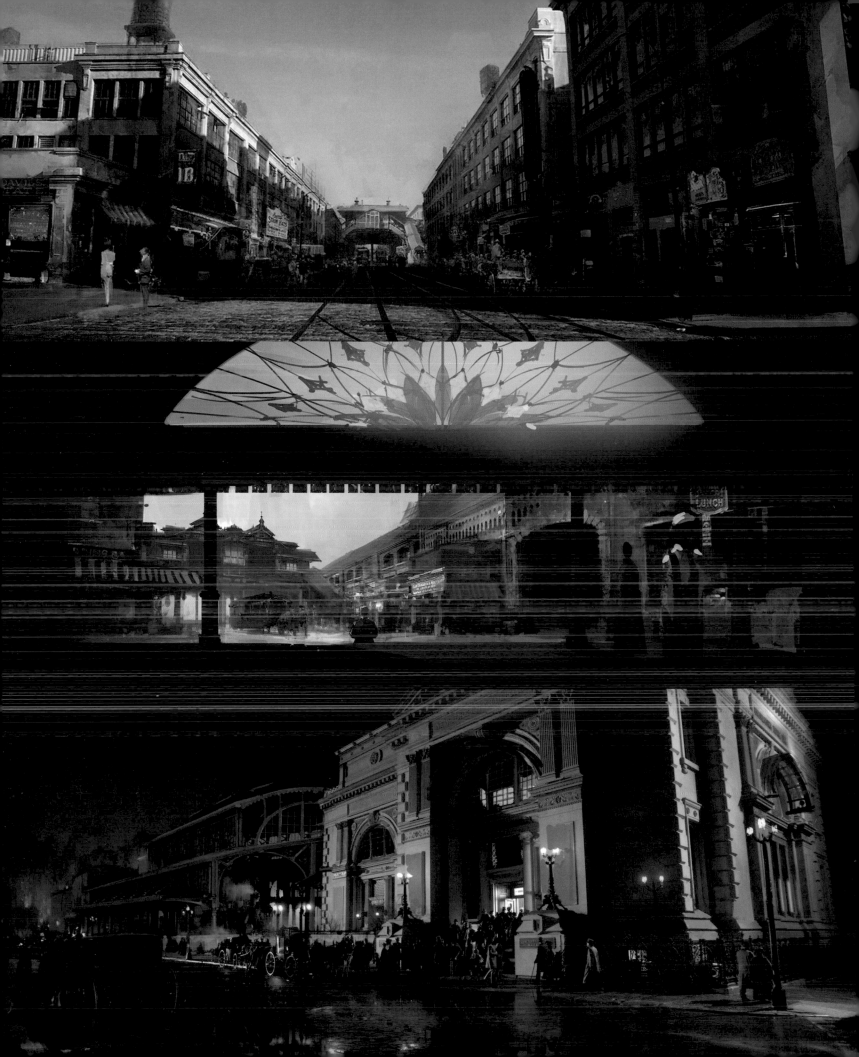

ZAC EFRON AS
PHILLIP CARLYLE

"Show business? Never heard of it." —PHILLIP CARLYLE

ACTOR ZAC EFRON GOT HIS START IN MUSICALS, ATTRACTING THE ATTENTION OF FANS WORLDWIDE FOR HIS LEADING ROLE IN THE *High School Musical* franchise. He later went on to sing and dance his way across the big screen in 2007's *Hairspray*. After a ten-year break from singing and dancing, *The Greatest Showman* marks Efron's return to the musical genre. Speaking of his colleague, Jackman says, "I know he was really excited, really determined to do something different than what he'd done before, and to take his dance and vocal skills to a new level. And he did."

Beyond singing and dancing and the wild spectacle of the film itself, Efron says he also "got" the character of Phillip Carlyle—the connection was immediate. Efron saw a clear path on how to play the prolific-yet-bored artist. "At his core," Efron says, "he's a lost, searching artist and he doesn't have any outlet. He's kind of caged in." When Phillip sees Anne Wheeler swinging and diving, twisting in the air like a bird stretching its wings, he understands that love and its kindred spirit—creative passion—can help set him free.

Playing Barnum's business partner and love interest to Zendaya's Anne Wheeler, Efron is clearly in his element. Whether he's swinging through the sky with Zendaya or executing intricate dance moves with Jackman, Efron makes everything look easy. What audiences don't see, however, is how much behind-the-scenes hard work went into the illusion of effortlessness. While Jackman and Efron formed an instant rapport, they also indulged in some healthy competition with one another. As Gracey says, "Zac would watch Hugh do his dance routines and then you'd see Zac go back to the studio to rehearse even more after seeing what Hugh just did. . . . They have a great friendship and they just push each other." Their on-screen camaraderie, witty banter, and high-energy athleticism is the direct result of each actor pushing the other to a new level of showmanship.

From the beginning, Efron knew this film had something others didn't—it was pure magic. As one of the first actors to sign to the project, he was also one of its chief supporters, and called studio heads to champion it during the earliest stages of development and to voice his support for Gracey. He was also dying to put his dancing shoes back on. He wasn't the only one. "I think it's been a long time," Gracey says, "where people have wanted Zac to reprise that role of singing and dancing on the big screen, and he hasn't wanted to do that until now." Hopefully, it won't be the last time.

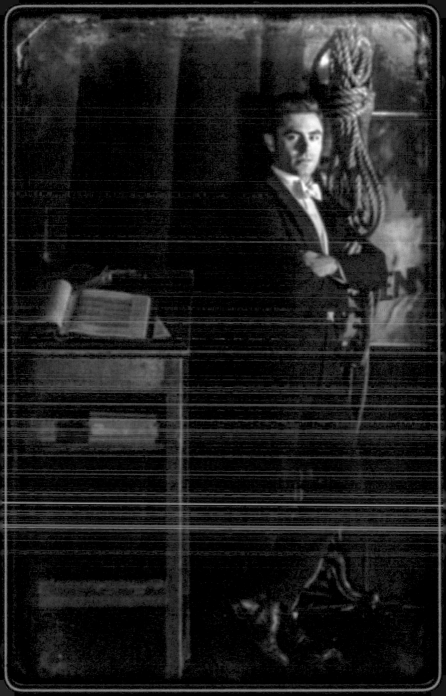

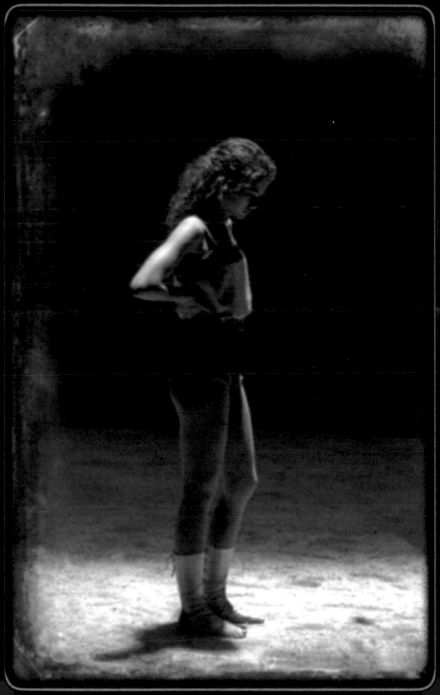

ZENDAYA AS
ANNE WHEELER

 A **UDIENCES CAN'T KEEP UP WITH ZENDAYA. A TRIPLE THREAT, SHE'S SIMULTANEOUSLY AN ACTRESS, SINGER, DANCER,** and, as if that weren't enough, she's also a serious contender on the red carpet as an internationally recognized style icon. Perhaps best known as Rocky Blue on the Disney sitcom *Shake It Up* and MJ in *Spider-Man: Homecoming*, that's about to change with her career-defining role as Anne Wheeler. Director Michael Gracey sums it up best when he says, "I don't know anyone who doesn't fall in love with Zendaya."

Very early on in rehearsal, Gracey invited Efron and Zendaya to his house to rehearse and, as he says, "I wished I had a film crew. Their performance together—their *rehearsal*—was amazing." The on-screen chemistry came easily to both actors. No stranger to love on the big screen, Efron admits, "Falling in love in a musical number on camera is

one of my favorite things to do in the world. I'm not ashamed to say it." Falling in love is one thing. Learning to fly, however, is another.

Beyond singing, dancing, and acting, Zendaya was also tasked with having to learn how to do the trapeze along with other complicated aerial stunts. "I can't even pick out what she's best at," admits Gracey. "It's ridiculous. I would give her the most insane instruction: I would put her up on rigs and fly her around the roof . . . and say to her, 'Just sing as I fly you around this room. You're just holding onto a rope and I'm going to throw a hat up to you and I need you to catch it.' And she would. It was almost like I was trying to come up with the most ridiculous scenario." Jackman, a man known for being a powerhouse of a hard worker, admits, "She's a true star, a hard worker. When she dances, and she's with twenty of the best dancers in the world, your eye goes to her." Of course, having pink hair and being able to swirl and dance—literally—above everyone else helps, too.

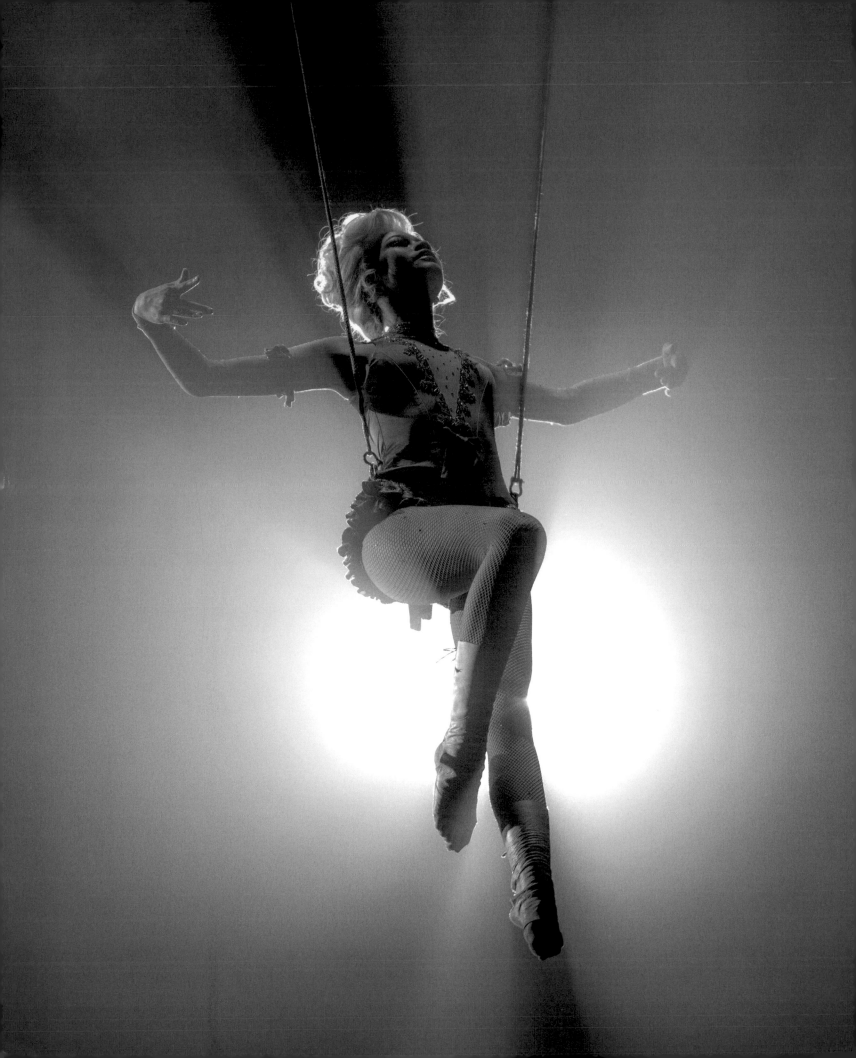

AERIAL & TRAPEZE WORK

"The Greatest Showman is a story about adventure. It's a story about people in love with the possibility of being the most they can be and about achieving the most they can out of themselves."
—YAHYA ABDUL-MATEEN

WHEN ZENDAYA SIGNED ON FOR THE PROJECT, GRACEY CONFESSED THAT he wanted to use her stunt double as little as possible. Faced with the prospect of flying through the air as the film's main trapeze artist gave Zendaya pause. "I had to get over my fear of heights on the very first day," she says. She also realized that she needed to get into serious shape, strengthening both her upper body and her core. Much of Zendaya's physical training revolved around aerial and trapeze work, which is vastly different from floor choreography. She trained for several months with aerialists and trapeze artists before she started on the choreography for "Rewrite the Stars," among other scenes. The work certainly paid off as Zendaya admits herself: "Flying around in air is definitely a new skill that I have acquired for this movie. I'm very proud of myself because it's new and it's something that I was able to do . . . to come out of my comfort zone."

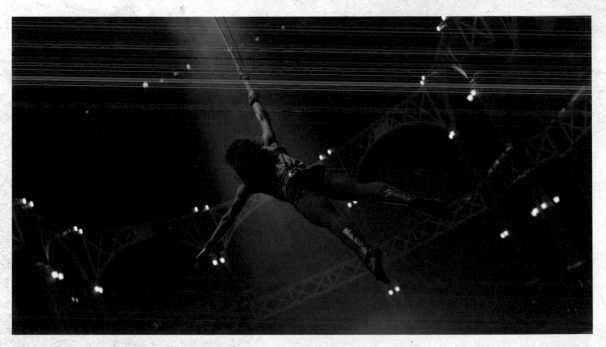

PAGES 63 AND 64: *Production images* • OPPOSITE: *Anne Wheeler on the trapeze* • ABOVE: *Scene from "Rewrite the Stars"*

FORBIDDEN LOVE
ANNE WHEELER
& PHILLIP CARLYLE

"All I want is to fly with you
All I want is to fall with you
So just give me all of you . . . "
—"REWRITE THE STARS" LYRICS

THE RELATIONSHIP BETWEEN TRAPEZE ARTIST ANNE WHEELER AND THEATER PRODUCER PHILLIP CARLYLE IS AS HEART-WRENCHING TO watch as it is beautiful. Torn by racial differences and class distinctions—Phillip, a white man, is wealthy; Anne, a black woman, is not—their love is forbidden, and yet audiences know in their heart of hearts that, as actress Zendaya says, "Love isn't something that someone can control." Their attempt to navigate love through the omnipresent racial and class divides is eloquently captured by the song "Rewrite the Stars," in which both characters sail in and out of each other's grasps and sing lovelorn lyrics that manage to be both simple and emotionally complicated.

Actor Zac Efron, who plays the role of Phillip Carlyle, says it was easy to fall in love with actress Zendaya on screen, and confirms that they locked down their first scene—during which the characters see each other for the first time and fall hopelessly in love on sight—in one or two takes. Zendaya describes that scene, saying, "And I just kind of swing right up to Phillip [on the trapeze], and they meet eyes and lock. It is one of the most beautiful shots ever. . . . It's a love-at-first-sight moment, and everything feels like slow motion. The world stops for a second." As star-crossed lovers, their on-again, off-again relationship is a searing look at what divides us from love, from each other. For the character of Phillip Carlyle to bridge love's divide, he must risk everything—his sense of propriety, family respect, and financial stability. Anne, too, has everything to risk and seemingly nothing to gain except, perhaps, more heartache and pain.

An alcoholic searching for greater meaning in his life, Phillip, though already successful as a theater producer, is nonetheless stifled and stuck, having spent years pandering to theater audiences

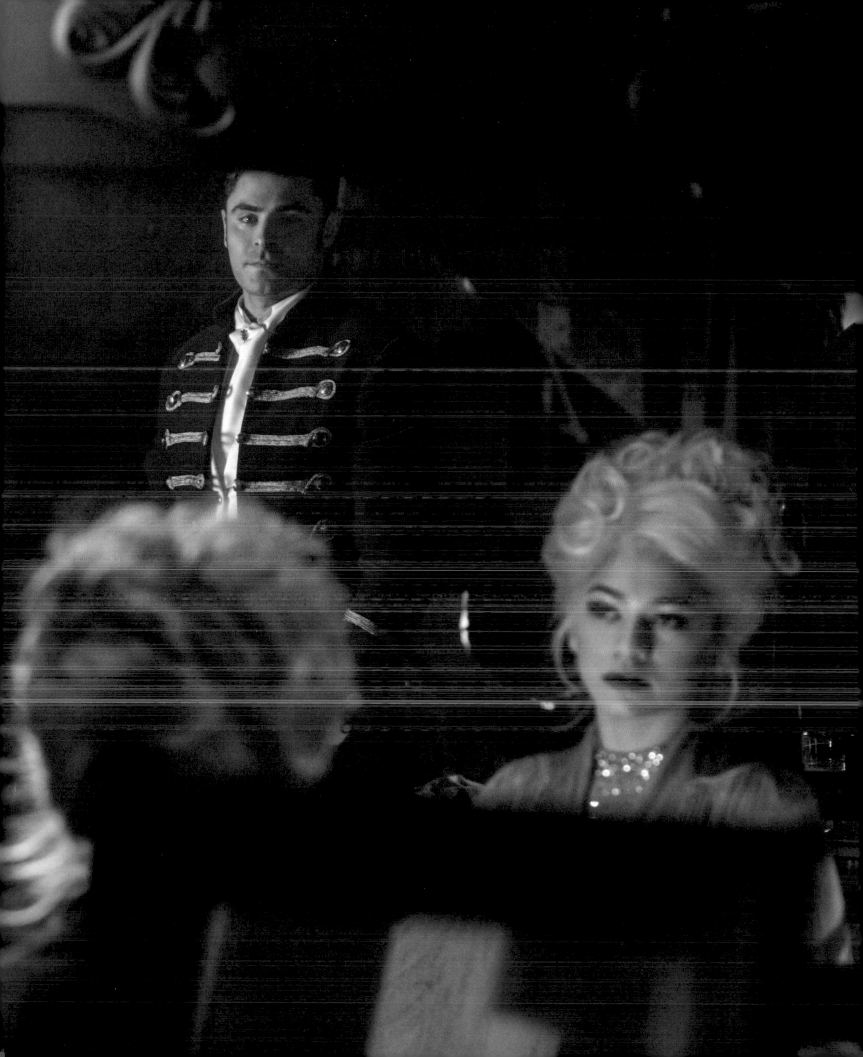

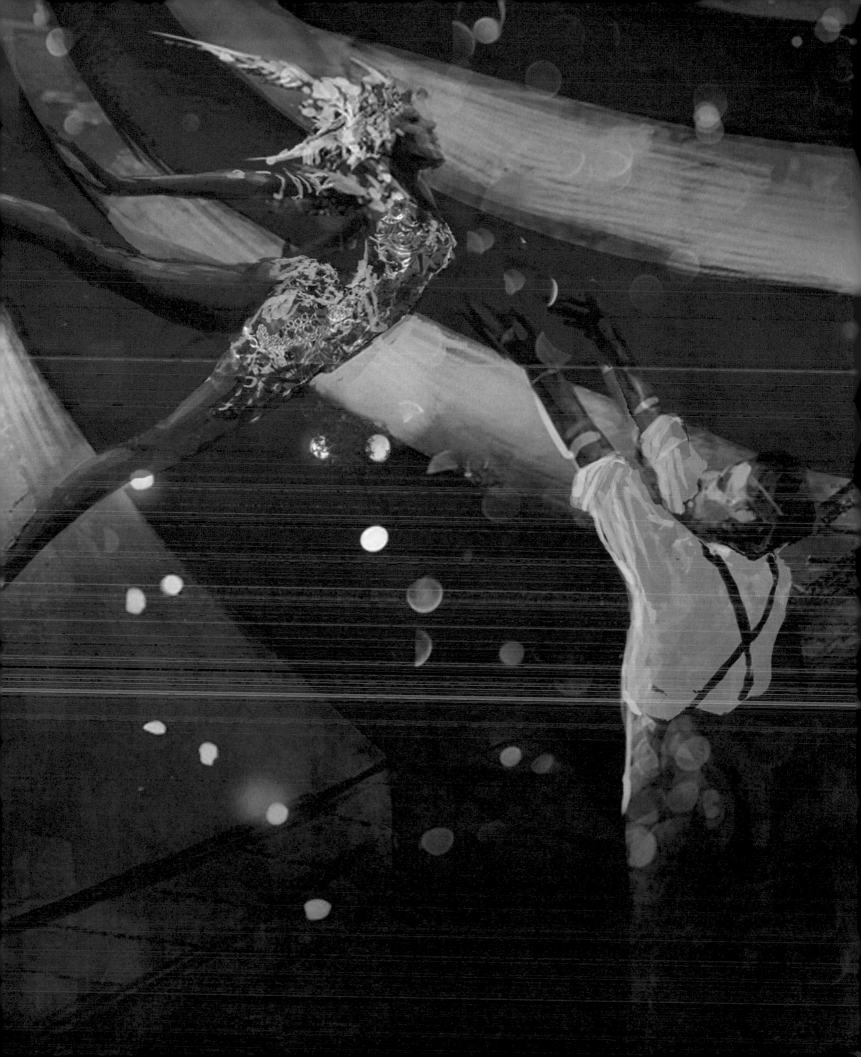

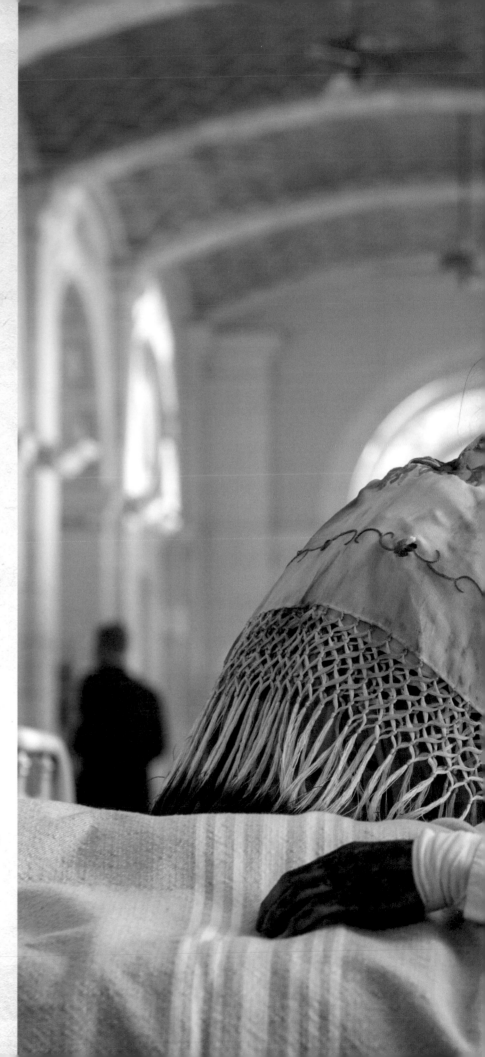

he doesn't respect. He yearns for the passion and the boundless creativity that seems to flow so effortlessly from P.T. Barnum's fingertips. As Efron says, "Phillip is searching for something more." More from life, more from love, more from his career—everything. "And that's a feeling," Efron says, "everyone can relate to." For Phillip, who's hemmed in by the expectations of high society, Barnum, with his shrug of nonconformity, offers a much-needed sense of freedom and a chance for Phillip to thumb his nose at the very patrons he once wooed. When Phillip enters the American Museum and spies the pink-haired angel, Anne Wheeler, swinging from the trapeze, he needs little else as buy-in. "For the first time, he sees the world in its true colors," says Efron. Those true colors extend to Anne, too, and by the end of the film, Phillip, perhaps more than any other character, fully embraces Barnum's vision of the world: a place where, circus or not, everyone's talent is validated and applauded, and love takes center stage.

Phillip's emotional breakthrough resonates beyond the big screen to real life, too. His breakthrough is the moment, Efron says, "when you realize that you don't have to live within the boundaries that everyone else has set through history or through time. You don't have to follow the rules. You don't have to color inside the lines. You can be your own person." You can be the ringmaster of your own life and, yes, you can rewrite the stars.

PAGE 69: *Phillip and Anne gaze at each other* •
PREVIOUS SPREAD: *Circus poster* (LEFT) *and concept art
by Brian Estanislao of "Rewrite the Stars"* (RIGHT) •
THIS SPREAD: *Anne and Phillip in the hospital*

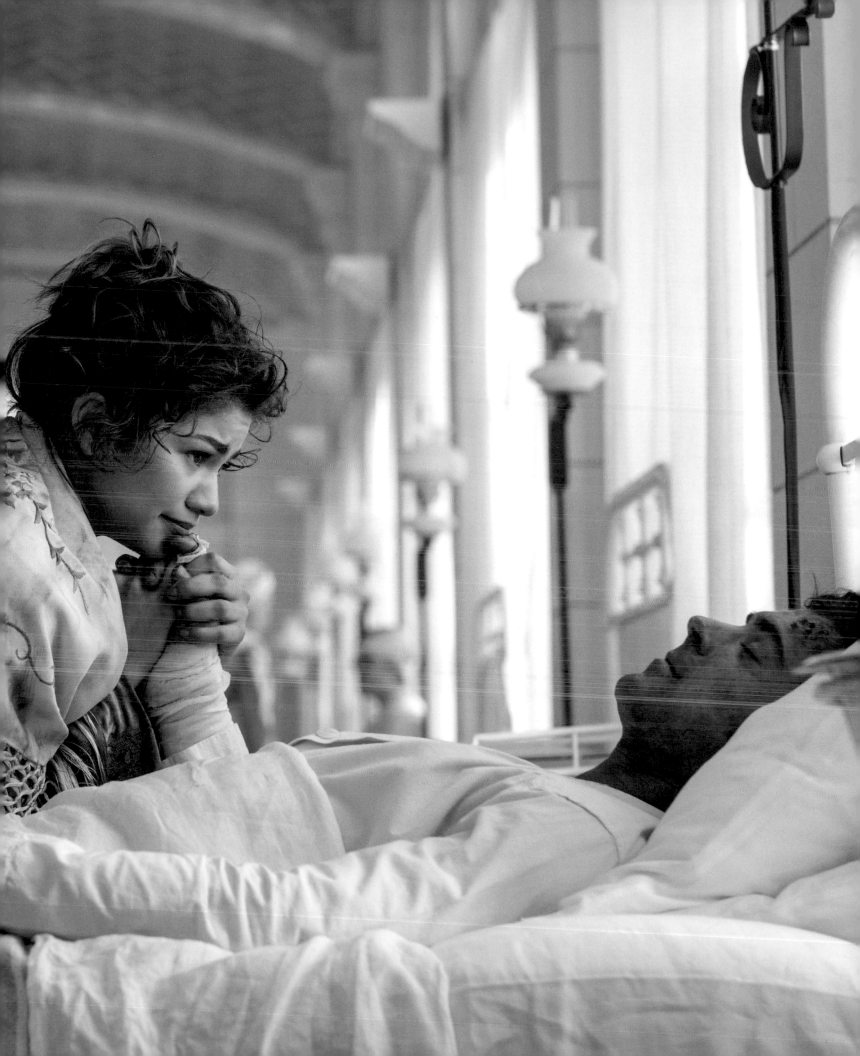

THE GREATEST OF EASE
SONGWRITERS' & CHOREOGRAPHERS'
NOTEBOOK

"The reason I love musicals is because when words no longer suffice, you sing."
—DIRECTOR MICHAEL GRACEY

SONGWRITING

"What's so cool about this [movie] is that, even though it's set in the 1800s, and even though you know it's a musical and musicals kind of have their own sound, there's something about this one musically that is very modern and contemporary."
—Zendaya

THIS ISN'T YOUR GRANDPARENTS' MUSICAL. AS ZAC EFRON EXPLAINS, "IT ISN'T A TURN-YOUR-HEAD AND SNAP-YOUR-FINGERS AND WE'RE-IN-A-SONG-EVERYONE'S -dancing kind of movie." Instead, the music is in complete service of the characters' emotions: every lyric, every chord change, and timbre of the instruments directly corresponds to the emotionality of the moment. Written by the acclaimed Oscar, Golden Globe, and Tony Award–winning duo Benj Pasek and Justin Paul, the music intentionally hits the film's high points and then ushers in its more sorrowful moments, too. Besides fulfilling the film's emotional core, the songs are remarkably contemporary one-hit wonders so catchy that cast members found themselves humming and singing them off set. Actor Yahya Abdul-Mateen, who plays

Anne Wheeler's brother, says, "We sing them during our down time, when we're not even filming or working." Suffice to say, audiences will come away from the movie theater doing the same.

CHARACTER AND SONG

"In collaborating with Michael [Gracey], everything was really motivated by character, so every character has a unique perspective, a unique voice, and the trick of it was figuring out who would be the modern representation of each character? Who would be the voice of P.T. Barnum now?"
—Benj Pasek

FOR PASEK AND PAUL, THE MOST EXCITING (AND CHALLENGING) ASPECT OF THE SONGWRITING PROCESS WAS FIGURING OUT THE MODERN-DAY VOICE FOR EACH character. Were she truly alive today, Pasek asks, "How would Charity Barnum sing now?" What would Barnum sound like? What kind of style of music would best give voice to his character? Those questions led to a musical investigation of different types of song genres—from

indie songs to pop music to standard Broadway-sounding tunes. Each song in the film required Pasek and Paul to dive deep. With input from Gracey, the songwriters discovered the sound and emotional nuance of every musical moment for every character. Their discoveries were aided by the phenomenal cast. "It's incredibly thrilling," Pasek says, "to have some of the best interpreters of musical theater working on these songs. Hugh Jackman, for example, is an incredible musical theater actor beyond all of his other work that everyone knows him for." The duo felt a certain responsibility to create songs that not only served the emotional and narrative arc of the film but also showcased the individual talents of each actor.

Along with researching different musical styles for each character, Pasek and Paul also referenced other musicals in terms of how certain scenes would work. For Efron and Jackman's duet "The Other Side," for example, they looked at some of the classic MGM musicals as inspiration, to see how two guys would do a dance-off. They wanted a similar kind of energy to run throughout their duet, with ample space for each character to show off his range and talent but also to build on the musical sequencing. Pasek says, "You're always looking to mine all of the great stuff that's come before and to try to have it come through your own filter." That said, however, it was incredibly important to everyone working on *The Greatest Showman* that it be a stand-alone, original, contemporary feature—and *not* resemble a standard musical from the past. Paul says, "So it was, like, take what works from the past but also try to be daring to create something new." In a sense, their objective wasn't dissimilar from P.T. Barnum's, as he expressed it, singing, "I think of what the world could be / A vision of the one I see."

"COME ALIVE"

"Come alive
Come alive
Go and light your light
Let it burn so bright."
—"Come Alive" lyrics

More than any other song in the film, "Come Alive" is its call to action. In it, Barnum invites everyone—no matter their station or background—to dream big and manifest their greatest vision of themselves. Jackman says, "'Come Alive' is really about celebration, about being fearless. . . . It's a song about the magic of life. Life is, hopefully, limitless. It has endless possibilities. But you have to wake up. You have to literally pick up your head and you have to be open to all the options that are there. You have to be open to the possibilities. 'Come Alive' is a call to live life fully."

As one of the first musical numbers to be filmed, "Come Alive" was also one of the production's most grueling. Filming took weeks and, as it was straight out of the gate, it provided an early model of the working relationship between cast and crew and how the rest of production would go, namely, give, give, give until you can't give anymore . . . then get up tomorrow and do it again. Shot in several different phases, in part because the physical spaces also change throughout the song—from the circus to the interior of the American Museum to New York City and beyond—the song was both physically demanding for the performers and, from the crew's perspective, multilayered and difficult. And yet, as actress Keala Settle, who plays Lettie Lutz, expresses, "It was the perfect number to be the first one because we, the Oddities, had just gotten there [on set]. We had had two days of rehearsal before then, with a couple of numbers in the [circus] ring, and then we changed—brand-new clothes, new shoes—and went in for 'Come Alive.' And the Oddities are standing next to these incredible dancers, and the thing is, we fit in! We looked like we were supposed to be there, every single person." That sense of belonging permeated the ensemble and, by bringing everyone closer, made the rest of the work easier.

"REWRITE THE STARS"

"'Rewrite the Stars' is one of my favorite numbers in the entire film because it's about these two star-crossed lovers and them working through their forbidden love."
—Zac Efron

The song "Rewrite the Stars" was very much subject to multiple takes. As Zendaya explains, "[The shooting] goes from one day to two to three and then four days long . . . and it just keeps going because it's one of the numbers that requires you take the time to get it right." It was a complicated shoot: Literally flying through the air, Zendaya and Efron swung around each other in choreographed movement designed to look simple but that was, in fact, fairly detailed—and potentially dangerous—to pull off. The scene didn't come without

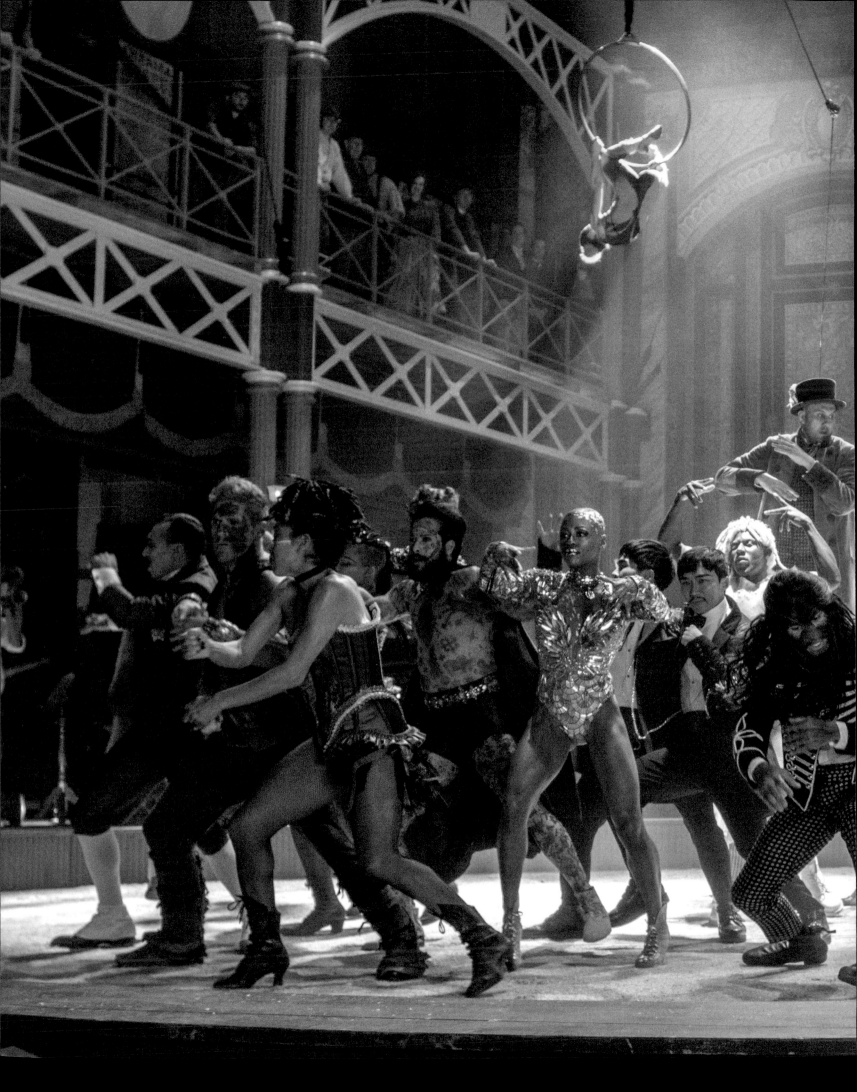

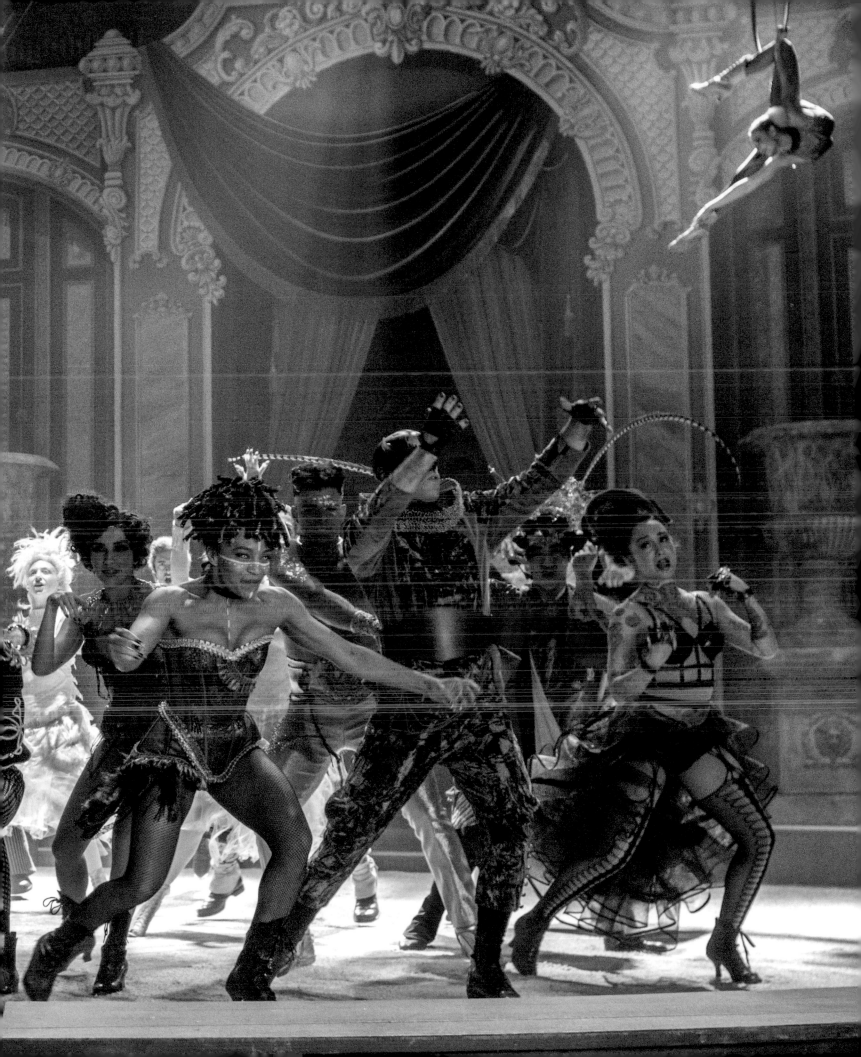

its physical difficulty. Zendaya admits that she garnered more than a few bruises from it but, as she says, "It's worth it." The fact that the song is performed in midair and there's a possibility that Phillip could miss Anne's hand or, worse, the characters could collide into one another only underscores the latent danger of their relationship. That no one falls is not only a miracle, it's also a statement about love itself being both a safety net and saving grace.

To light the scene, Cinematographer Seamus McGarvey hung a single spotlight above the actors. He did this to help give the effect, he says, of "the heat, the rest of the world diminishing like it does when you're in love for the first time. . . . And then we added little points of light around the set to effectively create a constellation behind them." The camera weaves in and out of this man-made starscape, tracking the actors' movements and inviting the audience into their star-crossed paths. For inspiration, McGarvey found himself referencing Marc Chagall's painting *Bouquet with Flying Lovers*, in which two lovers return to each other and float upwards into a far corner of a room, their bouquet of flowers earthbound below. The idea, cinematically, was to create a feeling of levity and weightlessness as Anne and Phillip suspend themselves, literally and figuratively, far above society's confines to revel in their young love. When the two actors spin midair, the camera records the world as a blur behind them—an apt cinematic effect that emotionally conveys the dizzying effect of love.

Watching the scene in playback and seeing Gracey's directorial vision come to life was magical, says Zendaya. A bit like dancing on air.

"THIS IS ME"

"There are young women and young men who need to hear a song like 'This Is Me' because it gives the message of being brave despite being bruised."
—Zendaya

The anthem of the Oddities, "This Is Me," almost didn't make it into the film. Pasek and Paul knew the Oddities needed a show-stopping number and, as one of the last songs written, "This Is Me" doesn't disappoint, in large part due to the impassioned singing of Broadway-trained actress Keala Settle. Pasek and Paul wrote the song on a plane with a keyboard and a pair of headphones. Jackman says, "The moment I heard it, I was, like, 'Okay, that's a huge hit. Um, and I wish I was the one singing it.'"

Settle's soulful rendition is heart-stopping. It's a declaration of belonging and is sure to resonate with anyone who wants to find acceptance in the world. As Zendaya says, "Somebody needs to hear the words of that song to help feel bigger about themselves . . . to feel like they're a part of something. I'm who I'm meant to be."

Settle herself was cast late to the part of Lettie Lutz. To imagine someone else in the role, a different Bearded Lady than Settle, is unthinkable. From the moment Settle opens her mouth to sing, her wicked eye makeup flashing, her full beard glinting in the light, audiences know they're watching an actress come into her own. As Jackman says, "I don't think anyone else will ever sing that song because it is hers."

"FROM NOW ON"

"Everyone's an oddity." —Director Michael Gracey

The Oddities are, without doubt, the heart and soul of the film and key to Barnum's professional success. It's heartbreaking, then, when Barnum turns his back on them and on his wife and children, choosing instead to focus his attention on his rising success and business partnership with Jenny Lind. Cast off by the very man who had first thrust them into the limelight and gave them a home, the Oddities, nonetheless, refuse to turn their back on Barnum when he's down and out. In "From Now On"—the triumphant, almost gospel-esque musical number that takes place in Barnum's local bar— the Oddities ask Barnum to look around, to open his eyes and recognize what he has helped build, and what he's forgotten, too: family.

Barnum's American Museum (and later the circus) is a home, and not just for the performers but for audiences, too. It's a place where people come to find themselves, to unburden themselves of daily pain and suffering. Amid the most exotic of creatures—elephants, lions, and sequin-dappled horses—and the most extraordinary of talents—trapeze artists, contortionists, and flame eaters—audiences are free. Life, in all its dazzling array, is not only put on display, but is also celebrated. Laughter comes easily. Smiles, too. Every moment of every day should be so precious. At the end of "From Now On," the characters are imbued with a newfound energy, purpose, and drive. The perfect send-off for movie-going audiences, too, "From Now On" embodies a collective and hopeful desire to be better, perhaps, than when we first entered the darkened theater.

FOUR DAYS, TWO SONGS

"For us as songwriters, we're always attracted to a story that's aspirational." —Justin Paul

I N 2013, SONGWRITERS BENJ PASEK AND JUSTIN PAUL MET WITH DIRECTOR MICHAEL Gracey in New York City and, after listening to Gracey's pitch and his vision that *The Greatest Showman* be a combination of both the real and the fantastical, they felt compelled to try their hand at composing some songs for it. Paul says, "He [Gracey] wanted contemporary-sounding music but it still had to tell the story. We love pop music and we love theater music, so we thought: we can do this. We don't know if it's possible, but we wanted to try. So, we set a goal for ourselves." Pasek says, "We had four days before Gracey left town." At the time, Pasek and Paul were still up-and-comers and new to the songwriting circuit. They hadn't yet won their Tony or Academy Awards. In fact, the duo hadn't written anything for film; their careers were very much just starting. Pasek says, "This was the big chance for us. We had a director making a movie musical in Hollywood who was going to actually listen to our songs. And the other people he was speaking to at the time had a lot more experience than we did."

The two songs the duo penned were an opening number that got cut from the film and "A Million Dreams." Upon hearing the roughs, Gracey gave the team notes straightaway and soon they all began to collaborate, citing the songs' strengths and weak points. Pasek and Paul weren't used to having an on-the-spot collaborator and real-time critique session. Pasek says, "You know, we tend not to write with someone in the room with us. We're sort of private and secretive about our process. . . . And Michael, because it was sort of established this way, has been our third collaborator on almost every song."

From that moment working forward, the duo became a creative trio, with each individual negotiating the songs' key components—everything from their placement to their narrative content. Each song was worked out one at a time until Pasek and Paul had written all the songs in the film. What began as four days and two songs evolved into a fully realized film and creative partnership better than any Hollywood dream.

PREVIOUS SPREAD: *Scene from "This Is Me"*

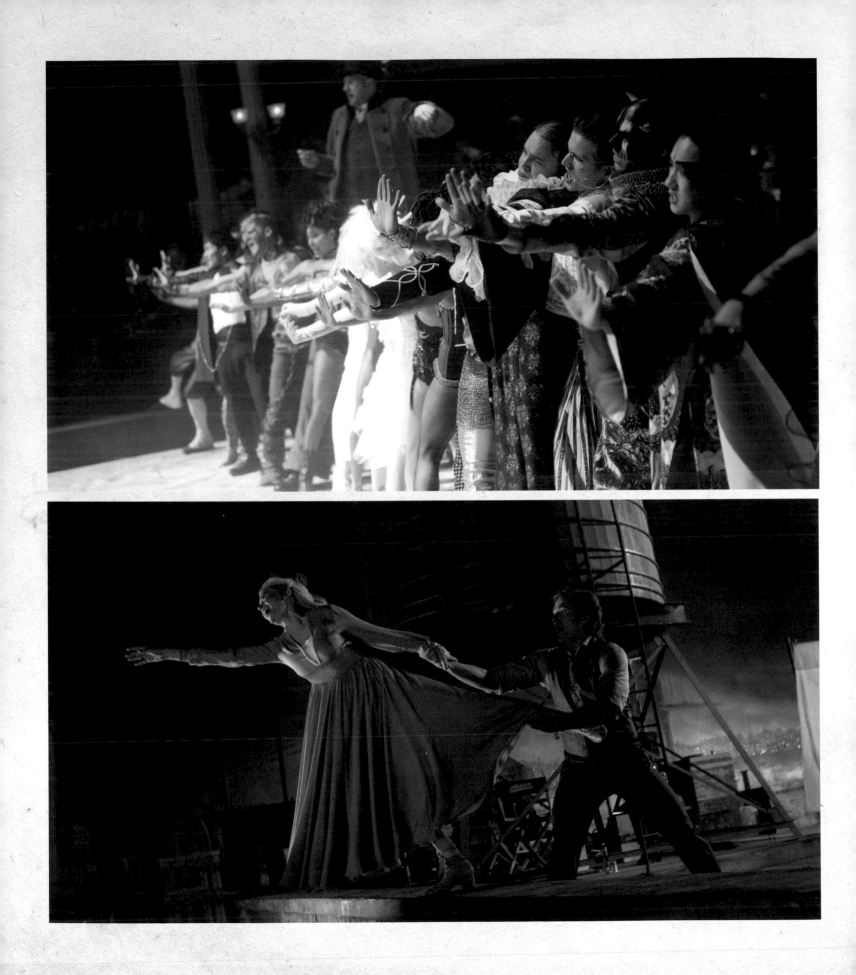

TOP: *Set photography, the Oddities* • ABOVE: *Scene from "A Million Dreams"*

"COME ALIVE"

BARNUM

YOU STUMBLE THROUGH YOUR DAYS
GOT YOUR HEAD HUNG LOW
YOUR SKY'S A SHADE OF GREY
LIKE A ZOMBIE IN A MAZE
YOU'RE ASLEEP INSIDE
BUT YOU CAN SHAKE AWAKE
'CAUSE YOU'RE JUST A DEAD MAN
 WALKIN'
THINKIN' THAT'S YOUR ONLY OPTION
BUT YOU CAN FLICK THE SWITCH
AND BRIGHTEN UP YOUR DARKEST DAY
SUN IS UP AND THE COLOR'S BLINDIN'
TAKE A WORLD AND REDEFINE IT
LEAVE BEHIND YOUR NARROW MIND
YOU'LL NEVER BE THE SAME

COME ALIVE
COME ALIVE
GO AND LIGHT YOUR LIGHT
LET IT BURN SO BRIGHT
REACHIN' UP
TO THE SKY
AND IT'S OPEN WIDE
YOU'RE ELECTRIFIED
AND THE WORLD BECOMES A FANTASY
AND YOU'RE MORE THAN YOU COULD
 EVER BE
'CAUSE YOU'RE DREAMIN' WITH YOUR
 EYES WIDE OPEN
AND YOU KNOW YOU CAN'T GO BACK
 AGAIN
TO THE WORLD THAT YOU WERE LIVIN'
 IN
'CAUSE YOU'RE DREAMIN' WITH YOUR
 EYES WIDE OPEN
SO COME ALIVE

I SEE IT IN YOUR EYES
YOU BELIEVE THAT LIE
THAT YOU NEED TO HIDE YOUR FACE
AFRAID TO STEP OUTSIDE
SO YOU LOCK THE DOOR
BUT DON'T YOU STAY THAT WAY

LETTIE

NO MORE LIVIN' IN THOSE SHADOWS
YOU AND ME, WE KNOW HOW THAT
 GOES

LORD OF LEEDS

'CAUSE ONCE YOU SEE IT, OH, YOU'LL
 NEVER NEVER BE THE SAME

ODDITIES

A LITTLE BIT OF LIGHTNIN' STRIKIN'
BOTTLED UP TO KEEP ON SHININ'
YOU CAN PROVE THERE'S MORE TO YOU

BARNUM

YOU CANNOT BE AFRAID

BARNUM/ODDITIES

COME ALIVE
COME ALIVE
GO AND LIGHT YOUR LIGHT
LET IT BURN SO BRIGHT
REACHIN' UP
TO THE SKY
AND IT'S OPEN WIDE
YOU'RE ELECTRIFIED

AND THE WORLD BECOMES A FANTASY
AND YOU'RE MORE THAN YOU COULD
 EVER BE
'CAUSE YOU'RE DREAMIN' WITH YOUR
 EYES WIDE OPEN
AND WE KNOW WE CAN'T GO BACK
 AGAIN
TO THE WORLD THAT WE WERE LIVIN' IN
'CAUSE WE'RE DREAMIN' WITH OUR
 EYES WIDE OPEN
SO COME ALIVE

COME ONE, COME ALL
COME IN, COME ON

ANNE

TO ANYONE WHO'S BURSTIN' WITH A
 DREAM

ODDITIES

COME ONE, COME ALL
YOU HEAR THE CALL

BARNUM

TO ANYONE WHO'S SEARCHIN' FOR A
 WAY TO BREAK FREE

ODDITIES

BREAK FREE
BREAK FREE

BARNUM/ODDITIES

AND THE WORLD BECOMES A
 FANTASY
AND YOU'RE MORE THAN YOU COULD
 EVER BE
'CAUSE YOU'RE DREAMIN' WITH YOUR
 EYES WIDE OPEN
AND WE KNOW WE CAN'T GO BACK
 AGAIN
TO THE WORLD THAT WE WERE LIVIN'
 IN
'CAUSE WE'RE DREAMIN' WITH OUR
 EYES WIDE OPEN

BARNUM/ODDITIES

AND THE WORLD BECOMES A FANTASY
AND YOU'RE MORE THAN YOU COULD
 EVER BE
'CAUSE YOU'RE DREAMIN' WITH YOUR
 EYES WIDE OPEN
AND WE KNOW WE CAN'T GO BACK
 AGAIN
TO THE WORLD THAT WE WERE LIVIN' IN
'CAUSE WE'RE DREAMIN' WITH OUR
 EYES WIDE OPEN
'CAUSE WE'RE DREAMIN' WITH OUR
 EYES WIDE OPEN
SO COME ALIVE

"REWRITE THE STARS"

PHILLIP

YOU KNOW I WANT YOU
IT'S NOT A SECRET I TRY TO HIDE
I KNOW YOU WANT ME
SO DON'T KEEP SAYIN' OUR HANDS ARE
 TIED
YOU CLAIM IT'S NOT IN THE CARDS
AND FATE IS PULLING YOU MILES AWAY
 AND OUT OF REACH FROM ME
BUT YOU'RE HERE IN MY HEART
SO WHO CAN STOP ME IF I DECIDE THAT
 YOU'RE MY DESTINY?

WHAT IF WE REWRITE THE STARS?
SAY YOU WERE MADE TO BE MINE?
NOTHING COULD KEEP US APART
YOU'D BE THE ONE I WAS MEANT TO
 FIND
IT'S UP TO YOU
AND IT'S UP TO ME
NO ONE CAN SAY WHAT WE GET TO BE
SO WHY DON'T WE REWRITE THE STARS?
MAYBE THE WORLD COULD BE OURS
TONIGHT

ANNE

YOU THINK IT'S EASY?
YOU THINK I DON'T WANT TO RUN TO
 YOU?
BUT THERE ARE MOUNTAINS
AND THERE ARE DOORS THAT WE CAN'T
 WALK THROUGH
I KNOW YOU'RE WONDERIN' WHY
BECAUSE WE'RE ABLE TO BE JUST YOU
 AND ME WITHIN THESE WALLS
BUT WHEN WE GO OUTSIDE
YOU'RE GONNA WAKE UP AND SEE THAT
 IT WAS HOPELESS AFTER ALL

NO ONE CAN REWRITE THE STARS
HOW CAN YOU SAY YOU'LL BE MINE?
EV'RYTHING KEEPS US APART
AND I'M NOT THE ONE YOU WERE
 MEANT TO FIND
IT'S NOT UP TO YOU
IT'S NOT UP TO ME
WHEN EVERYONE TELLS US WHAT WE
 CAN BE
HOW CAN WE REWRITE THE STARS
SAY THAT THE WORLD CAN BE OURS
TONIGHT?

PHILLIP/ANNE

ALL I WANT IS TO FLY WITH YOU
ALL I WANT IS TO FALL WITH YOU
SO JUST GIVE ME ALL OF YOU

ANNE

IT FEELS IMPOSSIBLE

PHILLIP

IT'S NOT IMPOSSIBLE

ANNE

IS IT IMPOSSIBLE?

PHILLIP/ANNE

SAY THAT IT'S POSSIBLE

HOW DO WE REWRITE THE STARS?
SAY YOU WERE MADE TO BE MINE?
NOTHING CAN KEEP US APART
'CAUSE YOU ARE THE ONE I WAS MEANT
 TO FIND
IT'S UP TO YOU
AND IT'S UP TO ME
NO ONE CAN SAY WHAT WE GET TO BE
WHY DON'T WE REWRITE THE STARS
CHANGIN' THE WORLD TO BE OURS?

ANNE

YOU KNOW I WANT YOU
IT'S NOT A SECRET I TRY TO HIDE
BUT I CAN'T HAVE YOU
WE'RE BOUND TO BREAK AND MY
 HANDS ARE TIED

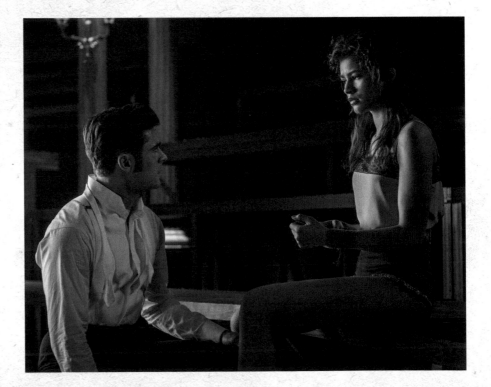

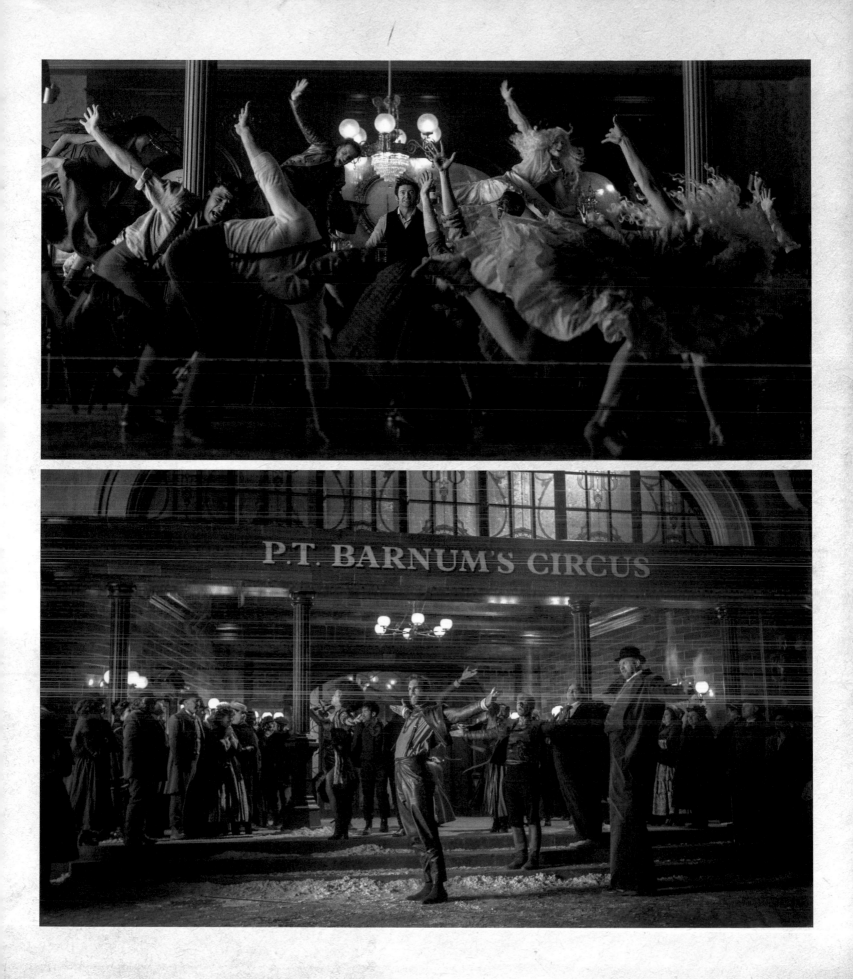

OPPOSITE: *Scene from "Rewrite the Stars"* • TOP: *Scene from "From Now On"* • ABOVE: *Scene from "This Is Me"*

"THIS IS ME"

LETTIE

I AM NOT A STRANGER TO THE DARK

HIDE AWAY, THEY SAY

'CAUSE WE DON'T WANT YOUR BROKEN
 PARTS

I'VE LEARNED TO BE ASHAMED OF ALL
 MY SCARS

RUN AWAY, THEY SAY

NO ONE'LL LOVE YOU AS YOU ARE

BUT I WON'T LET THEM BREAK ME
 DOWN TO DUST

I KNOW THAT THERE'S A PLACE FOR US

FOR WE ARE GLORIOUS

WHEN THE SHARPEST WORDS WANNA
 CUT ME DOWN

I'M GONNA SEND A FLOOD, GONNA
 DROWN 'EM OUT

I AM BRAVE

I AM BRUISED

I AM WHO I'M MEANT TO BE

THIS IS ME

LOOK OUT 'CAUSE HERE I COME

AND I'M MARCHIN' ON TO THE BEAT I
 DRUM

I'M NOT SCARED

TO BE SEEN

I MAKE NO APOLOGIES

THIS IS ME

ODDITIES

OH, OH

OH, OH

OH, OH

OH OH OH

LETTIE

ANOTHER ROUND OF BULLETS HITS MY
 SKIN

WELL, FIRE AWAY, 'CAUSE TODAY

I WON'T LET THE SHAME SINK IN

WE ARE BURSTIN' THROUGH THE
 BARRICADES

AND REACHIN' FOR THE SUN

ODDITIES

WE ARE WARRIORS

LETTIE

YEAH, THAT'S WHAT WE'VE BECOME

ODDITIES

YEAH, THAT'S WHAT WE'VE BECOME

LETTIE/ODDITIES

I WON'T LET THEM BREAK ME DOWN TO
 DUST

I KNOW THAT THERE'S A PLACE FOR
 US

FOR WE ARE GLORIOUS

WHEN THE SHARPEST WORDS WANNA
 CUT ME DOWN

I'M GONNA SEND A FLOOD, GONNA
 DROWN 'EM OUT

I AM BRAVE

I AM BRUISED

I AM WHO I'M MEANT TO BE

THIS IS ME

LOOK OUT 'CAUSE HERE I COME

AND I'M MARCHIN' ON TO THE BEAT I
 DRUM

I'M NOT SCARED

TO BE SEEN

I MAKE NO APOLOGIES

THIS IS ME

OH, OH

OH, OH

OH, OH

OH OH OH

THIS IS ME

LETTIE	**ODDITIES**
AND I KNOW THAT I	OH, OH
DESERVE YOUR LOVE	OH, OH
THERE'S NOTHING I'M NOT	OH, OH
WORTHY OF	OH OH OH

LETTIE

WHEN THE SHARPEST WORDS WANNA
 CUT ME DOWN

I'M GONNA SEND A FLOOD, GONNA
 DROWN 'EM OUT

THIS IS BRAVE

THIS IS BRUISED

THIS IS WHO I'M MEANT TO BE

THIS IS ME

ODDITIES

LOOK OUT 'CAUSE HERE I COME

LETTIE

LOOK OUT 'CAUSE HERE I COME

ODDITIES

AND I'M MARCHIN' ON TO THE BEAT I
 DRUM

LETTIE	**ODDITIES**
MARCHIN' ON	TO THE BEAT I DRUM
MARCHIN' MARCHIN'	
ON	

ODDITIES

I'M NOT SCARED

TO BE SEEN

I MAKE NO APOLOGIES

LETTIE/ODDITIES

THIS IS ME

ODDITIES	**LETTIE**
WHENEVER THE	
WORDS (OH)	
WANNA CUT ME DOWN	OH
I'LL SEND THE	
FLOOD (OH)	
TO DROWN 'EM OUT	OH
OH	I'M GONNA
	SEND A FLOOD
OH	GONNA DROWN
	THEM OUT
OH, OH	
OH OH OH	OH

LETTIE/ODDITIES

THIS IS ME

"FROM NOW ON"

BARNUM

I SAW THE SUN BEGIN TO DIM
AND FELT THAT WINTER WIND BLOW
 COLD
A MAN LEARNS WHO IS THERE FOR HIM
WHEN THE GLITTER FADES AND THE
 WALLS WON'T HOLD
'CAUSE FROM THAT RUBBLE WHAT
 REMAINS
CAN ONLY BE WHAT'S TRUE
IF ALL WAS LOST, THERE'S MORE I
 GAINED
'CAUSE IT LED ME BACK TO YOU

FROM NOW ON
THESE EYES WILL NOT BE BLINDED BY
 THE LIGHTS
FROM NOW ON
WHAT'S WAITED 'TIL TOMORROW STARTS
 TONIGHT
TONIGHT
LET THIS PROMISE IN ME START
LIKE AN ANTHEM IN MY HEART
FROM NOW ON
FROM NOW ON

I DRANK CHAMPAGNE WITH KINGS AND
 QUEENS
THE POLITICIANS PRAISED MY NAME
BUT THOSE WERE SOMEONE ELSE'S
 DREAMS
THE PITFALLS OF THE MAN I BECAME
FOR YEARS AND YEARS, I CHASED THEIR
 CHEERS
A CRAZY SPEED OF ALWAYS NEEDING
 MORE
BUT WHEN I STOP AND SEE YOU HERE
I REMEMBER WHO ALL THIS WAS FOR

AND FROM NOW ON
THESE EYES WILL NOT BE BLINDED BY
 THE LIGHTS
FROM NOW ON
WHAT'S WAITED 'TIL TOMORROW STARTS
 TONIGHT
IT STARTS TONIGHT
AND LET THIS PROMISE IN ME START

LIKE AN ANTHEM IN MY HEART
FROM NOW ON
FROM NOW ON
FROM NOW ON

ODDITIES

AND WE WILL COME BACK HOME
AND WE WILL COME BACK HOME
HOME AGAIN

BARNUM/ODDITIES

AND WE WILL COME BACK HOME
AND WE WILL COME BACK HOME
HOME AGAIN

AND WE WILL COME BACK HOME
AND WE WILL COME BACK HOME
HOME AGAIN

BARNUM

FROM NOW ON

BARNUM/ODDITIES

AND WE WILL COME BACK HOME
AND WE WILL COME BACK HOME
HOME AGAIN

AND WE WILL COME BACK HOME
 (FROM NOW ON)
AND WE WILL COME BACK HOME
 (FROM NOW ON)
HOME AGAIN

AND WE WILL COME BACK HOME
 (FROM NOW ON)
AND WE WILL COME BACK HOME
 (FROM NOW ON)
HOME AGAIN

ODDITIES

AND WE WILL COME BACK HOME (FROM
 NOW ON)
AND WE WILL COME BACK HOME (FROM
 NOW ON)
HOME AGAIN
FROM NOW ON

BARNUM

THESE EYES WILL NOT BE BLINDED BY
 THE LIGHTS

ODDITIES

FROM NOW ON

BARNUM

WHAT'S WAITED 'TIL TOMORROW STARTS
 TONIGHT
IT STARTS TONIGHT
LET THIS PROMISE IN ME START
LIKE AN ANTHEM IN MY HEART

BARNUM/ODDITIES

FROM NOW ON

BARNUM

FROM NOW ON
FROM NOW ON

ODDITIES

AND WE WILL COME BACK HOME
AND WE WILL COME BACK HOME
HOME AGAIN

AND WE WILL COME BACK HOME
AND WE WILL COME BACK HOME
HOME AGAIN

AND WE WILL COME BACK HOME
AND WE WILL COME BACK HOME
HOME AGAIN

FROM NOW ON
FROM NOW ON
HOME AGAIN
OH

FROM NOW ON
FROM NOW ON
HOME AGAIN

CHOREOGRAPHY

"There's nothing in the world that can bother you when you're trying to master a dance. You're just free. You're set free."
—Zac Efron

CHOREOGRAPHER ASHLEY WALLEN HAS WORKED WITH GRACEY FOR OVER TWENTY YEARS ON A VARIETY OF TELEVISION AND LIVE-MUSIC projects. "Any project that involved dance," Wallen says, "he'd speak to me about it." Five years prior to filming, Wallen began choreographing moves for *The Greatest Showman* in his studio with about ten other dancers. As he—and other members of the cast and crew—waited for the official go-ahead on the movie, Wallen continued to layer his choreography. By the time auditions had begun, Wallen had a fairly good idea of how the dance sequences would work . . . or at least what he, as the choreographer, expected from his dancers.

The characters and, in fact, the ensemble dancers themselves, each express themselves differently. Wallen explains, saying, "They've all got their own kind of body language," and that language is tailor-made both for the specific scene and for the uniqueness of character. Wallen acknowledges that each dance number has its own corresponding model of inspiration: Charity and Barnum's dance in "A Million Dreams" takes its cues from the classic pairing of Fred Astaire and Ginger Rogers; "This Is Me" is a contemporary number, with the hip-hop-inspired moves to prove it; "Come Alive" is inspired by the old-school spectacles of MGM's musicals; "From Now On" is its own beast, a mash-up of several references and yet wholly new.

Besides learning complicated dance moves, the cast also needed to work within the physical parameters of the sets themselves, a task that seems straightforward but, factoring in slippery sawdust below and swinging trapeze artists above, is anything but. The sawdust,

in particular, was tricky to dance on. Wallen and Set Designer Nathan Crowley added another type of dust to make it less slippery only to discover that the new dust was too sticky. The secret magical ingredient turned out to be sand, which evened out the texture and gave the dancers something more solid to spin, twist, and flip on.

For the flooring in Barnum's American Museum, Crowley went a step further and created a "sprung floor," which he then layered with wood decking, sawdust, sand, and, finally, dust. Simple concrete would have been far too unforgiving for the dancers to work on eight, sometimes ten, hours a day. Even the tiled floor is painted on—to give the illusion of being a hard surface when, really, it's malleable enough for a dancer's soft shoe.

For Michelle Williams's big number, "Tightrope," however, less was more—no fancy flooring, no work-arounds needed. To lock down the emotionally charged, ethereal, and effortless-looking performance, Williams and Wallen rehearsed for eight weeks. The prep work shows and not just in Williams's performance but in the totality of the whole ensemble. Every actor signed up for ten weeks of dance rehearsal, an unusually long amount of time for pre-production. Efron admits it was difficult to make the choreography look easy, saying, "This was some of the most technical choreography I've ever attempted in my life." The choreographers were aiming for the art of dancing without making it look like dancing. For inspiration, Efron studied some of the classics, including everything from *The Band Wagon* with Fred Astaire and Gene Kelley vehicles like *Singin' in the Rain* to Baz Luhrmann's *Moulin Rouge* and Michael Jackson's concert moves. Efron also closely watched Wallen, saying, "Ashley looks sick when he dances. And by sick I mean ill. And by ill, I mean dope. And by dope, I mean awesome. He's really good."

Everyone had to get to a point where they were no longer concentrating on what they were doing and could just play that character and the dancing became effortless. "And that," says Gracey, "is when it's truly impressive."

PREVIOUS PAGE: *Scene from "From Now On"* • OPPOSITE: *Set photography*
• OVERLEAF: *Concept art by Craig Sellars*

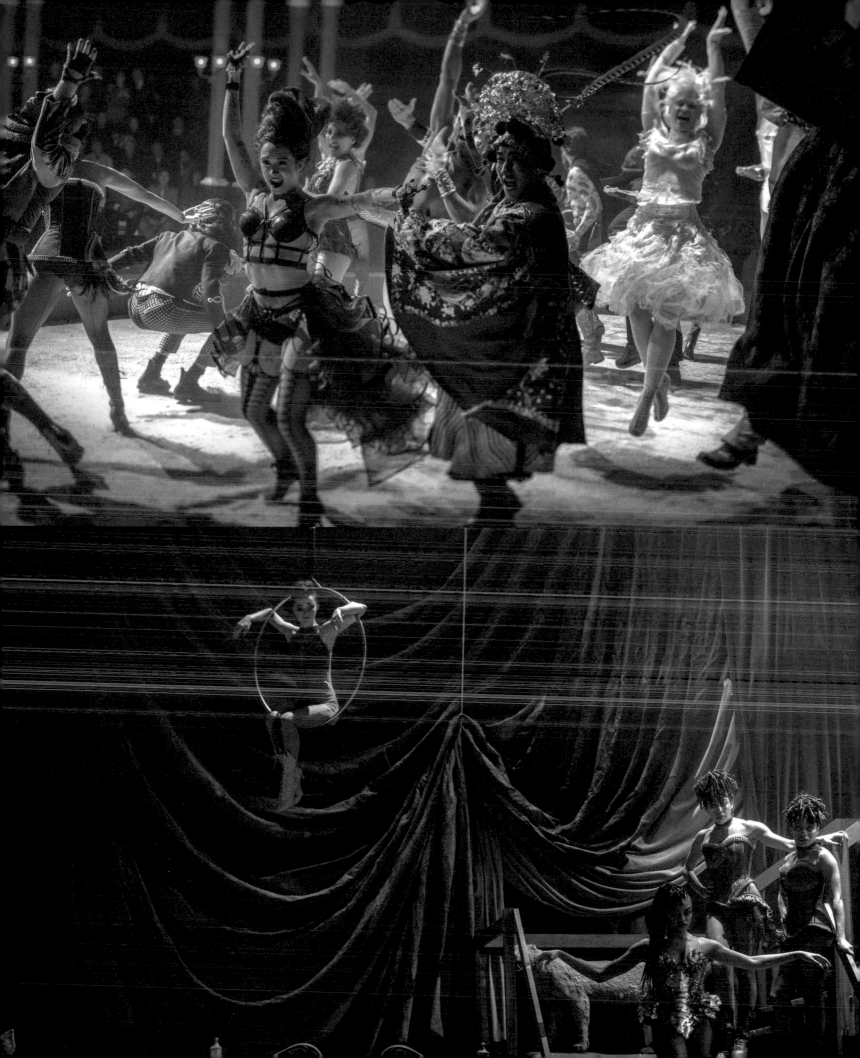

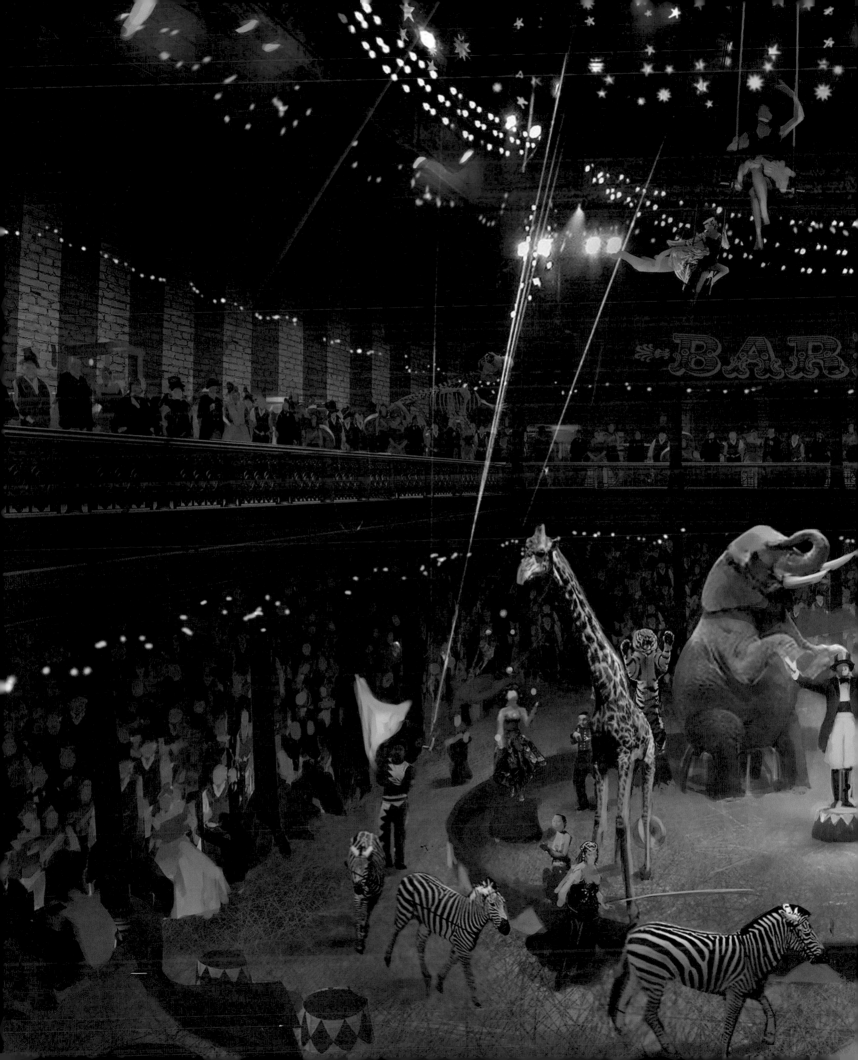

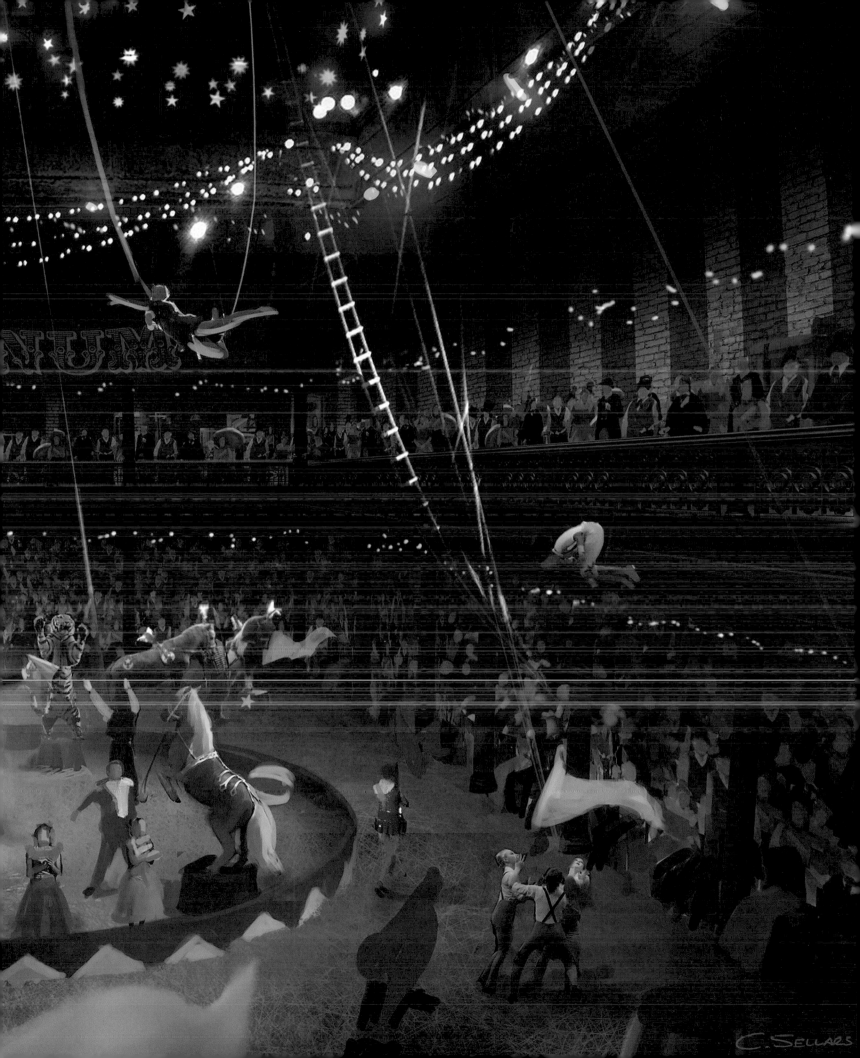

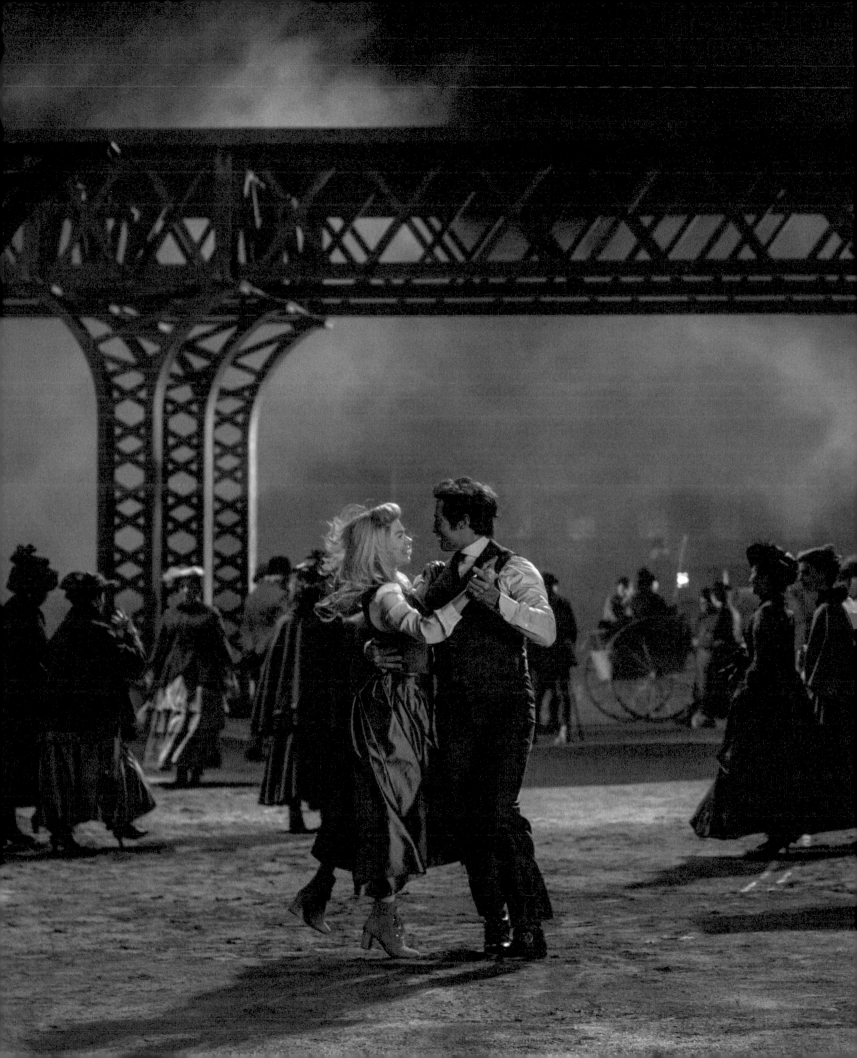

EIGHT WEEKS

"I did some dance moves and techniques that I've never done before."
—Hugh Jackman

NO STRANGER TO PHYSICAL CHALLENGES, JACKMAN SAYS, "I LIKE TO DANCE and I like to work hard." Speaking about Choreographer Ashley Wallen, however, Jackman admitted that rehearsals were especially daunting, saying, "I don't know if you've ever met any choreographers—they're very kind, but when you get in the room, there's something kind of sadistic about them, and they really love to punish you." He laughs. "I wished my legs were twenty years younger." Jackman underwent an intense ten-week run of full-on dance rehearsal right before filming that proved as strenuous and technically challenging as any physical training he's done for other super-powered films. During some sequences, Jackman confided to Wallen: "I'm not sure I can get there." And Wallen would say, "You will get there."

Wallen confesses that he has a magic number: eight. It was rumored that Gene Kelly would spend eight weeks working on a number, and Wallen would remind his dancers of this fact whenever they'd tire. If this cheerful reminder elicited groans from overworked dancers, they weren't the only ones: "Apparently Frank Sinatra really hated that," Jackman says, "'cause he's, like, 'I can shoot a whole movie in eight weeks, and we're just doing one number.'" (Sinatra and Kelly worked together on several musicals, including *On the Town*.) Jackman continues, "So Ash [Wallen] says to me, 'If it's eight weeks for Gene Kelly, it's ten weeks for you, Hugh Jackman.'"

Jackman pushed himself to adopt Wallen's style of movement. The dancing itself is modern—it's not slow or formal; it speaks to today's audiences. "You know," Jackman says, "this is Barnum. He wouldn't want some staid, old, period piece. He'd want the music and the dancing to be fantastic and cutting-edge and new, something you'd never seen before. I don't care how many Katy Perry concerts or Broadway shows you've gone to, you haven't seen anything like this." And if it took Jackman ten weeks to get the show-stopping performances down, it's likely no one else will come close to replicating it.

OPPOSITE: *Scene from "A Million Dreams"*

FROM PAGE TO SCREEN
SCREENWRITERS'
NOTEBOOK

SCREENWRITER JENNY BICKS WAS TASKED WITH THE JOB OF CREATING BOTH THE FILM'S NARRATIVE ARC AND ENSURING THAT EVERY SCENE OF DIALOGUE seamlessly transitioned into its musically dramatic acts. To address this challenge, Bicks, along with a host of other screenwriters including Jordan Roberts, Bill Condon, Jonathan Tropper, Michael Arndt, and Josh Singer, worked closely with the director and songwriting duo Benj Pasek and Justin Paul. Together, the teams smoothed out scenes and created space for the musical numbers to unfold within the context of the storyline itself. Unlike other musicals where the song-and-dance numbers seemingly appear out of nowhere, *The Greatest Showman* grounds the break-out emotional moments in song and dance so that the narrative supports both the music and the choreography and vice versa. In fact, much of the film's lyrics serve to advance the plot—decisions are made in song, convictions renewed, love expressed.

Creating the storyline for a movie musical is an unusual process in that both the music and the screenwriting, ideally, happen together. During the initial script-writing stage, Bicks fleshed out the first draft and then Condon, having honed his expertise on the award-winning *Dreamgirls*, added the musical moments, and helped navigate the storyline so that each musical act built upon the next. Condon's lyrics for the songs were makeshift until Pasek and Paul officially came on board. Gracey initially envisioned the film's

songs as being composed by different songwriters—a veritable soundtrack of original hits, written by different chart-topping musicians and thematically schemed to the subject of P.T. Barnum and his life. After spending a year commissioning different songwriters, however, the team realized that Pasek and Paul were best poised to write the entirety of the film's music: Their songs were consistently well-written and catchy, combining the grandeur of the Broadway sound with the urgency of a pop song. It became clear that their musical voice would help guide and unify the film. Bicks and Condon, working closely with their songwriting counterparts, integrated the musical numbers throughout the story so that the songs—even the lyrics themselves—are an extension of the characters' emotional lives and share the spotlight with the film's actual dialogue.

Beyond this, however, Bicks and Condon faced another challenge: how to reconcile the real-life, historical persona of P.T. Barnum, a man of epic proportion and passion, with their fictional portrayal. Theirs is a light touch on history, with Jackman's Barnum a shade of the real man, his most pronounced characteristics adapted for the modern, cinematic audience. The real-life Barnum was a man who believed in the power of the story to enchant and entertain and, perhaps most importantly, to alleviate the doldrums of the everyday. The screenwriters took a page from Barnum's book and brilliantly followed in his tradition, delivering a tale of wonder as bright as any child's imagination, loosely basing facts on the fantastic, and giving imagination, song, and dance free reign.

OPPOSITE: *Barnum in the opening of the "Greatest Show"* • OVERLEAF: *Concept art by Joel Chang*

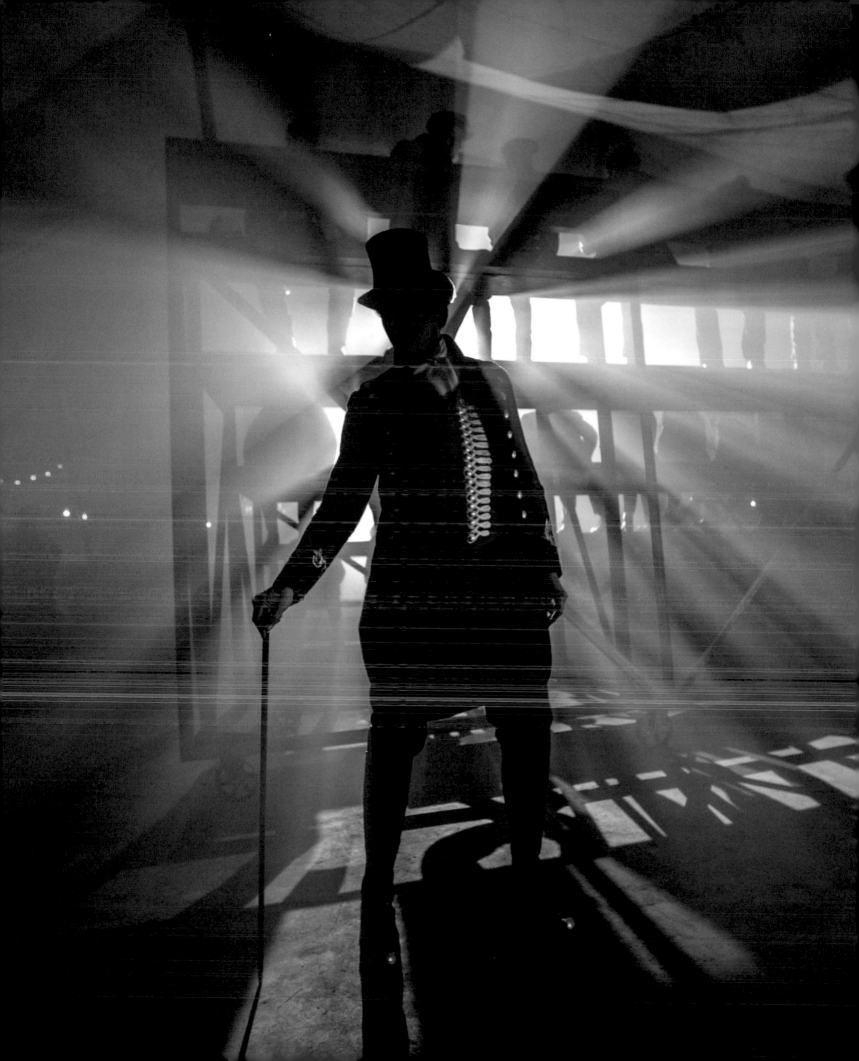

CHAPTER 3

THIS
IS ME

YOU WANT PEOPLE TO LAUGH AT ME?

—CHARLES STRATTON

THEY'RE ALREADY LAUGHING, KID. YOU MIGHT AS WELL GET PAID.

—P.T. BARNUM

THE GREATEST SHOWMAN

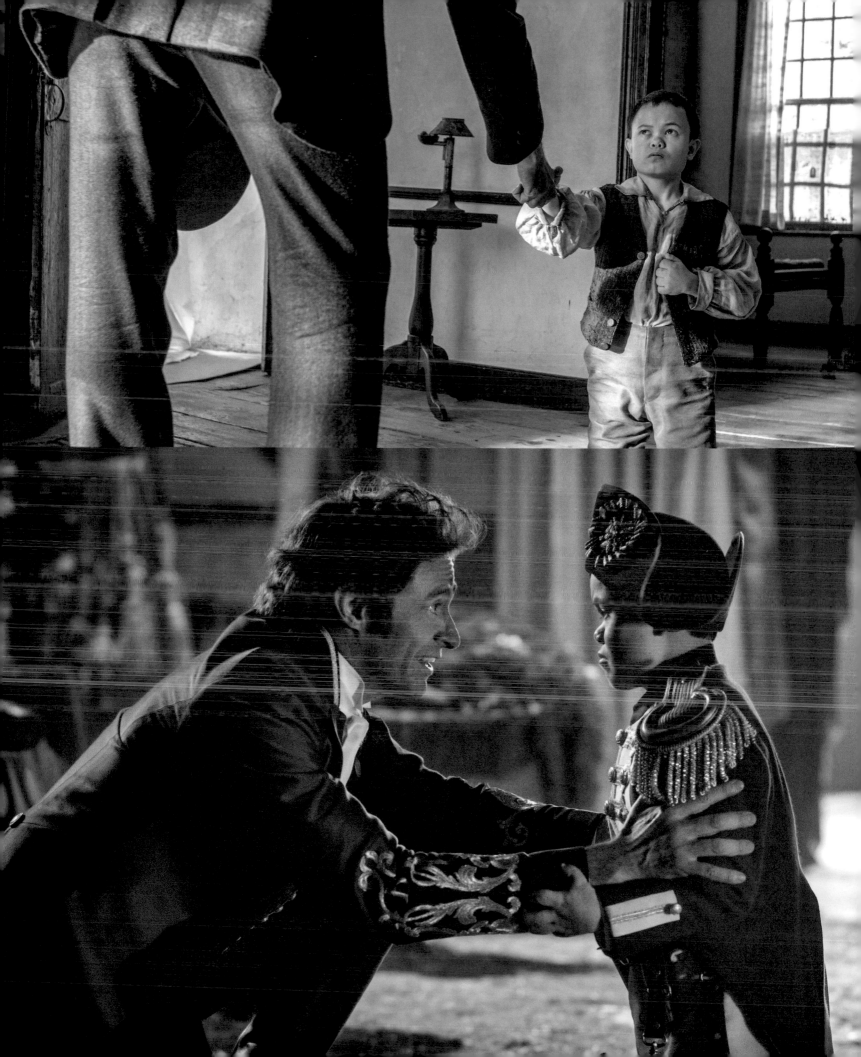

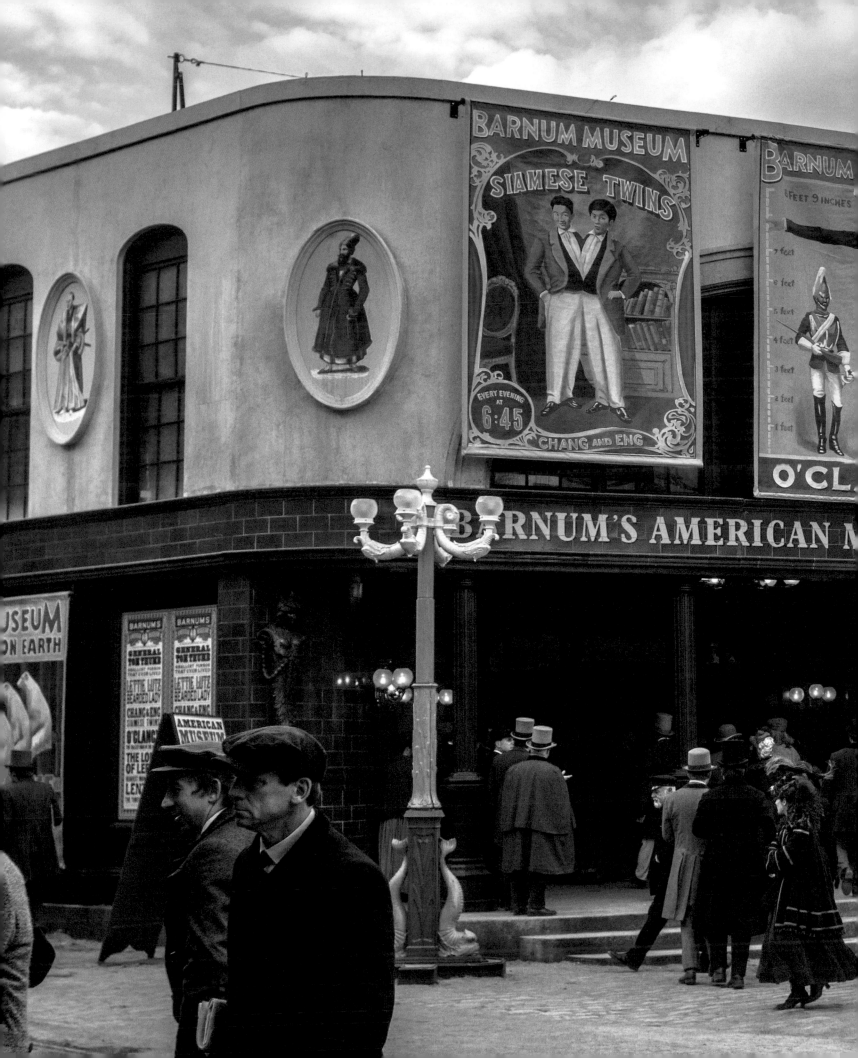

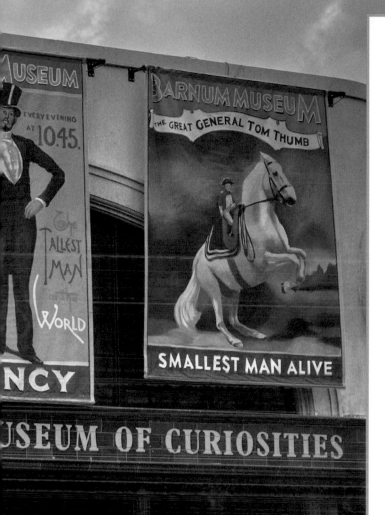

IN *THE GREATEST SHOWMAN*, BARNUM UNDERSTANDS, DEEPLY, WHAT IT MEANS TO BUILD SOMETHING FROM NOTHING—— HE, HIMSELF, IS HIS OWN SUCCESS STORY. HE SEES IN THE Oddities what none before him have: talent, spirit, integrity, and, ever the New Yorker, a business opportunity. Rather than casting the Oddities aside or relegating them to a lesser venue, Barnum instead pulls them out of the shadows and into the spotlight of his museum. Partnering with theater producer Phillip Carlyle, who craves creative adventure as well as the love of the beautifully daring Anne Wheeler, a trapeze artist in Barnum's shows, Barnum fast-tracks his success and that of everyone who surrounds him.

In creating a stage for the Oddities, Barnum, whether intentional or not, flouts conventionality and offers another way of seeing and being in the world. Far from being just his employees, the Oddities become Barnum's second family. The lives of Lettie Lutz, General Tom Thumb, the Irish Giant, and more are inextricably connected to his: The museum itself is their very home. When Lettie Lutz leads the heart-felt song "This Is Me," audiences recognize it as an anthem for anyone who has ever searched for a sense of home and acceptance. Barnum not only provided both, he also supplied a paycheck and something even better—love.

PAGE 99, TOP: *Barnum meets Tom Thumb* • PAGE 99, BOTTOM: *Barnum gives Tom Thumb a pep talk before going on stage* • THIS SPREAD: *Scene featuring the American Museum of Curiosities*

INTRODUCING
THE ODDITIES

"When [Barnum] puts the Oddities into the spotlight, not only does he turn them into stars but he makes them feel love for the first time in their lives." —DIRECTOR MICHAEL GRACEY

WHILE SOME OF THE ODDITIES IN *THE GREATEST SHOWMAN* WERE CREATED SPECIALLY FOR THE film, many were based on real-life people with true-to-life physical conditions. To create the fantastical look of each character—some of whom are seen only briefly on screen—Hair and Makeup Heads Nicki Ledermann and Jerry Popolis turned to the worlds of art and fashion for visual inspiration. More than anything else, Popolis says, "It was really important not to cover them up too much, to not lose their sense of humanity, and to show their real inner beauty." To that end, some of the hair and makeup for the Oddities is quite abstract and otherworldly. For Ledermann and Popolis, the goal is to communicate a sense of beauty and wonder in the Oddities' most defining characteristics . . .

all the better for audiences to truly see them. The opportunity to combine visual influences from an array of sources excited both artists. As Ledermann says, "The film is a bit of fashion, a bit dreamy, a bit of fantasy," and nowhere is that seen more clearly than with the Oddities.

The Oddities are a family unit and, in many respects, they're the heart and soul of the film. It was important that their "home"—the American Museum—be a physical reflection of their emotional presence. To that end, the museum is a vibrant place. It's as much a character in the film as one of the performers. As the living, breathing heart of the Barnum machine, it's full of color and contains a dizzying collection of objects and curiosities that seem to belong to the realm of the magical. The museum, like the Oddities themselves, is the physical embodiment of the idea that anything is possible.

OPPOSITE: *Concept art of the Oddities by Brian Estanislao* (TOP) *and Jamie Jones* (MIDDLE) • OPPOSITE BOTTOM: *Set photography of the Oddities*

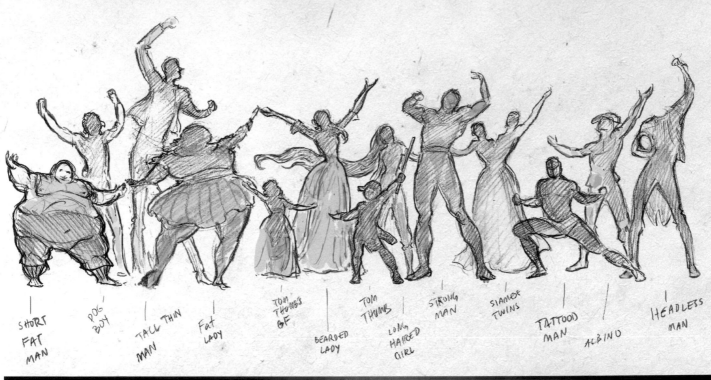

SHORT FAT MAN

DOG BOY

TALL THIN MAN

FAT LADY

TOM THUMB'S GF

BEARDED LADY

TOM THUMB

LONG HAIRED GIRL

STRONG MAN

SIAMESE TWINS

TATTOOD MAN

ALBINO

HEADLESS MAN

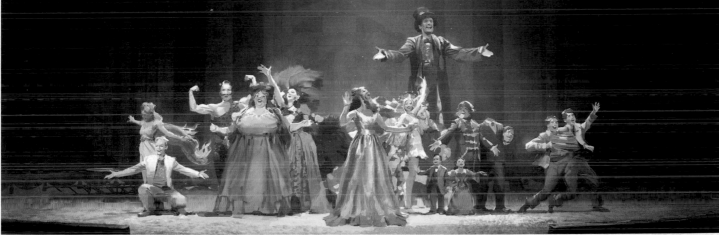

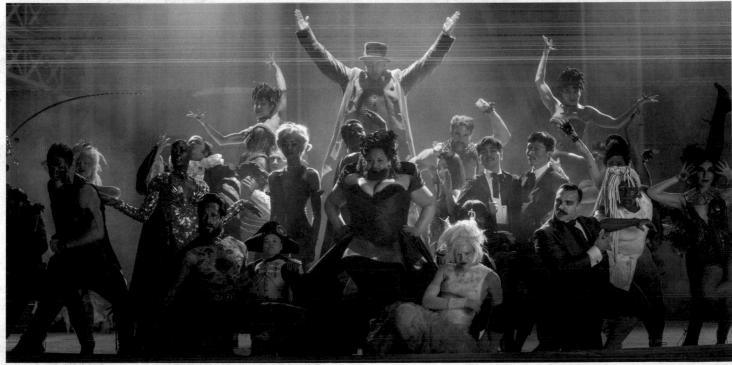

To create the space in which the Oddities perform and live, Production Designer Nathan Crowley found himself thinking about the back lots of Universal and Warner Bros. studios. While the front of the museum is orderly, with its Great Exhibition–like columns, the inside is total chaos—the space is a circus in every manner of the word. Behind the facades of the back lots of the real-life Universal and Warner Bros. studios are lots of "wiggly piggly stairs" as Crowley describes them. He says, "I've always liked them because it feel like a natural backstage." Crowley wanted a similar feeling for the inside of the Oddities' space. "It was about creating a confusing space with depth," he says. And to accomplish that topsy-turvy sense of depth, he and his team layered the visuals, packing the space—including the staircases—to the gills, leading all the way up to the curtain. Such cramped and crammed space communicates the visual sensation that life, at least in Barnum's world, is overflowing with energy,

creativity, and the possibility of riches. (It's also fun-filled, messy, and wonderfully disorganized—the distinct opposite of the serious and staid theaters favored by the prim and prudent.)

No matter their appearance of hardship, in the film, Barnum created a home for those individuals deemed strange, unfit for society, or worse. We should all be so lucky. As Gracey says, "The more I read, the more I was convinced that even if, when Barnum started, his motives weren't more than wanting to make money, what he did, whether on purpose or accidentally, was bring people together who the world would otherwise ignore." *The Greatest Showman* helps audiences remember that no one made a difference by being like everyone else.

BELOW: *Concept art by Craig Sellars* • BOTTOM: *Concept art by Jamie Jones of a scene that was cut from the film* • OPPOSITE TOP: *The Oddities* • OPPOSITE BOTTOM: *Circus poster props*

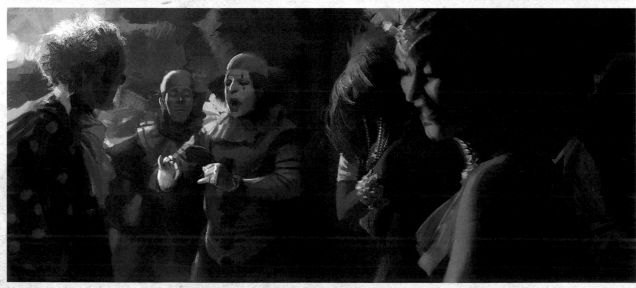

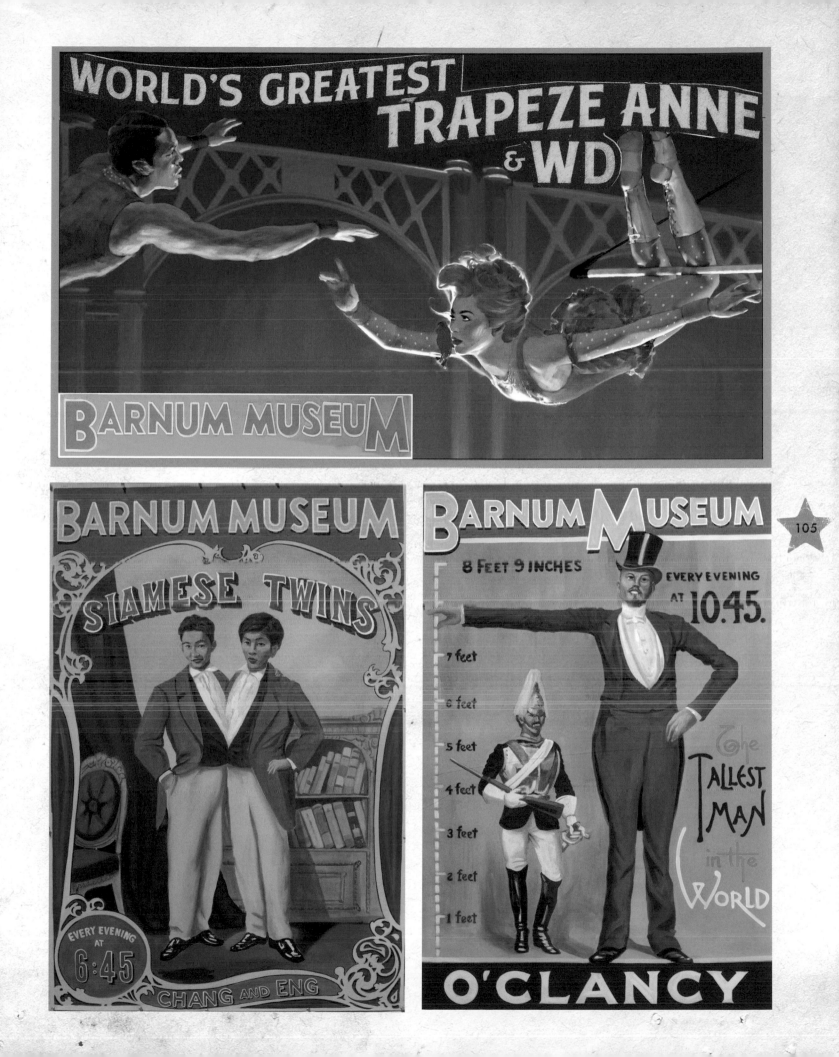

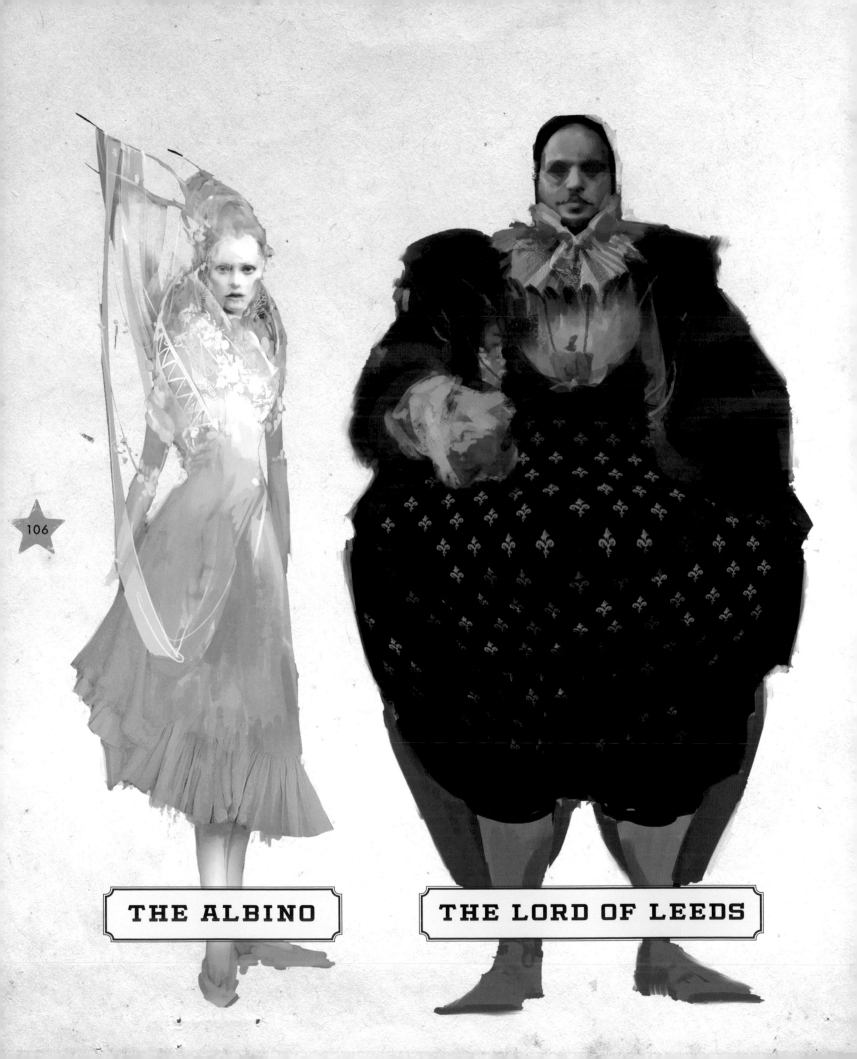

THE ALBINO

THE LORD OF LEEDS

107

BLOCK HEAD

O'CLANCY

CONSTANTINE

ELEPHANT BOY

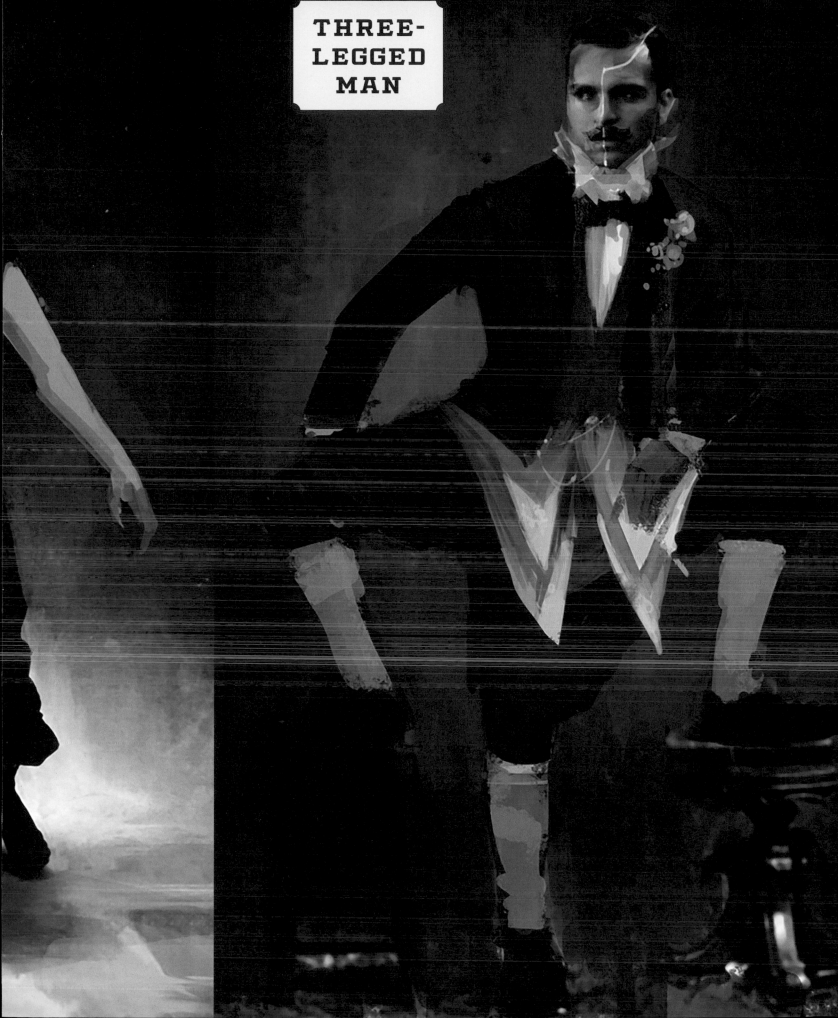

THREE-
LEGGED
MAN

CHANG & ENG

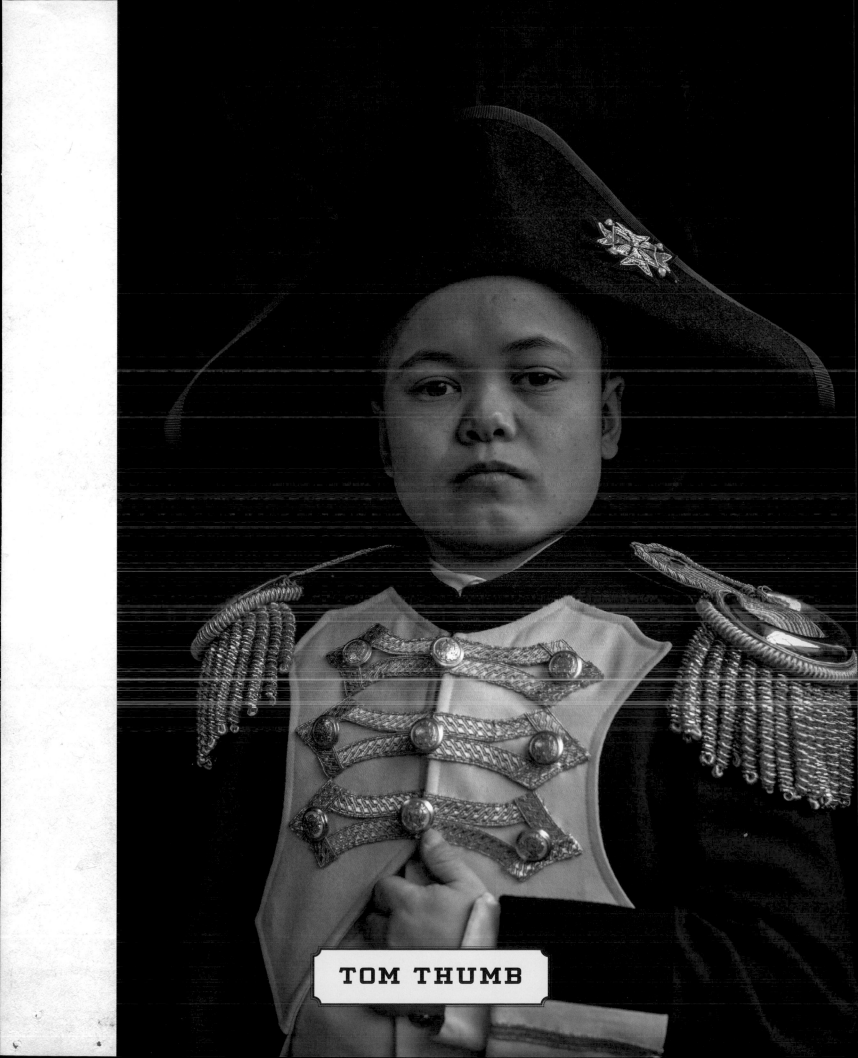

TOM THUMB

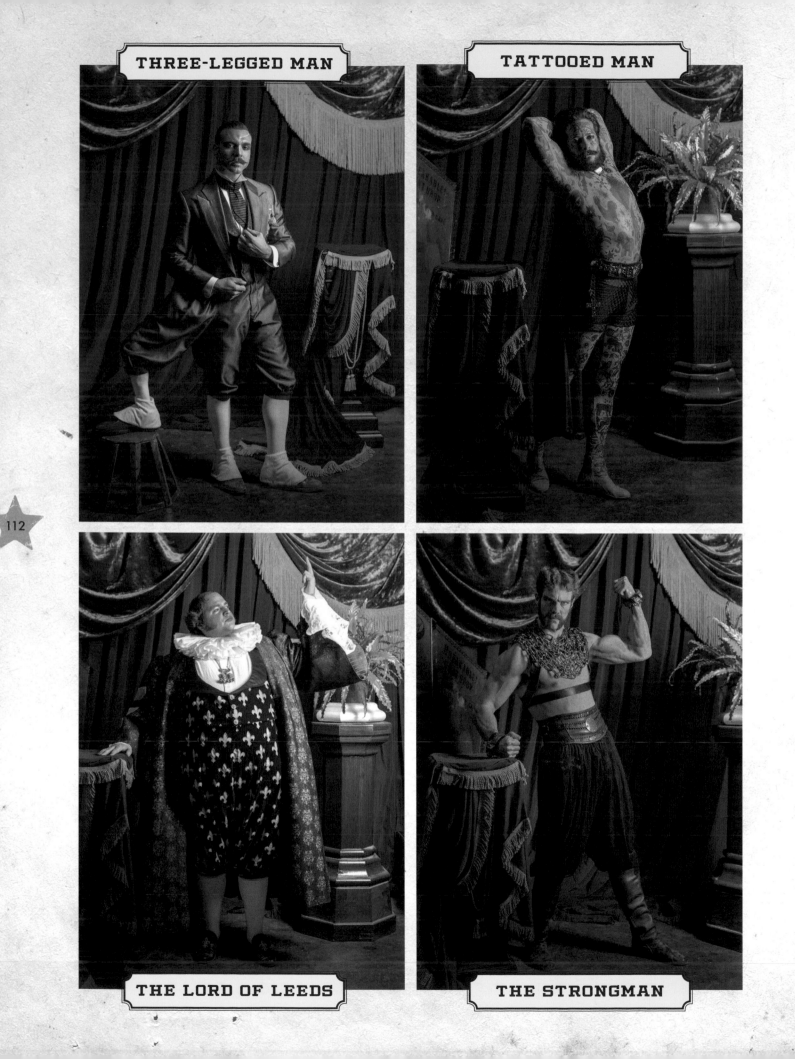

THREE-LEGGED MAN

TATTOOED MAN

THE LORD OF LEEDS

THE STRONGMAN

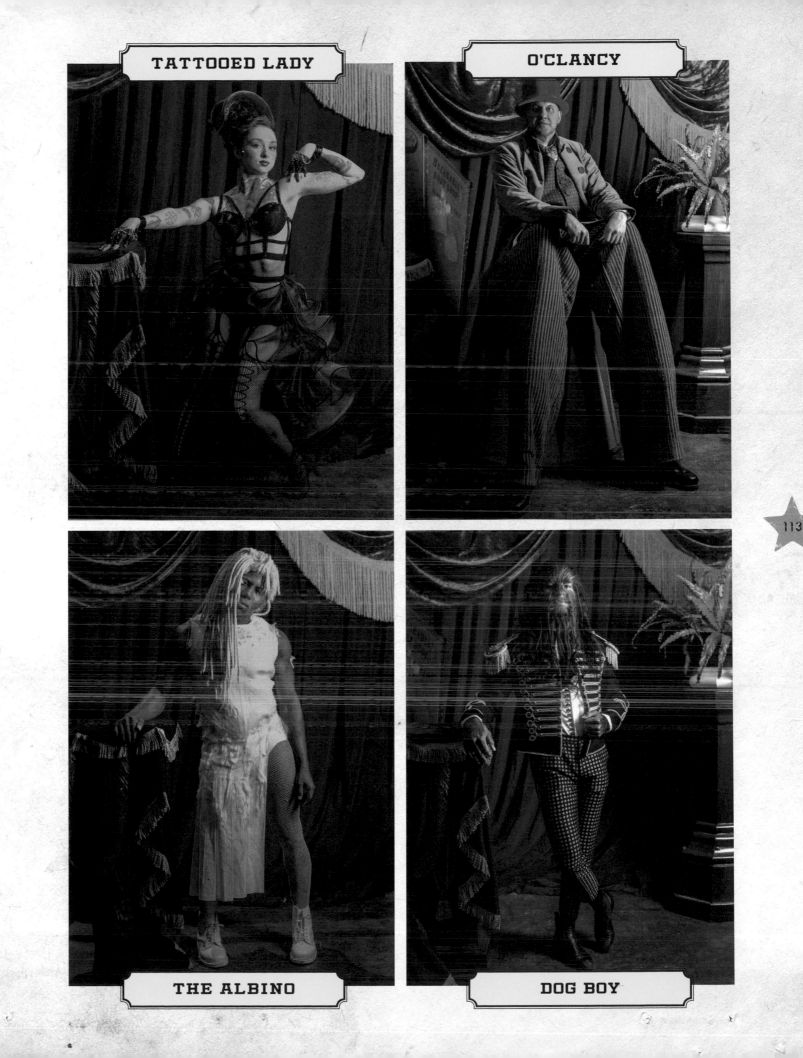

TATTOOED LADY

O'CLANCY

THE ALBINO

DOG BOY

113

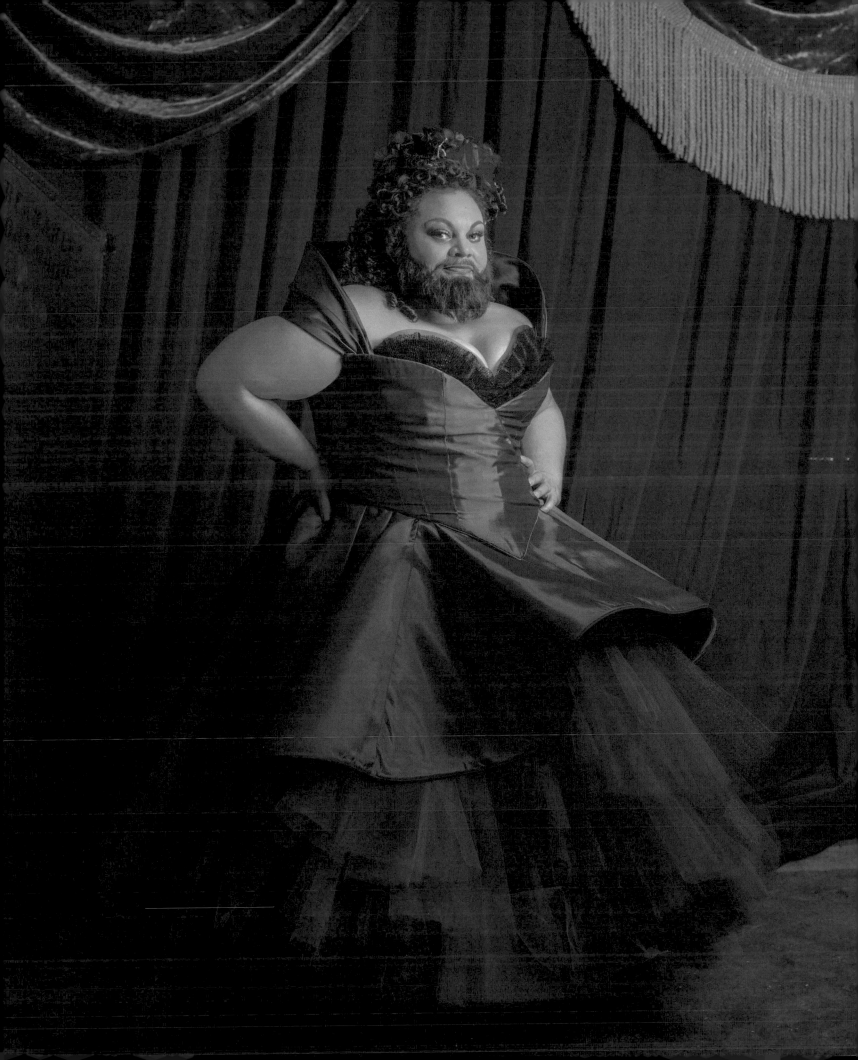

THE BEARDED LADY
LETTIE LUTZ

"To be a Broadway actor coming into a film of this magnitude is heaven because it's like doing opening night every take." —KEALA SETTLE

FOR SEVERAL YEARS BEFORE FILMING COMMENCED, BROADWAY ACTRESS KEALA SETTLE, ALONG WITH A GROUP OF OTHER SINGERS, workshopped the film's music, by running each number with a choir, Pasek and Paul, and Gracey in a table-read setting. These workshops are akin to test runs of the musical numbers so the creative teams can hash out issues *before* the official cast runs through everything. Workshops are also used to woo studio execs and to provide a look at what the film will eventually become. Settle, in essence, workshopped songs she thought were going to be played by someone other than her. As Settle says, "As an actor, you do all these workshops and read-throughs. You don't even think you're going to see the script or the music again. You just do the reading, collect the money, you know, for the time that was spent, and go." For *The Greatest Showman*, however, she did a couple rounds, and when she sang "This Is Me" during the third workshop, she stepped into the role of a lifetime: Lettie Lutz.

Created late in production as a song for the Oddities, Settle first heard "This Is Me" in a demo version and, as she explains, "had a small stroke" upon hearing it. A self-proclaimed introvert, Settle wasn't anxious for the attention. She also doubted her ability to carry the song. (A huge melody, it's not for the feint of heart to attempt.) She told Gracey she couldn't do it and soon found herself making a bet with him: "If you get me a bottle of Jameson," she said, "I'll do it." He did. Settle admits, "I was scared out of my mind to sing it as that character."

Her knock-out anthem of the song cemented her place both as leader of the Oddities and as one of the film's break-out talents. Gracey couldn't believe his luck; he had been casting around trying to find an actress to play Lutz and, here, Settle had been under his nose the whole time. Settle found Lutz to be a privilege to play, and admitted that, as an actor, some roles are life-changing. Lutz was one such character. "There's a strength that this character has that I don't," Settle says. Getting in touch with her

character's sense of strength coupled with the never-ending swell of support offered to her by the cast and crew—both on and off stage—allowed Settle, she says, to also find a sense of personal empowerment. Even the simple act of putting on Lutz's beard was transformative and gave Settle a jolt of inner strength, but not in the beginning. She explains, saying, "It's funny because when I first put [the beard] on, I wanted to hide behind it, that very first day . . . And Hugh came to find me and he goes, 'No, no, no, no, no. You don't get to hide. Not after all this time.' And he gave me a big hug and we started crying. . . . And then, by the time we started shooting, the beard became the thing that gave Lettie her grit and strength." Settle soon found herself strutting around the set as Lutz, her dazzling eye makeup projecting a sense of fierceness, and her beard, bold and eye-catching, projecting a sense of pride.

Now, Settle says, "People don't know who I am *without* the beard."

PAGE 114: *Keala Settle as Lettie Lutz* • BELOW: *Production image* • RIGHT: *Circus poster prop*

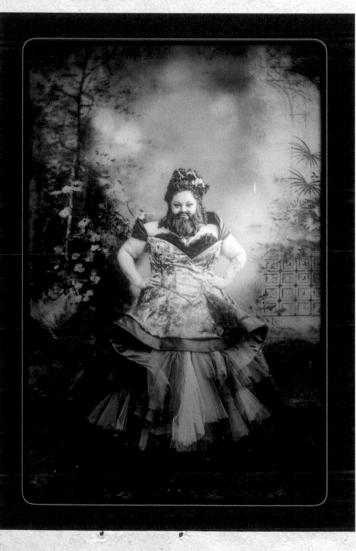

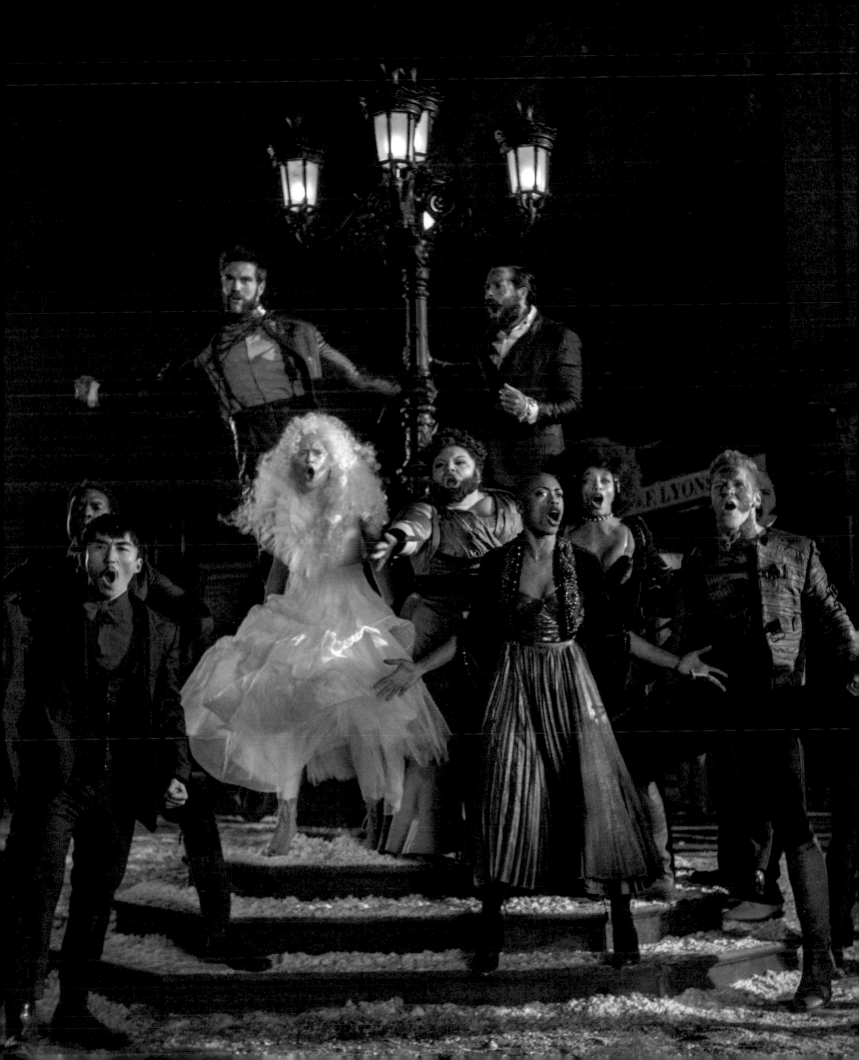

THE BEARD

"It's a beautiful thing to be unique." —NICKI LEDERMANN

THE TRANSFORMATION OF GETTING SETTLE TO *BECOME* LUTZ—BEARD AND ALL— took roughly two-and-a-half hours of work by the Hair and Makeup Departments. First, Settle's own hair is pin-curled, in preparation for the wig application. The beard is adhered to Settle's face in four different layers. Once the first layer is applied, it's blow-dried to help ward off perspiration and then each subsequent layer is added until it builds to the effect of being a full beard. It's then worked into the hairline of Settle's wig. Ledermann says the trick with getting the beard to look just right was making sure Settle still looked feminine. She says, "Just to plop a beard on somebody can be a hit-or-miss thing. So, it was actually quite a long process. And we went through several stages. We had a long beard and then it got shorter and shorter and shorter, and we eventually came to a good compromise." Getting the beard to stay in place was a challenge, too. Ledermann says, "Settle's physically and emotionally all over the place in the film and she has to sing, then she has to dance, and her beard is popping off everywhere, all the time. I think I tried every single glue except for Krazy Glue to make that beard stay on her face." It was worth it, however. Popolis says, "When Keala put the beard on, I mean, she changed. She became this amazing, beautiful creature."

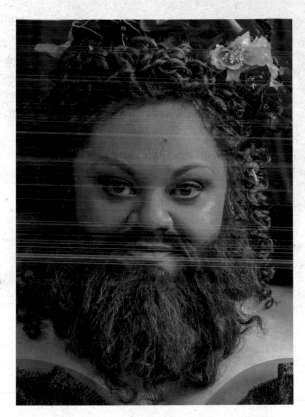

OPPOSITE: *Scene from "This Is Me"* ABOVE: *Close-up of Lettie's beard*

119

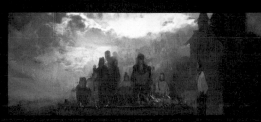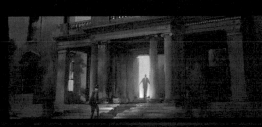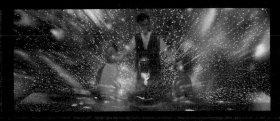
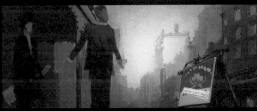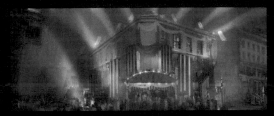
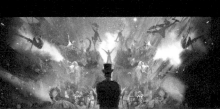
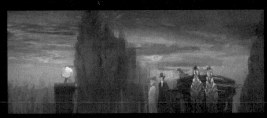
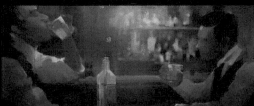
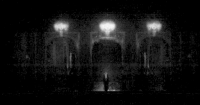

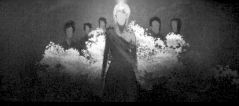 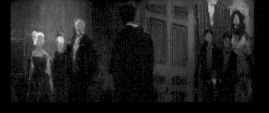

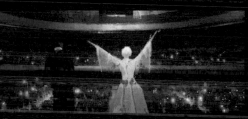

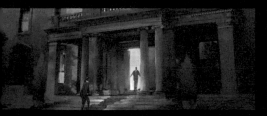

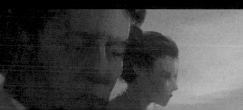

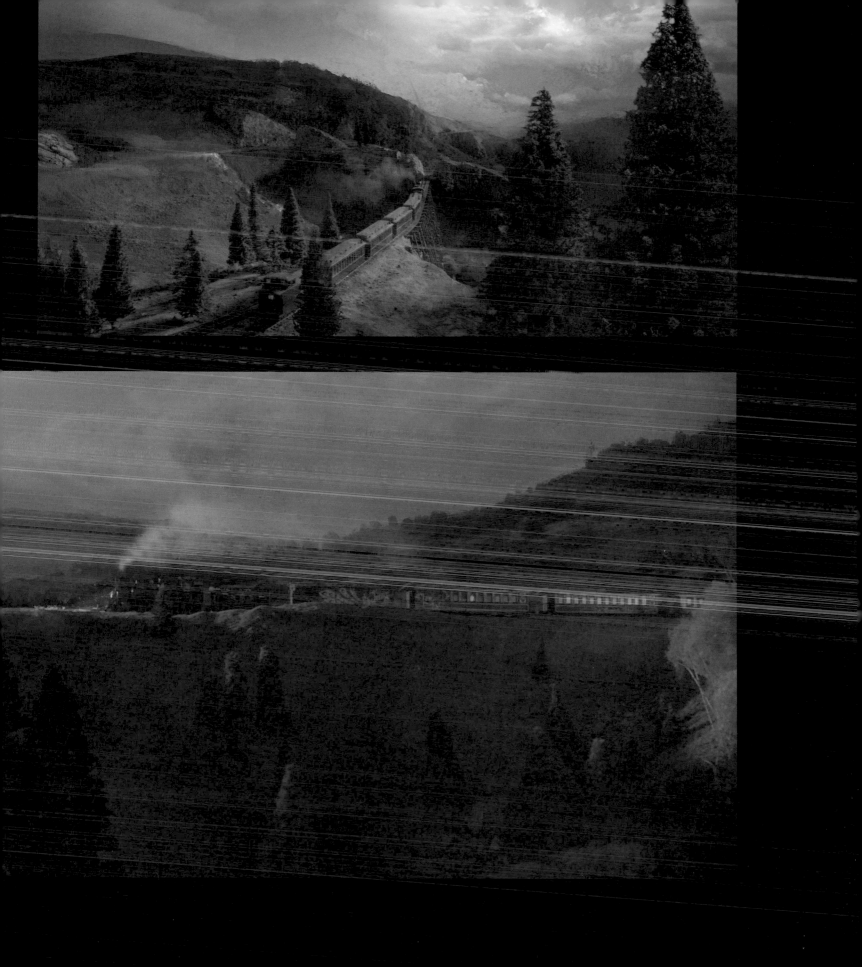

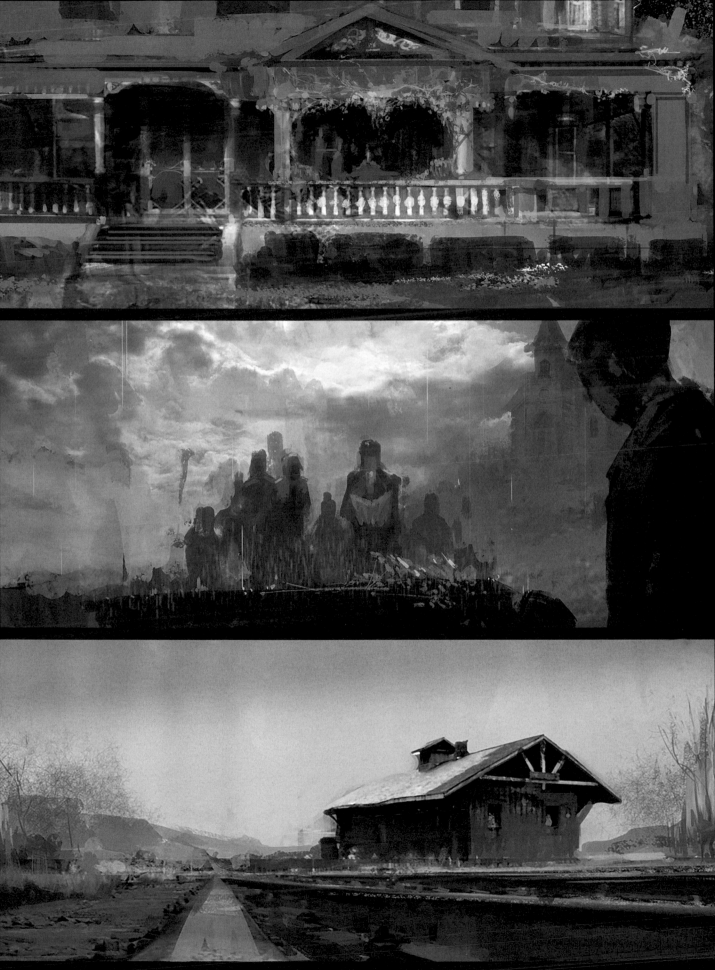

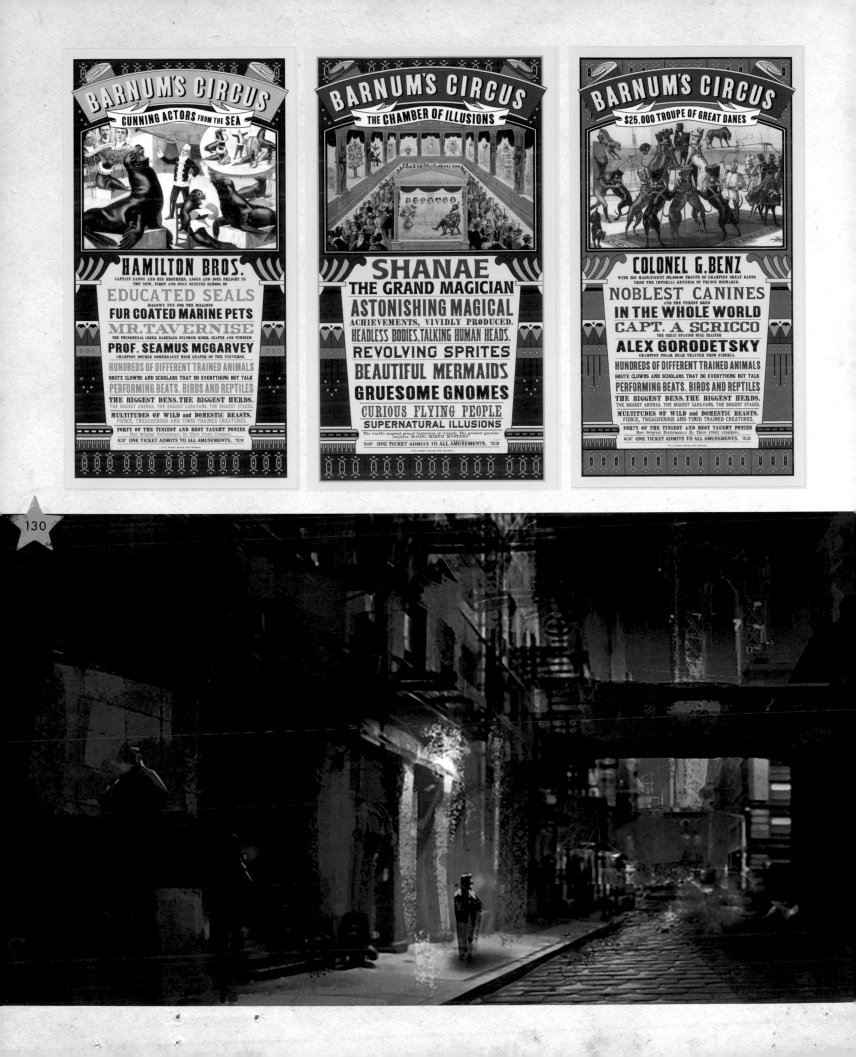

PAGES 126–127: *Concept art by Joel Chang* • PAGES 128–129: *Concept art by Joel Chang of various locations* • OPPOSITE BOTTOM AND THIS PAGE: *Concept art by Joel Chang* • OPPOSITE, TOP ROW: *Circus tent poster props* • PAGES 132–133: *Barnum tenement miniature* • PAGE 134: *Set photography of Barnum's museum of curiosities* • PAGE 135: *Concept art by Joel Chang of the aftermath of the fire*

131

seemingly over-the-top it looked. Cast members certainly felt as though they were stepping into an alternate world, one that was decidedly real yet magical, too. Efron notes, "[Crowley] created a new world. It's beautiful but real, too, and everything looks true to the time, even the animals—the lions, the bears, which are legitimately full of embalming fluid." One look and audiences get the sensation that they, too, have entered a world where dreams come true.

To build Barnum's American Museum, Crowley adapted a 1930s brick warehouse located on the property of Brooklyn, New York's Steiner Studios. *The Greatest Showman* was lucky enough to be able to use the warehouse before the studio changed it into a series of sound stages. To transform it into Barnum's American Museum, Crowley's team made some aesthetic changes to the building's exterior but touched little else. The interior, however, required some major outfitting, including adding a Victorian-inspired steel structure as the balcony. Luckily, the inside of the building already extended upwards about sixty-five feet, which gave Production plenty of space to add trapeze rigs and other aerial wires without having to replace the whole ceiling.

While some of the buildings in the film are massive, others are literal miniatures. For the overview of New York City, for example, in the musical number "A Million

Dreams," Crowley's team used 3-D printers to create a miniature version of the cityscape. "We have eight printers," Crowley explains. "We ran them around the clock for about six weeks and built about five hundred New York buildings of about four different sizes, and then they all got painted." The slow pan over the City includes a scenic view of the Hudson and East Rivers—both were simply painted on set with high-gloss paint. The backing on the top of the rooftop for "A Million Years" was also painted by hand. Production design has been doing 360-degree backing for years, Crowley says. "The hard part now," he says, "is to find good enough scenic painters that still know the techniques." What the team discovered, however, is that good scenic painters abound in New York City. "So we laid out the City with all its perspectives using new techniques, and then we had the rivers in there and the three-sixty backing where we used the old techniques."

Much of the work on *The Greatest Showman*, Crowley says, was "a voyage of discovery." Whether building a circus from scratch or erecting a miniature cityscape, Crowley has shown that no voyage is too outrageous to embark upon. All you need is a good team behind you, an ambitious leader/director out front, and the imagination to find the way.

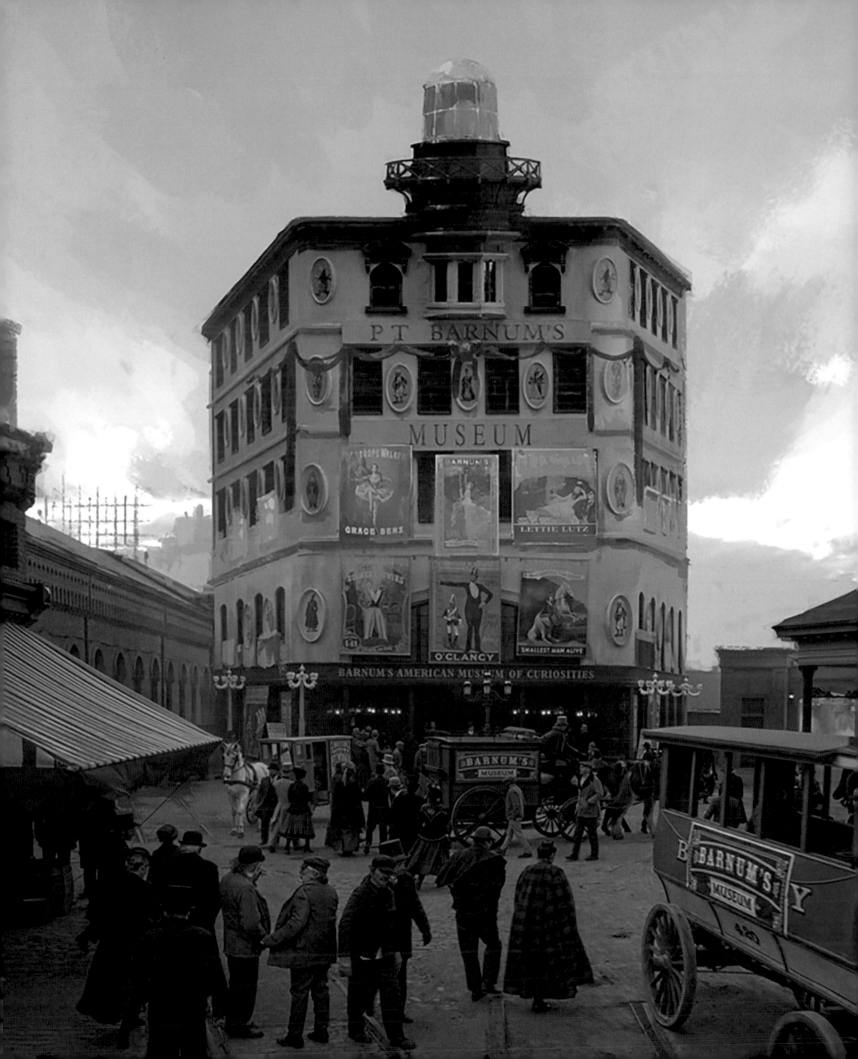

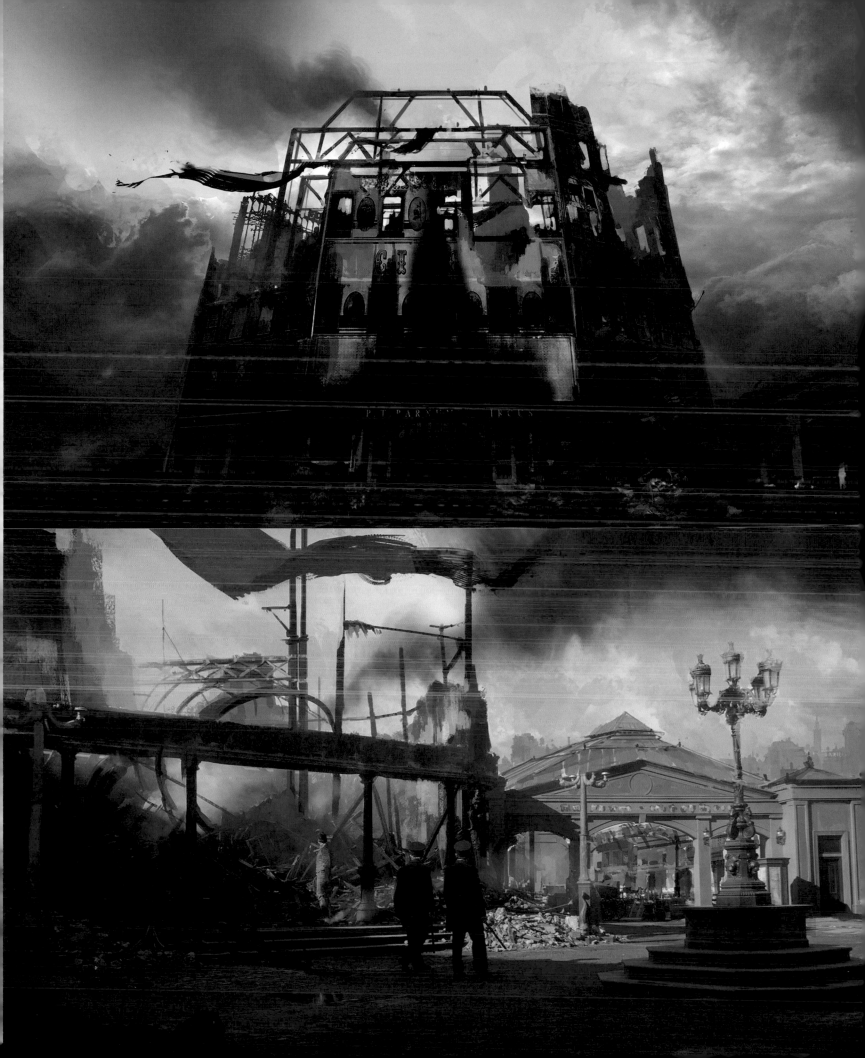

PEOPLE COME
TO MY SHOW FOR
THE PLEASURE OF
BEING HOODWINKED,
AND JUST ONCE, I'D
LIKE TO GIVE THEM
SOMETHING REAL.

—P.T. BARNUM,
SPEAKING TO JENNY LIND

THE GREATEST SHOWMAN

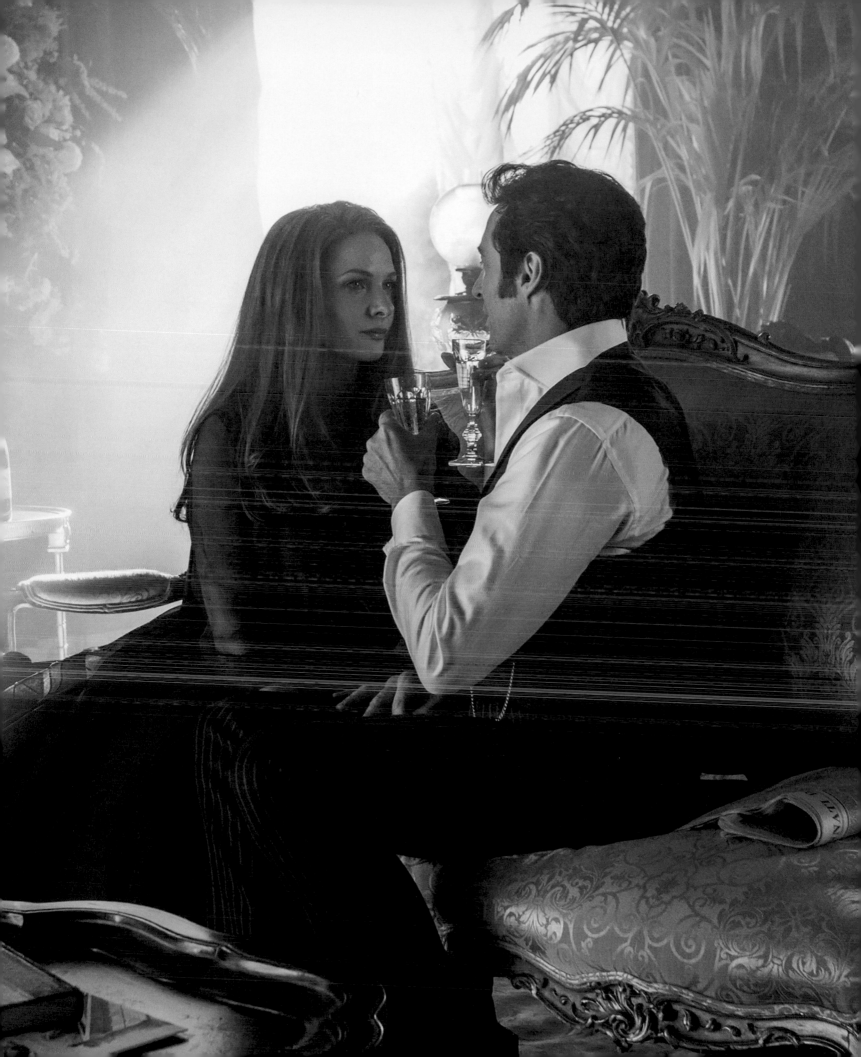

THE LIFE OF THE GREATEST SHOWMAN ON EARTH HAS AN ADDENDUM: JENNY LIND. WITHOUT THE SO-CALLED SWEDISH NIGHTINGALE, Barnum may have spent a lifetime packaging magic, forever on the hunt for the Next Big Thing. With Lind, he got the opportunity of a lifetime: He could promote and sell a real superstar. Played by actress Rebecca Ferguson, the real-life Lind was a musical sensation during the mid-nineteenth century, the toast of England and Europe. However, in the States, no one knew her name. That was no obstacle for Barnum. Before the singer arrived on our shores, he set out to make her a celebrity in the American press. He was so successful, in fact, that more than thirty thousand people were on hand to welcome the singer when her steamer boat arrived in New York City's Canal Street Pier in 1850. (Some perspective: Three thousand fans greeted the Beatles at Kennedy Airport in 1964.) Newspaper reporters at the time called the unprecedented excitement surrounding her American tour "Lind Mania." As Rebecca Ferguson says, "I talked to someone who knew everything about her who said people actually fainted on her because she was like the Beatles or Michael Jackson. She was a true star within the opera."

In the film, Lind ends up being both Barnum's savior and liability. As her manager, Barnum achieves the one thing he never had: respectability in the upper class. A darling of the cultural elite, Lind helps elevate Barnum's status with the very people his museum—and other exploits—long offended. In the film, their business relationship rests on one burning emotion: desire. Barnum desires to be accepted by the high society that Lind already has eating from the palm of her hand, and Lind wants something more than what she has. As Ferguson says, "Their

incredible chemistry . . . isn't about love, but it's about someone seeing what you're missing." Though it's tempting to assume theirs was a whirlwind romance, combining business with pleasure, the only love affair the two concocted was with the American public, whom they wooed time and time again. But Lind, despite their shared success, decides to part ways with Barnum due to a morality clause. Their tour—and Barnum's world—comes to a rollicking, devastating finish.

The time he spends away from his museum, his family of Oddities, and his wife and children extracts a deep personal and financial cost on Barnum. An extrovert's extrovert, Barnum depends on his family and friends to help keep him loyal. When the Oddities confront Barnum in the bar, their home having been destroyed in a blazing fire and Barnum's financial future seemingly doomed, they do so because they know—and he does,

too—that he's better than a humbug. He would never willingly turn his back on those he loves. He doesn't discard; he collects. He doesn't put down; he exalts. He doesn't bemoan life and its hardships; he celebrates life and shoulders its obstacles with good humor, joy, and perseverance. And when the fundamental vastness of the world can't be adequately summed up in words, it's best to rely, as Jackman and the rest of the cast do, on the power of song and dance.

PREVIOUS PAGE: *Jenny Lind and P.T. Barnum in a hotel room* • THIS SPREAD: *Jenny Lind wows audience* • INSET: *Barnum realizes that he is ruined after his museum burns down*

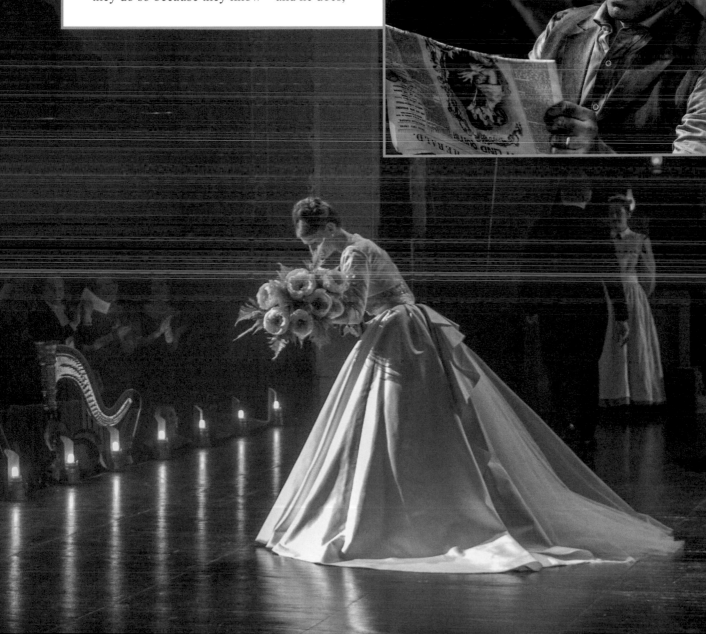

REBECCA FERGUSON AS
JENNY LIND

"I've given you the world, haven't I?"
—JENNY LIND TO P.T. BARNUM

REBECCA FERGUSON WAS FIRST APPROACHED ABOUT THE ROLE OF JENNY LIND WHEN HER AGENT PHONED AND ASKED "DO YOU WANT TO DO A musical?" Ferguson says she laughed, and nearly put the phone down. Not having read the script, she agreed to view one of Gracey's famous pitches. She met Gracey in London and she says, "He had me in two minutes." She continues, saying, "He introduced me to this world that he believed in, that he loved, that he has created, and that had—at that point—been going on for seven years with Hugh [and Gracey] trying to get it made." Gracey was so passionate, Ferguson says, that "the story spurted from every pore of his body . . . and how do you not get completely taken in by that?" Once she heard the music by Pasek and Paul, she was over the moon. "I remember the first time they played my song," she says, "I started crying a bit. . . . I mean, everything they seem to touch just turns into gold."

From the moment she arrived on set, Ferguson knew the production was special. She explains, saying, "I don't feel like there are different stations in this film where you have the art department and

the director and the actors and the music totally separate from one another. Everyone is involved and I think that creates the magic on set . . . and that includes the Hair and Makeup." She admits that as soon as the wig comes on, Jenny Lind seemingly appears from thin air. "That's also magic," Ferguson says. Spoken like Barnum himself.

"NEVER ENOUGH"
"Musicals are scary. Musicals are hard."
—Rebecca Ferguson

For the song "Never Enough," the crew filmed inside BAM's Harvey Theater in Brooklyn. A spacious theater dating from 1904, the film crew had plenty of space to work with and was able to play with the lighting, casting silhouettes of the audience around the theater and honing in on the glow of the spotlight that illuminates Jenny Lind. With over four hundred extras, the scene is the film's most populous, and, coupled with the opulent set, is meant to communicate a feeling of grandeur. For Ferguson, however, who had never done a musical before, the spectacle was nerve-

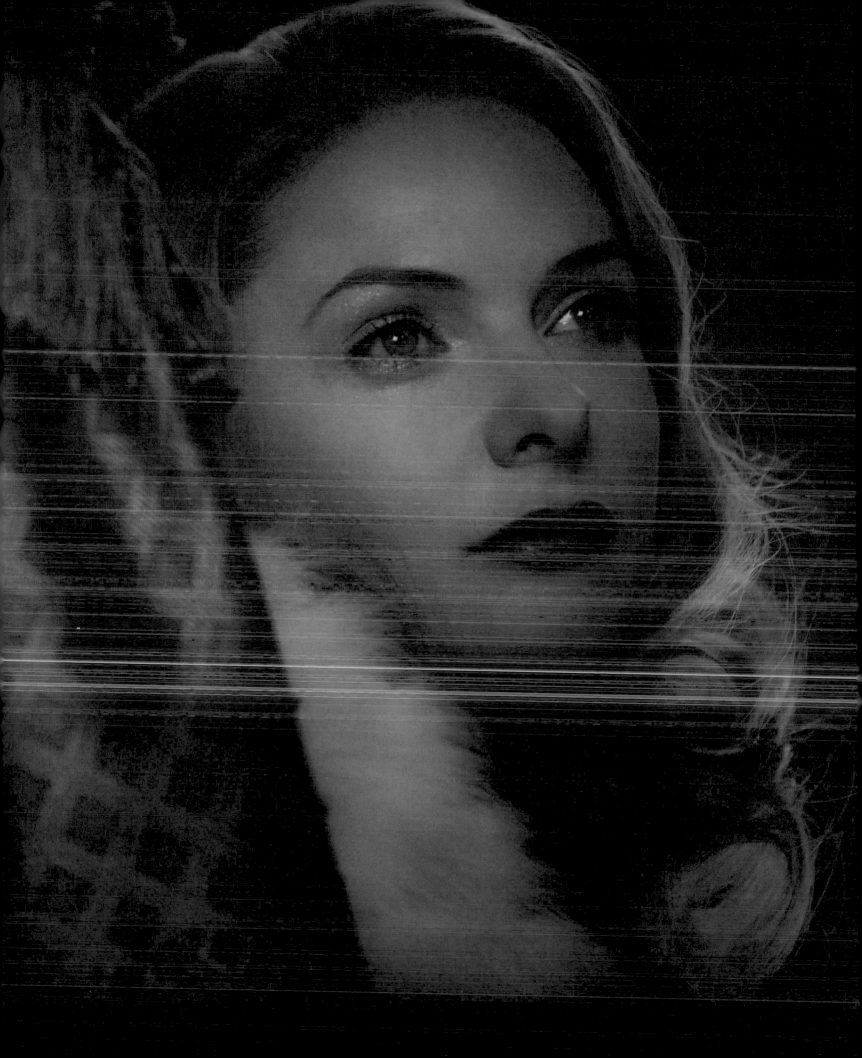

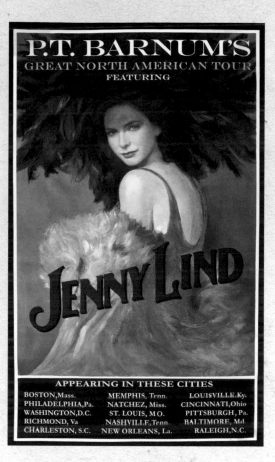

inducing. "I'm standing on a stage," she says, "and I'm shaking in muscles I didn't actually know I had, and I look over to Hugh and he's just smiling. And I can see the calmness of Michael [Gracey] and I think, *You bet on me.*"

Ferguson performed the song from beginning to end and, after several takes, began layering in bigger, more comfortable displays of movement until they cinched a version that was just right. Ferguson says, "I think I had so much adrenaline in me that I could hit the top notes and do the grand gesturing straight away . . . I was probably like a bubbling pot. You just needed to lift the lid for me to explode." Still, that scene was just one of many in which Ferguson sings the song again; each version, however, is imbued with a different emotionality, a different take on the lyrics. "It's beautiful," she says, "how the lyrics can turn, and the emotions can set a completely different tone to the song." By the film's end, audiences have witnessed several different takes of the song, each more emotionally charged than the previous one. In this respect, "Never Enough" perfectly exemplifies how a song can take the place of dialogue to lay bare a character's emotion.

A SINGING ANGEL

"The dress was so long, and the heels were so high..." —Rebecca Ferguson

To create Jenny Lind's look for the film, Costume Designer Ellen Mirojnick turned to work by Galliano for inspiration. From the outset, Mirojnick wanted sweeping, Cinderella-esque gowns for the Swedish Nightingale. Lind's signature color, with few exceptions, is angelic (or princess) white, the better to convey the sense that her voice and beauty are heaven-sent. Couture-made, each one of her dresses are high drama: Even when she's not standing center stage, Lind is always the center of attention, and Mirojnick made sure of this by creating voluminous skirts that filled the surrounding space and blossomed from Ferguson's petite bodice. Accessories were kept to a minimum as Ferguson's beautiful hair color was its own accent piece.

PREVIOUS PAGE: *Rebecca Ferguson as Jenny Lind* • ABOVE: *Tour poster* • OPPOSITE: *Barnum and Jenny on stage*

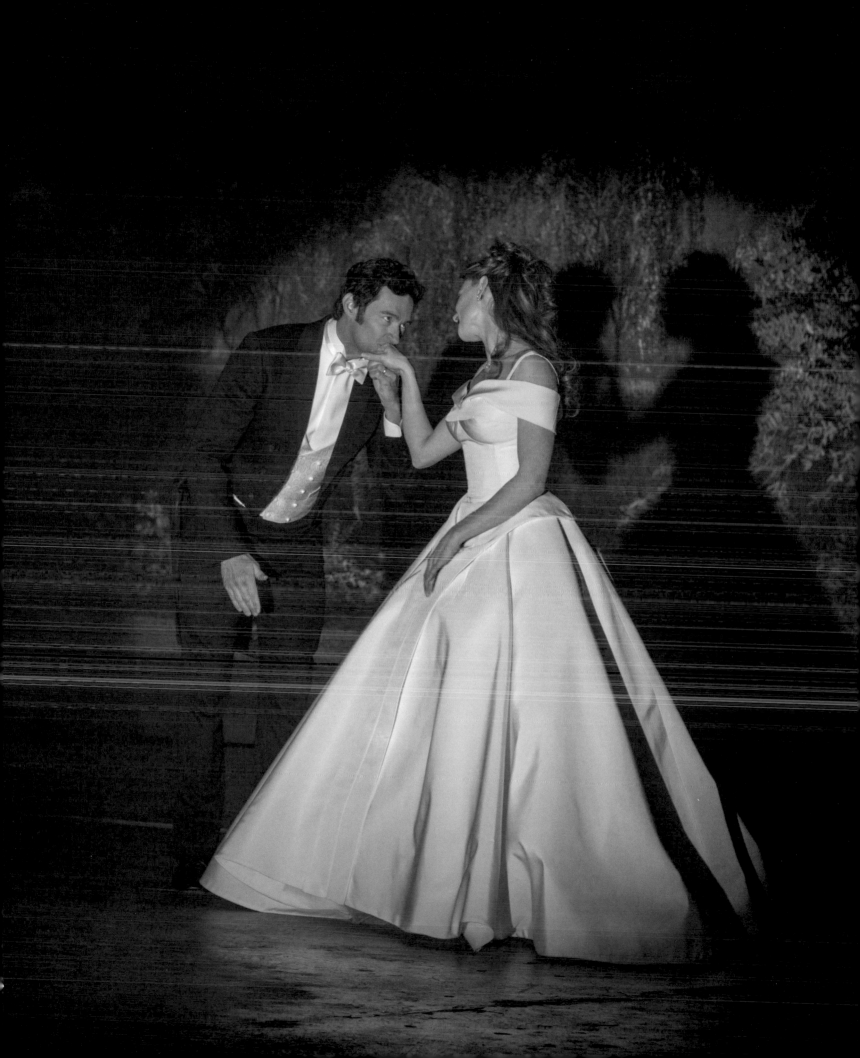

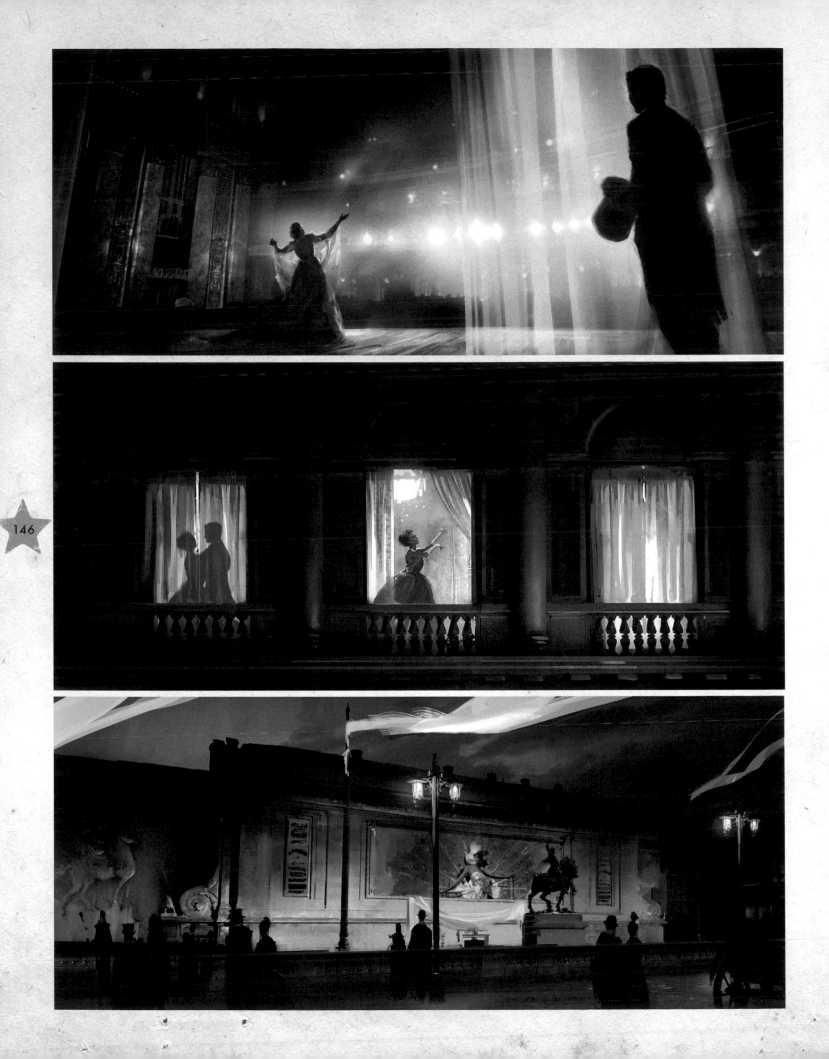

OPPOSITE: *Concept art by Craig Sellars of Barnum watching Jenny perform* (TOP); *concept art by Jamie Jones of Charity in "Shadow Dances" while Barnum is away* (MIDDLE); *concept art by Joel Chang of high society attending Jenny's first concert* (BOTTOM) • BELOW: *Newspaper prop art by Brian Estanislao*

TOP HATS & TAILS
COSTUME DESIGNER'S
NOTEBOOK

FOR COSTUME DESIGNER ELLEN MIROJNICK, COSTUME DESIGN ISN'T ABOUT PRECIOUS DETAILS—THE PRECISE APPLICATION OF A SEQUIN, FOR EXAMPLE, OR FINE STITCHWORK. Instead, she prefers to work on a grander scale and in broader strokes of imagination. "I'm a visualist who thinks on a bigger scale," she says, and that means Mirojnick's main design objective is to capture the feeling—the mood—of the director's intended vision for the film. For *The Greatest Showman*, Mirojnick was a bit in the dark, however. "This has been a process I've never, in my entire career, ever encountered," she admits. "I didn't know what the script was—what the demands of the script were at all." She came on board only two days prior to shooting and, not having seen the script, wasn't prescribed by it, which ended up working to her creative advantage.

The production schedule for Mirojnick's team was incredibly tight, with fittings and wardrobe requirements being fulfilled sometimes as close as a few hours prior to shooting. The tight deadlines forced Mirojnick and her twenty-person team to work not only quickly but also flexibly. While the deadlines were intense, they were the least of Mirojnick's worries. Conscious of designing characters for a circus, and in creating menswear for the greatest showman in American history, Mirojnick in no way, shape, or form wanted anyone, least of all Hugh Jackman, to come across as appearing foolishly clownish. Jackman's ringmaster's red jacket was particularly tricky as the actor recalls: "I probably had ten fittings on that red coat because, let's face it, the red ringmaster's coat is pretty iconic, and she just had a spin on it that was sort of sexy, a little bit Adam Ant and a little [David] Bowie-ish, and still looking like it was a classic ringmaster's costume."

Fortunately, for Jackman's other clothing, menswear showcased beautiful cuts and silhouettes during the turn of the century. "So we were able, with fabric and texture," Mirojnick explains, "to make an extremely handsome and attractive, extroverted character who would sell anything to become that

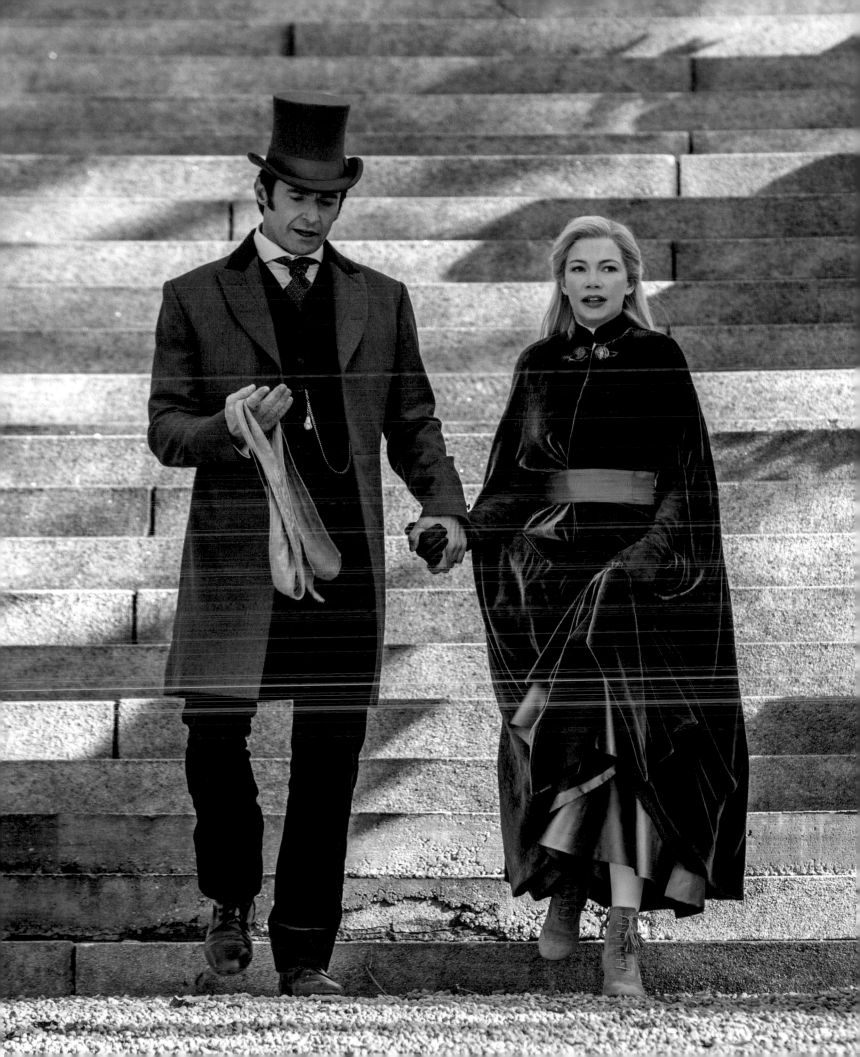

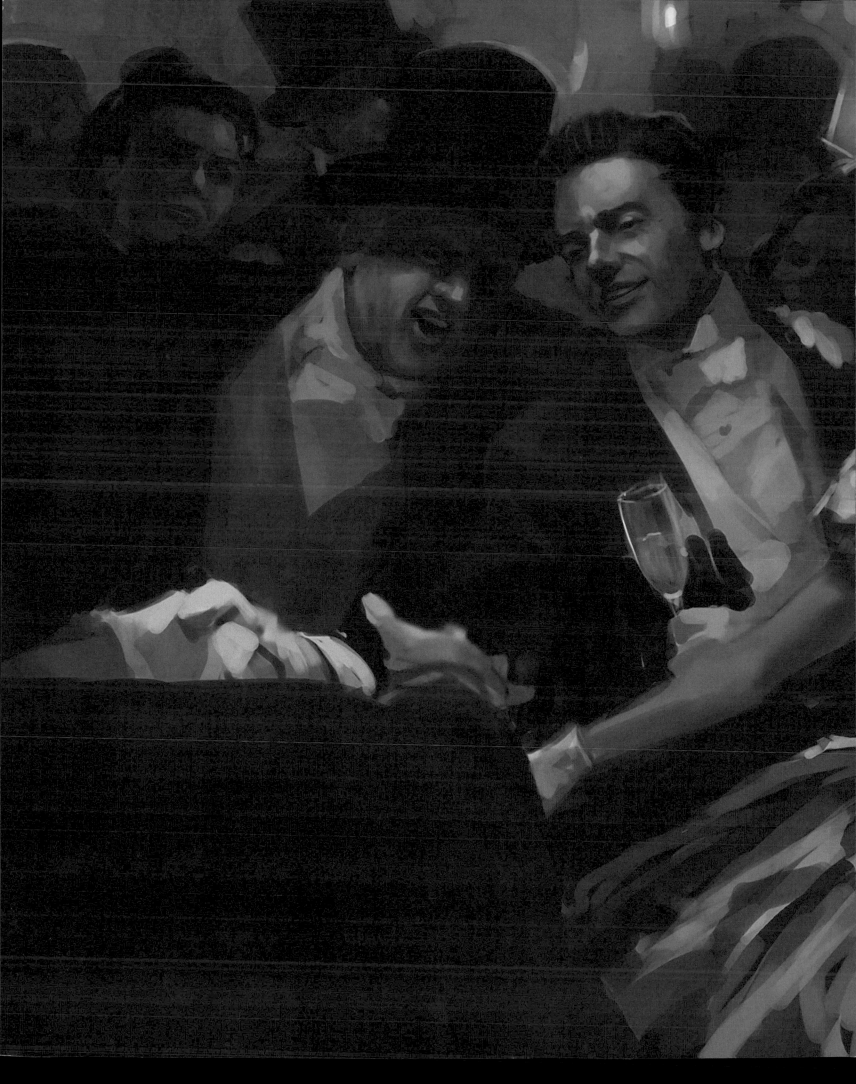

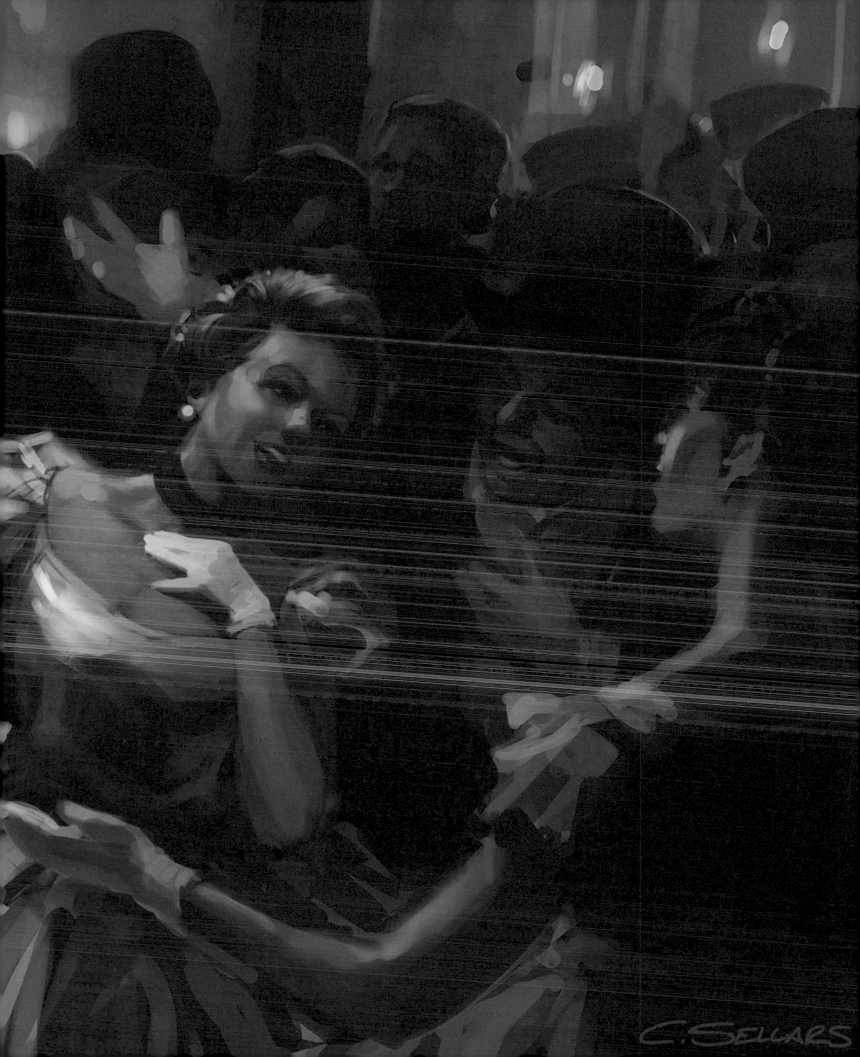

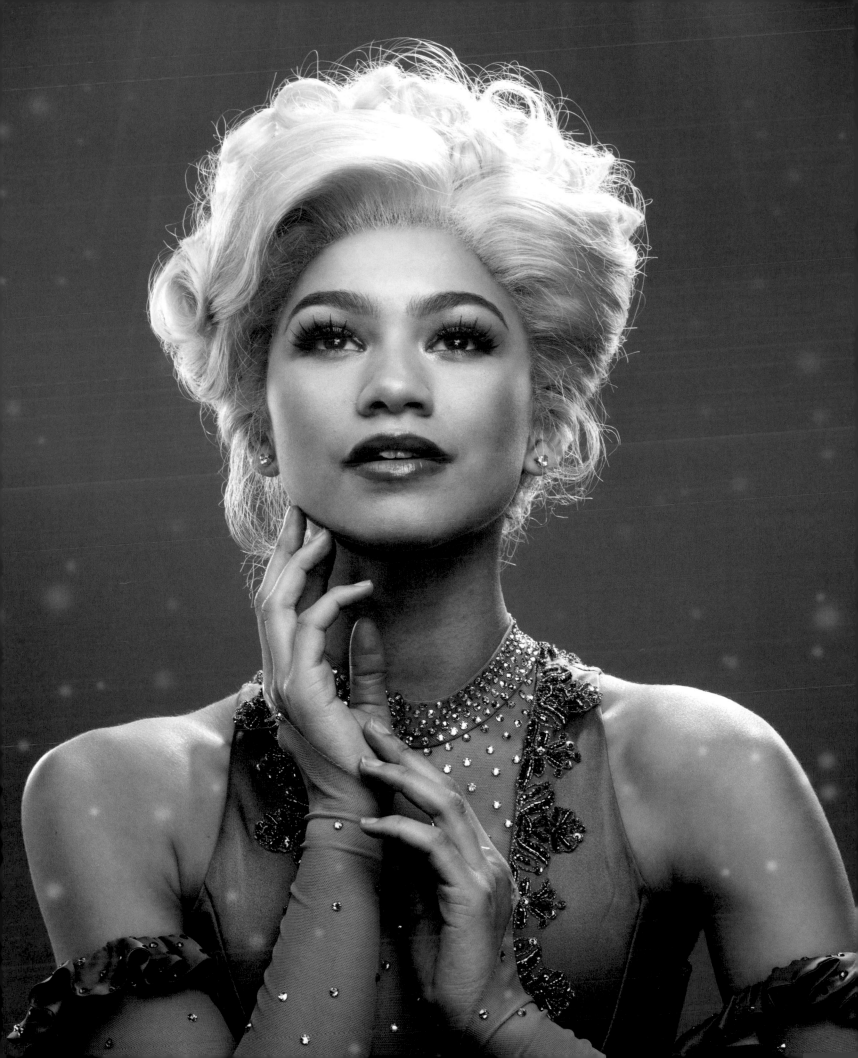

much bigger in his life." The team added subtle details to Jackman's clothing—pinstripes, texture, and bold colors—that signaled his brash, youthful arrogance and, later, became a more sophisticated look—elegant, rich-looking clothes—when he becomes an accepted presence in high society. A character's "look," however, doesn't begin and end with the clothing. After all, Anne Wheeler wouldn't be Anne Wheeler without her cotton-candy-pink hair.

Though pink hair is a relatively subdued color choice when compared to the full range of Mirojnick's off-the-charts color palette. While the film itself takes place during the 1800s, Gracey didn't want Mirojnick to feel inhibited by the sartorial specificities of the time period . . . and that included the colors of the characters' clothing. Instead, he wanted to capture the larger-than-life quality of the circus, bursting with all its rich, sumptuous hues. In order to accomplish such a task, Mirojnick had to think and design outside the normal bounds and expectations of wardrobe. The resulting color palette is unlike any other in cinematic history—deep purples coexist with rusty hues of orange; pinks range from being electric—bordering on neon—to soft bubblegum and pink lemonade. Meant to match the intensity of the musical numbers and the fantastical vibrancy of Barnum's spirit and that of all the characters, the colors are truly eye-popping, and present a contemporary twist on the historical.

While some of the cuts and silhouettes of the clothing look period-piece-worthy, the fabric is certainly modern; it was essential that every actor have clothing that was flexible enough for dance scenes and, for Zendaya, unitards, often outfitted with complicated harnesses, were key. Mirojnick worked closely with the other teams in production to ensure that the clothing was as functional as it was beautiful. In some cases—as with the costume for the Three-Legged Man—Mirojnick depended on a little help from Special Effects. "The Three-Legged Man was an engineering feat that Special Effects helped us with. You zip the leg on and off. Don't tell anyone, but you do," Mirojnick confesses.

HAT TRICKS

"There are certain predictable things you have to have: You have to have the red jacket. You have to have the top hat. You have to have the cane." —Costume Designer Ellen Mirojnick, on the ringmaster's look

Hugh Jackman's top hat isn't just a hat. It's also a prop, and one that had to be carefully designed so Jackman could successfully perform the film's hat tricks. To create it, Mirojnick turned to costume-maker extraordinaire Barrett Stribling, who made sure the hat was heavy enough to flip out of Jackman's hands and land on his foot but also light-enough in appearance to seemingly float back to his head. Made in Budapest, the hat seemingly possesses magical properties. Once Jackman placed it on his head—coupled with the ringmaster's vest, red jacket, and cane—he became, as Mirojnick says, the embodiment of P.T. Barnum, a transformation infinitely more magical than any hat trick.

153

PAGE 149: *Barnum and Charity* • PAGES 150–151: *Concept art by Craig Sellars of Jenny Lind backstage* • OPPOSITE: *Anne Wheeler* • RIGHT: *The hat!* • 154–159: *Set photography*

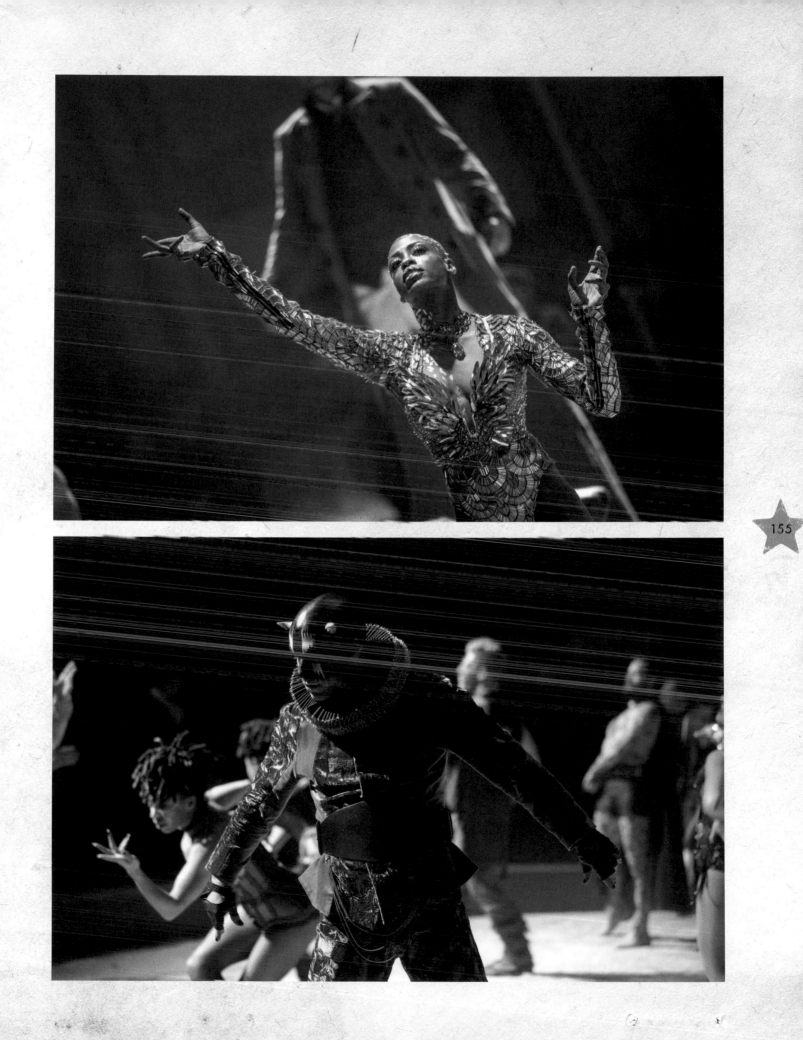

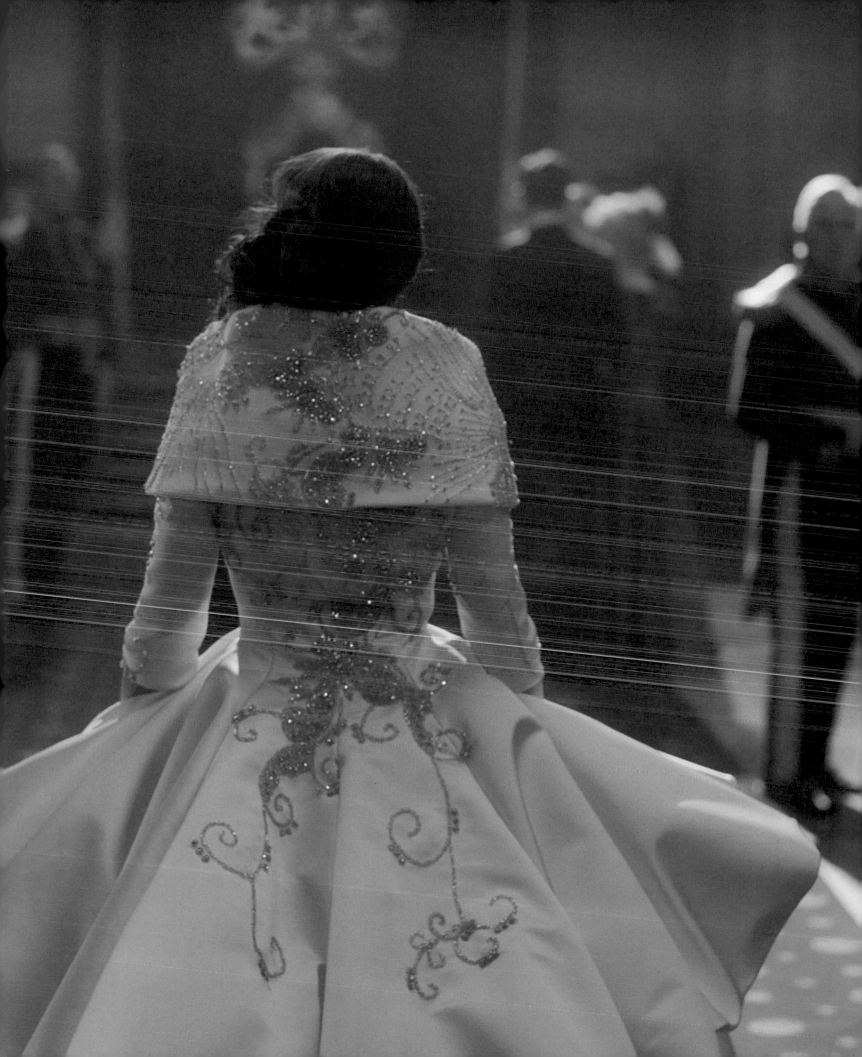

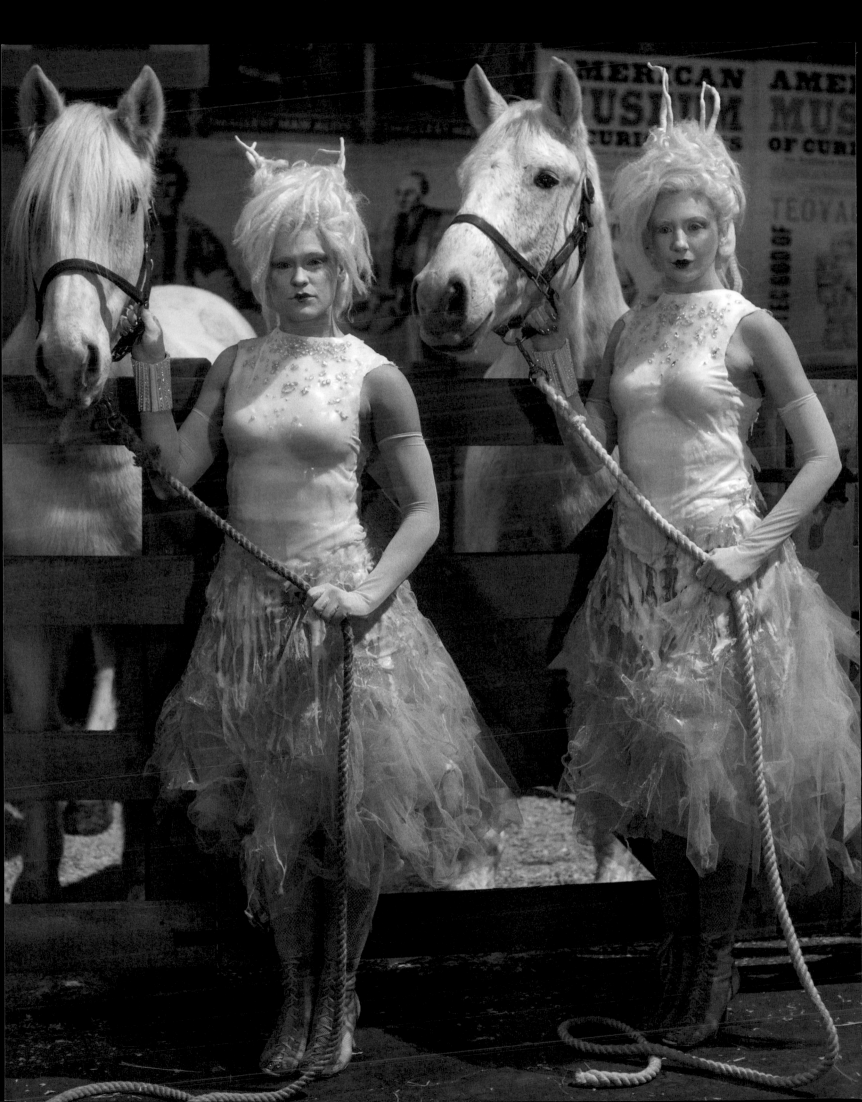

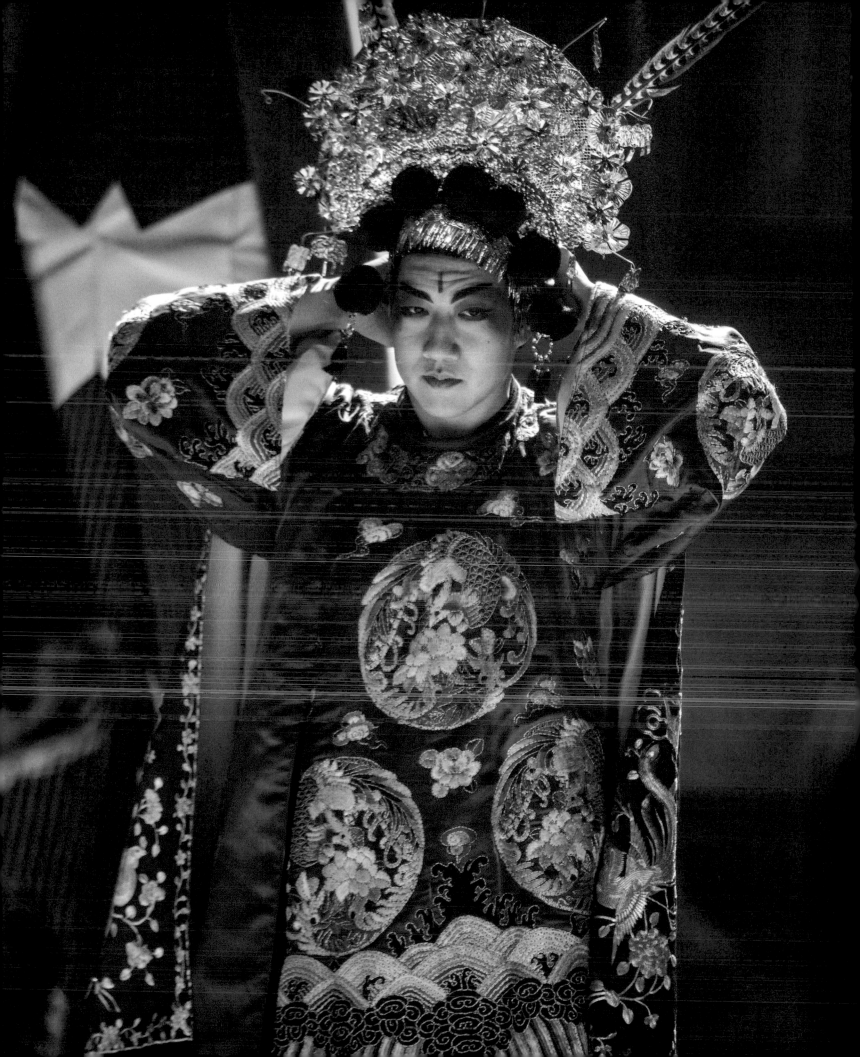

PLAYING WITH FIRE
SPECIAL EFFECTS &
PRODUCTION DESIGN
NOTEBOOK

"He built that museum from the ground up. Why, if anyone can find their way in and out, it's your father." —LETTIE LUTZ, SPEAKING TO CAROLINE AS BARNUM ENTERS THE FLAME-ENGULFED AMERICAN MUSEUM

TO FILM THE AMERICAN MUSEUM FULLY ENGULFED IN FLAMES, THE PRODUCTION DEPARTMENT FIRST HAD TO CREATE THE BUILDING ITSELF. BECAUSE FILMING THE scene was potentially dangerous, the set needed to be constructed in a controlled environment. Production Designer Nathan Crowley says, "In the old MGM musicals, you'd shoot on the back lot, a back lot that no longer exists." Lacking the expanse of a back lot, the crew built their big sets at the Brooklyn Navy Yard. With the help of the Navy Yard and Steiner Studios, they found an area with enough brick buildings and cobblestones and old tram tracks the team could control. The Production team outfitted an old building already standing on the studio's property. Crowley says, "With a little bit of tweaking, we built the exterior of the museum and, with a bit of twisting, it becomes this five-way junction so we can get several angles out of one spot.

And it's a bit endless because it goes out to a real dry dock with giant steps, allowing us to get all sorts of vertical scale and horizontal."

The scene in which the museum goes up in flames was filmed in the early hours of the morning, around 4 o'clock. Fifty-foot technocranes afforded tremendous flexibility for the crew to film around the building—the same cranes were used to film the climax of "Come Alive." Besides being able to film the tops of trees (or a burning building), when needed, the cranes can also quickly "swoop" down from high positions to capture on-the-ground movement. Describing the cranes' flexibility for "Come Alive," Cinematographer Seamus McGarvey says, "[The crane] allows us with this thin arm to travel through the dance . . . you're not watching proscenium style. It's very definite. You feel like you're inside [the scenes]." That kind of flexibility allowed the team a tremendous amount of freedom to move in or out quickly, which helps when you need to safely film a burning building.

OPPOSITE: *Concept art by Joel Chang* (TOP); *set photography of the fire* (MIDDLE) *and Barnum rushing toward the burning building* (BOTTOM) • OVERLEAF: *The American Museum of Curiosities burns* • PAGES 164–165: *Concept art by Jamie Jones of Barnum and the Oddities watching the fire* • PAGES 166–167: *Concept art by Craig Sellars of the fire* (TOP ROW), *and set photography of the aftermath* (BOTTOM)

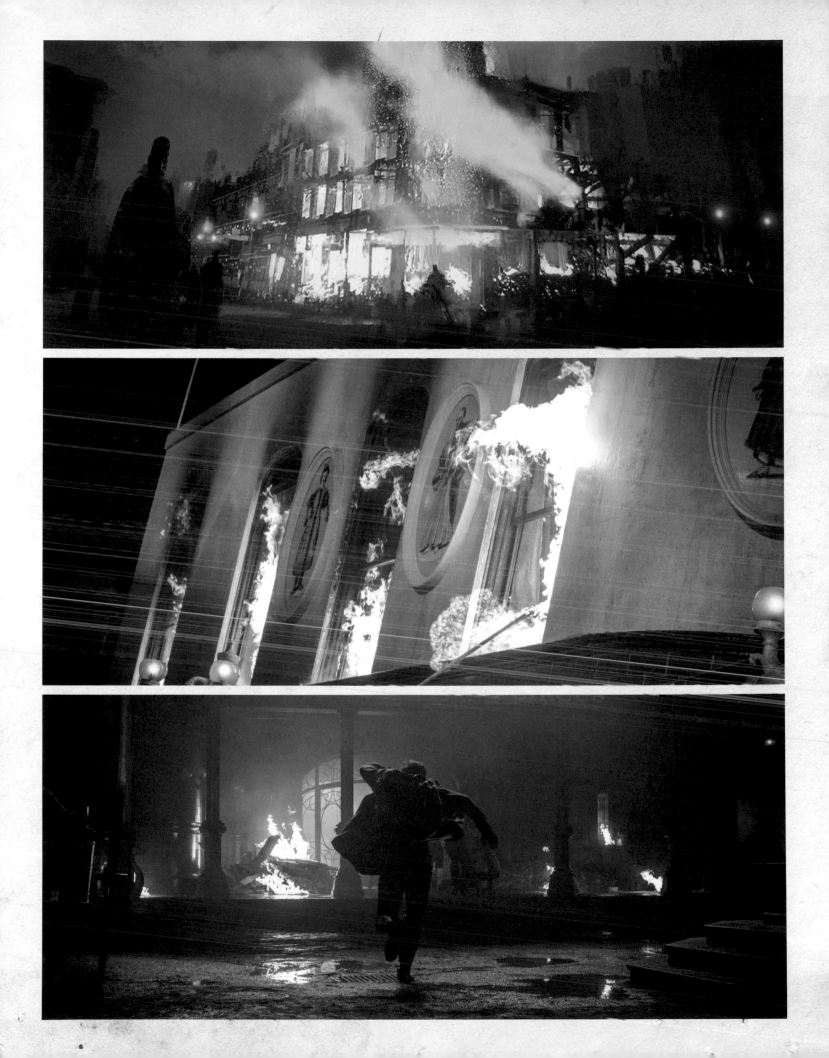

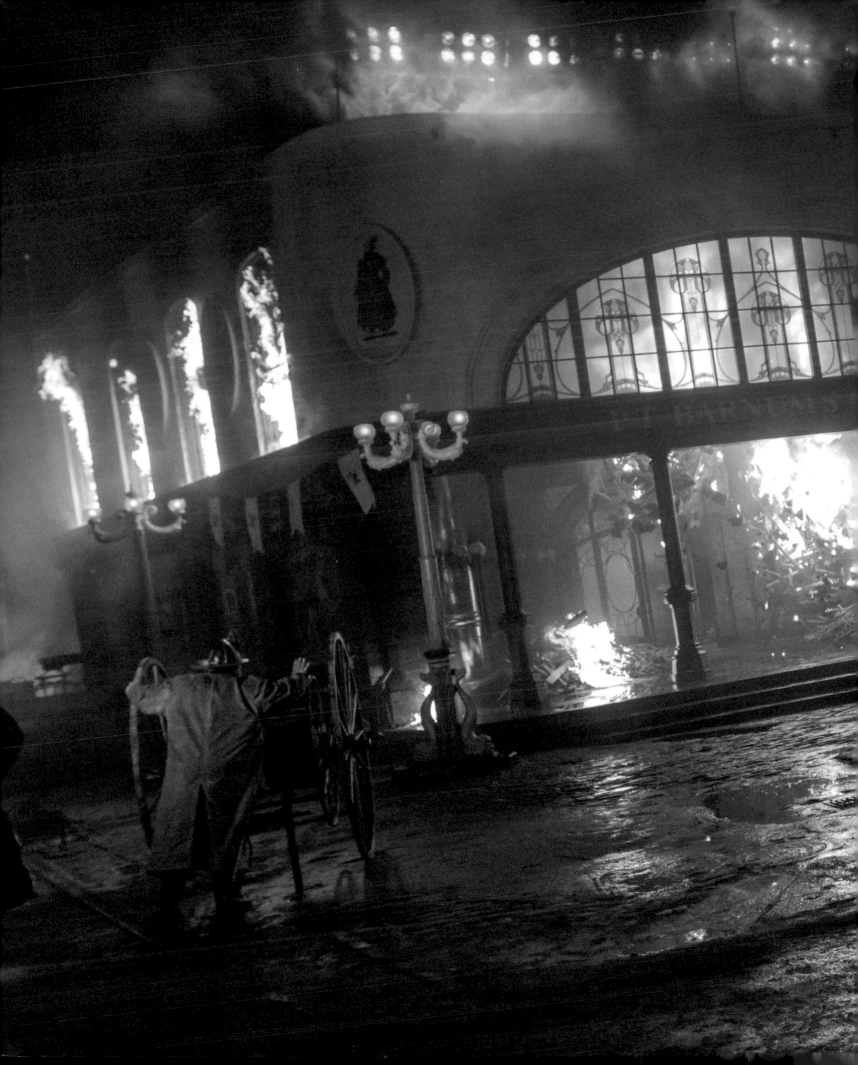

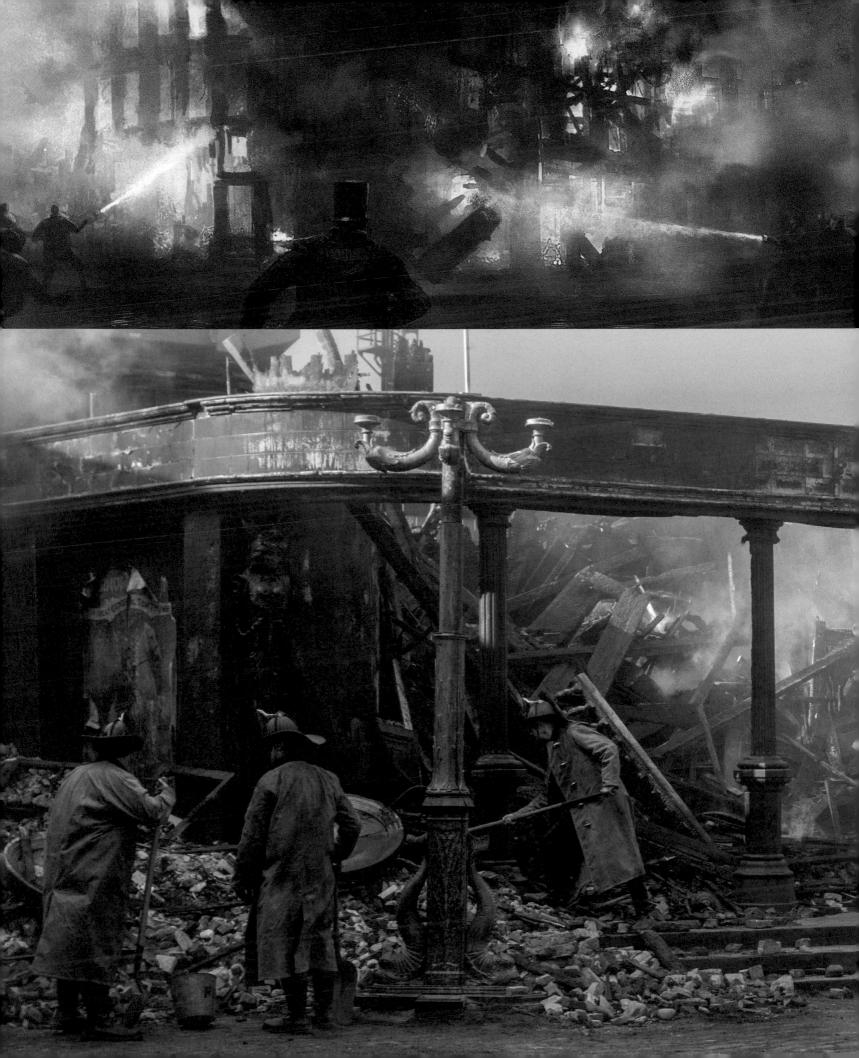

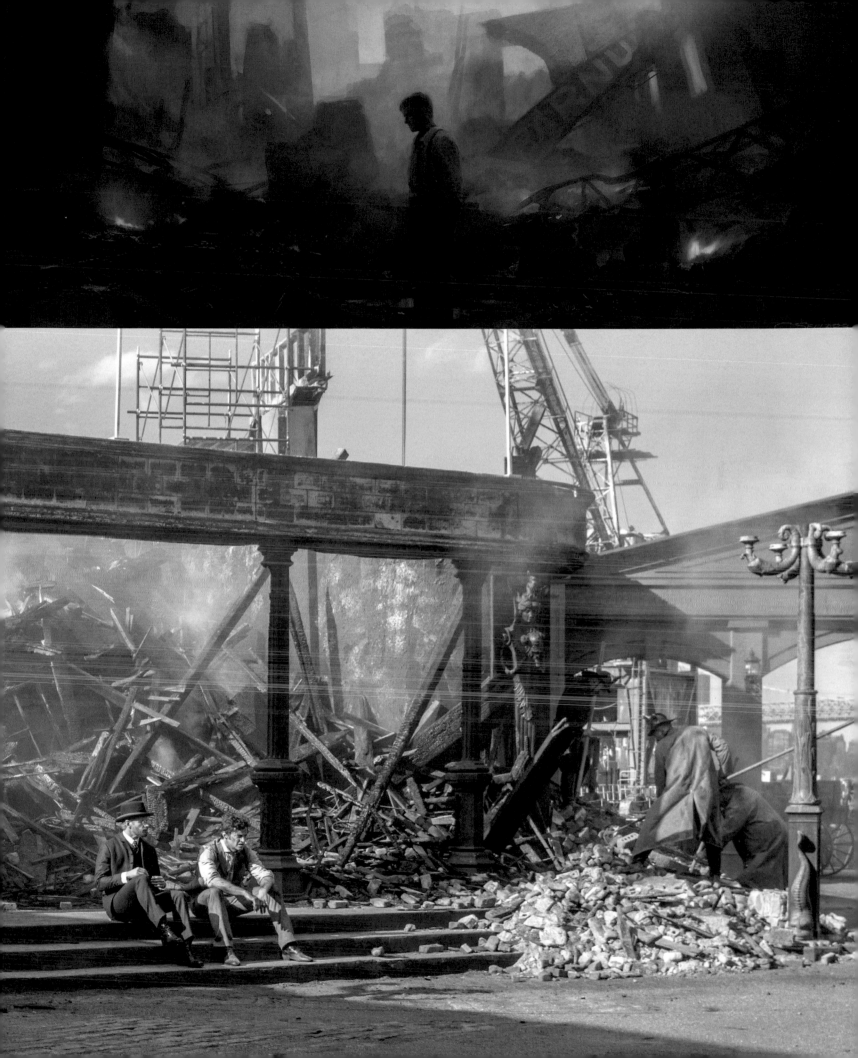

THE NOBLEST
ART IS THAT
OF MAKING
OTHERS HAPPY.

—P.T. BARNUM

THE GREATEST SHOWMAN

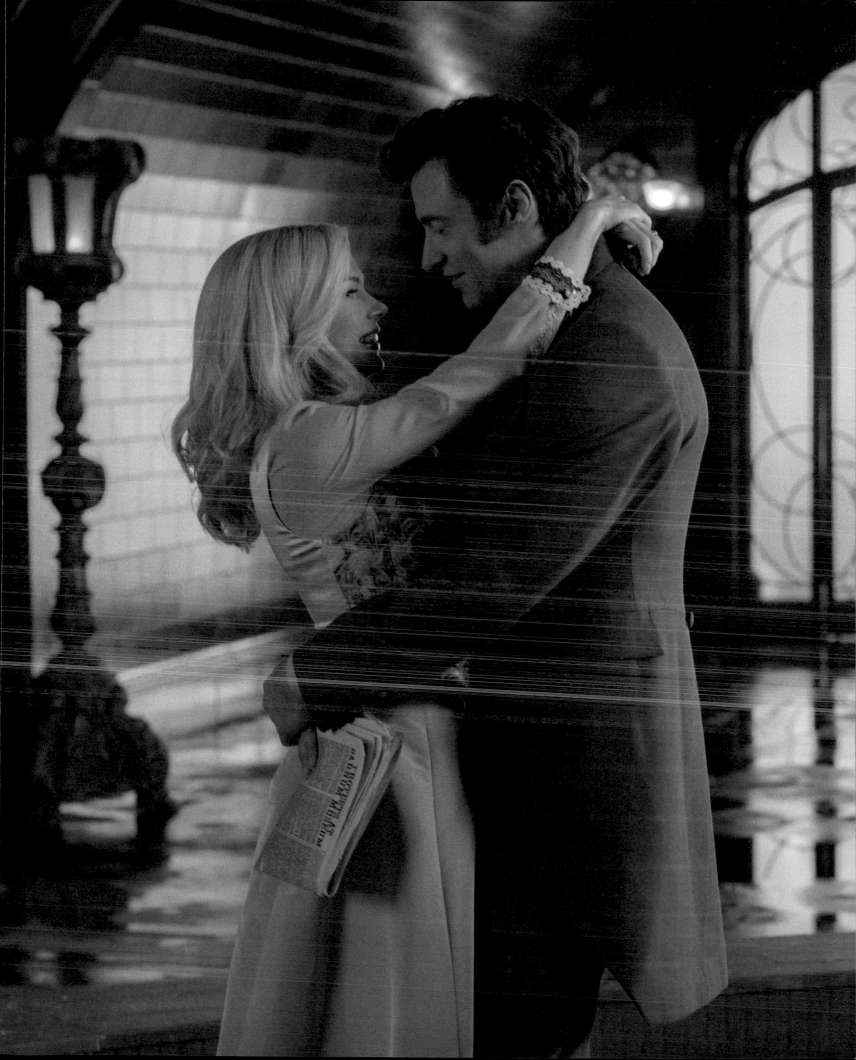

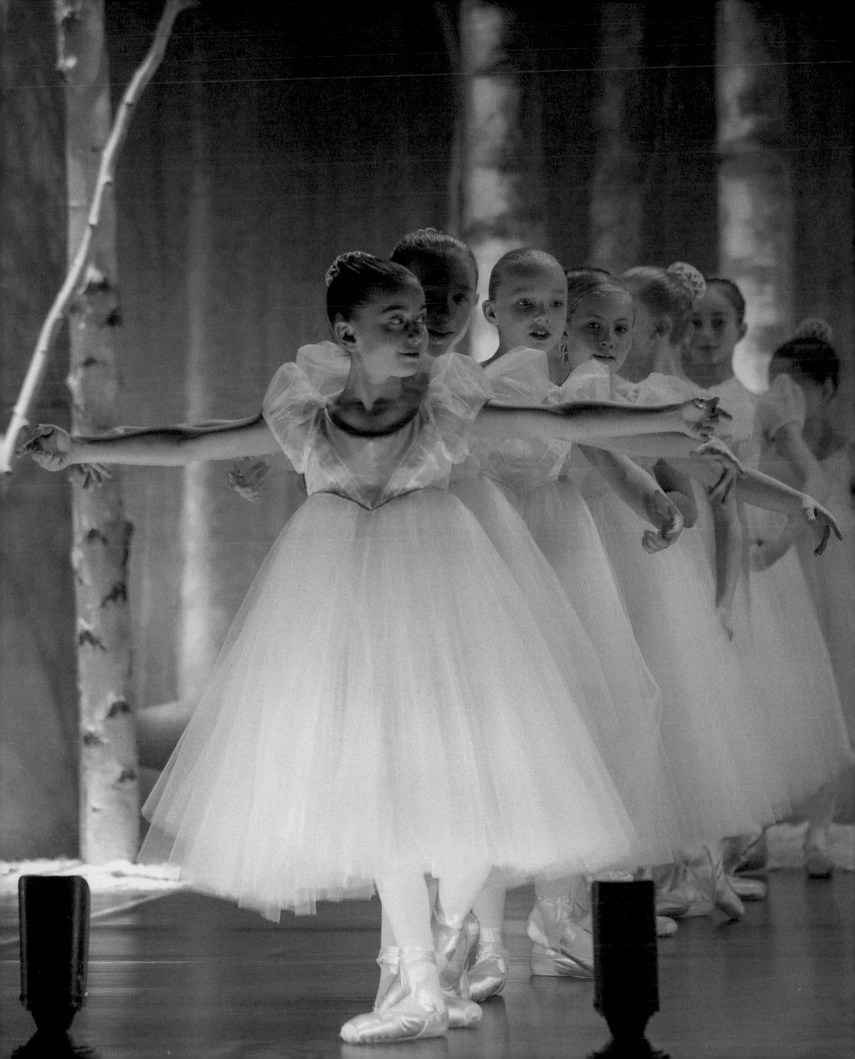

HAVING REALIZED THAT HIS LIFE IS MADE INFINITELY BETTER BY HIS FAMILY—AND BY HIS PRESENCE IN THEIR LIVES— BARNUM DEDICATES HIMSELF wholeheartedly to rebuilding all that he has lost. This time, however, he takes a more light-hearted approach. Rather than rebuilding the American Museum from the ground up, he gets an enlightened idea: Why not bring the circus—the show— to the people? Though the concept of a traveling show had already been in existence for some time, it took a risk-taking visionary like Barnum to turn it into the greatest show on earth.

The Greatest Showman ends with Barnum sitting amid the audience, watching his daughters perform. Yes, he may have shown up to their ballet performance sitting astride a sequined elephant, underscoring the fact that he's not your typical dad; but in all the ways that count, he's the definition itself of a family man: loyal, generous, and kindhearted. Turns out that for the greatest showman in the world, sitting among the audience is the greatest place to be.

PAGE 171: *Charity and Barnum* • PAGES 172–173: *Concept art by Joel Chang of the ballet* • THIS SPREAD: *Set photography of the recital* • ABOVE: *Concept art by Joel Chang of a performer* • BELOW: *Concept art by Jamie Jones of ballerinas on the Met steps*

175

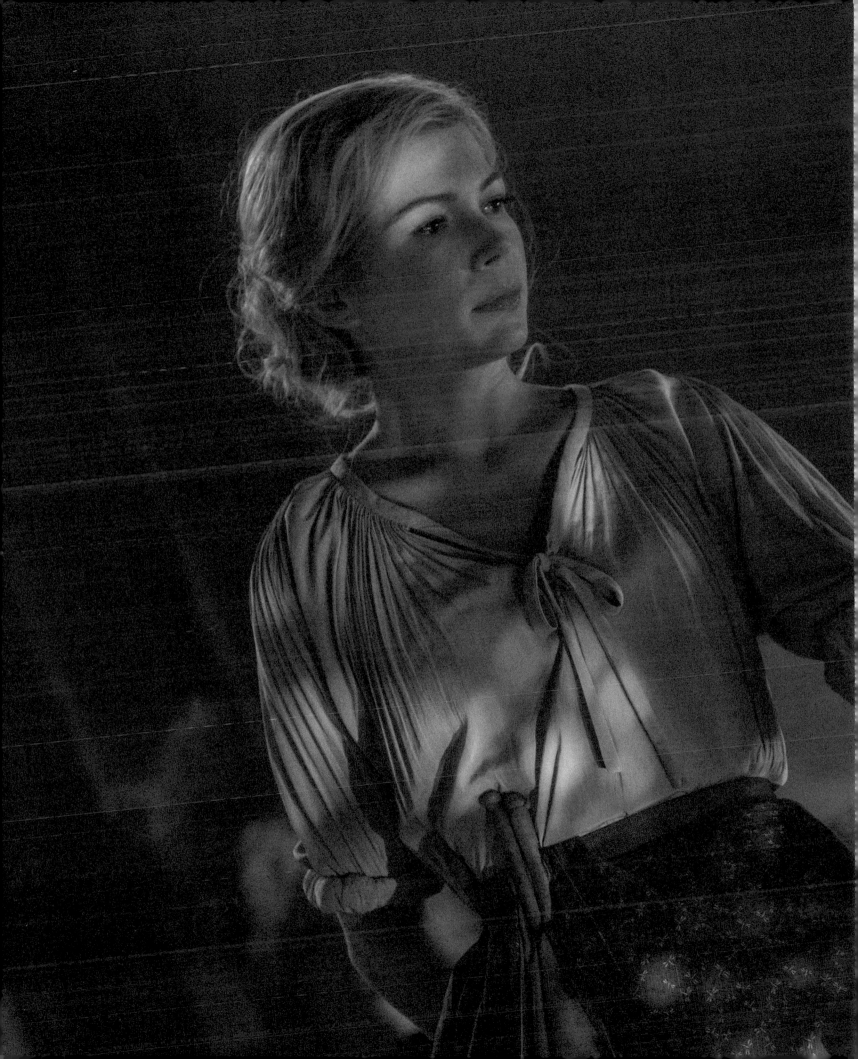

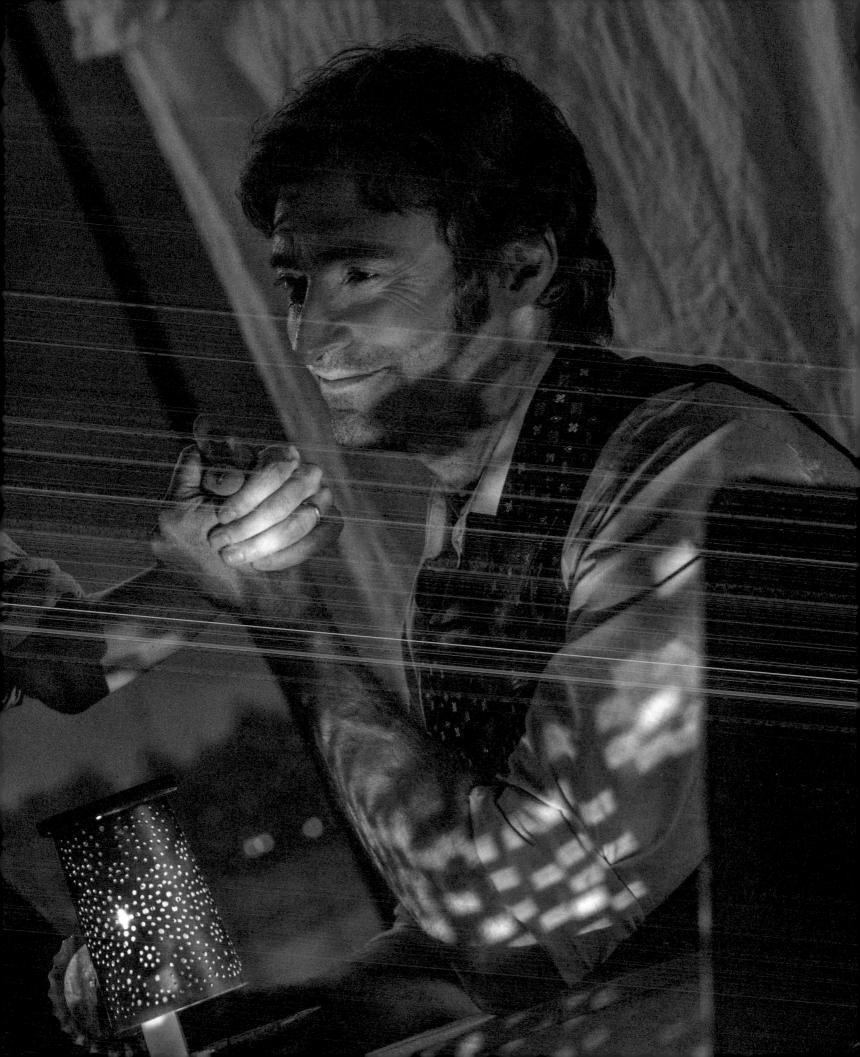

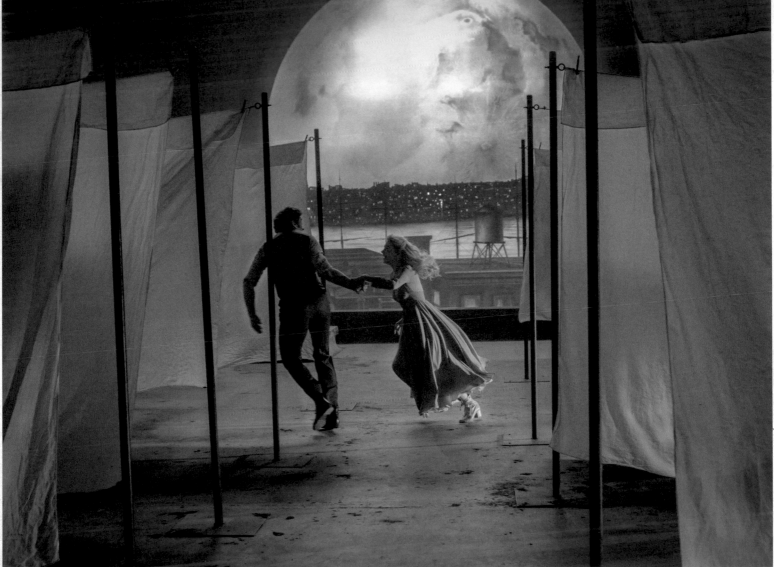

PAGE 177: *Concept art by Jamie Jones* (TOP) *and set photography* (BOTTOM) *from "This is Me"* • PAGES 178–179: *Barnum and Charity on the rooftop celebrating their daughter's birthday* • THIS PAGE: *Concept art by Joel Chang* (TOP) *and set photography* (BOTTOM) *from "A Million Dreams"* • OPPOSITE: *Concept art by Jamie Jones of Barnum in the ring* (TOP), *Charity in "Shadow Dances"* (MIDDLE), *and an unknown scene* (BOTTOM)

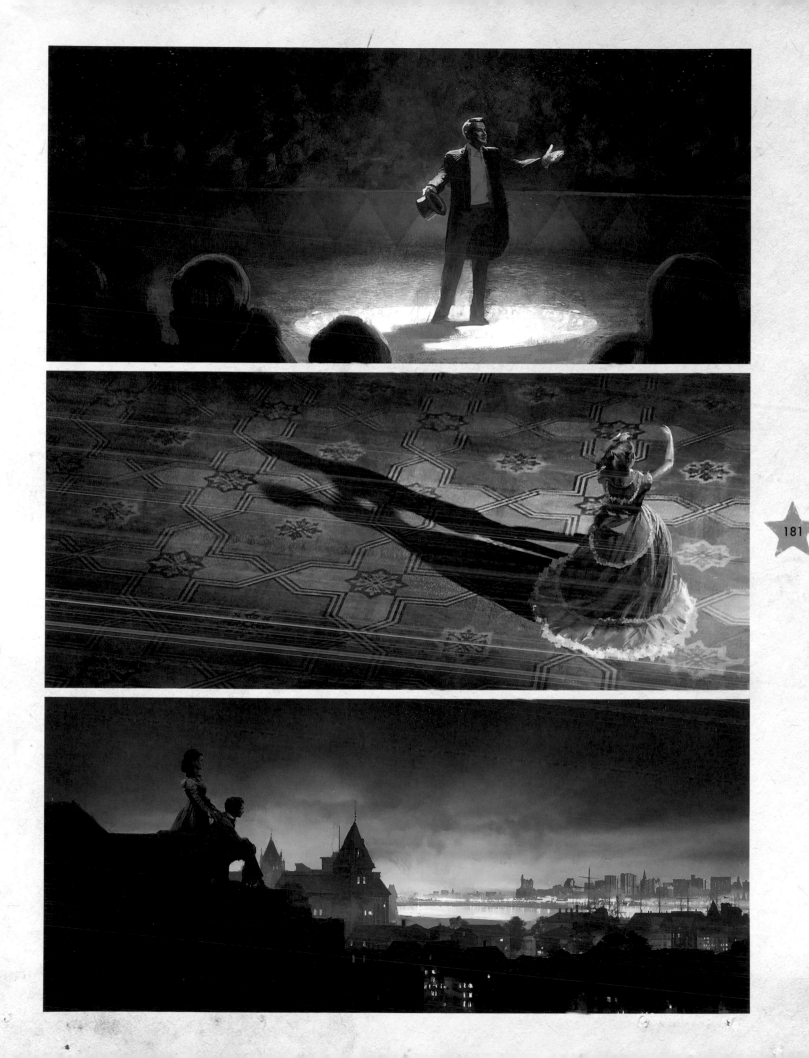

GLITTER & SAWDUST
PRODUCER'S
NOTEBOOK

"He's about the only person in the world who could do Wolverine and P.T. Barnum."
—Larry Mark, speaking about Hugh Jackman

WHILE WATCHING HUGH JACKMAN'S HIGH-VOLTAGE PERFORMANCE AS HOST OF THE 2009 ACADEMY AWARDS, Producer Larry Mark thought, "This guy's the greatest showman on earth." The parallel between Jackman and the spirit of P.T. Barnum, for Mark, was immediate. Two months later, the men spoke about the possibility of Jackman playing Barnum . . . and of the film being an original movie musical. Seven years later, Mark is happy to give the world what they didn't know they were waiting for.

An early champion of Jackman as Barnum, Mark watched the actor's enthusiasm and charisma work its magic on the set of the film, too, as Jackman became the de facto ringleader for the entire production. "I think this is the first movie in which Jackman's played a family man and, in real life, he is the most amazing family man," says Mark. It's this quality, perhaps more than any other, that lends credibility to his performance as Barnum. Throughout his life—and death—critics of Barnum have called him many things: a fraud, a hustler, a con man, and a huckster, to name a few. The word "circus," in fact, was meant as a derogative to describe one of his shows. Barnum, however, seized upon the power of the word and turned it upside down, claiming it for himself as an exclamation of pure joy and abandon.

At the film's end, audiences see Barnum for who he really is: a family man, whose joy and unbridled love of life is rivaled only by the love he has for his wife and children. That message, to Mark, is the film's emotional core. "Hopefully," he says, "the film will touch your heart and dazzle your eyes."

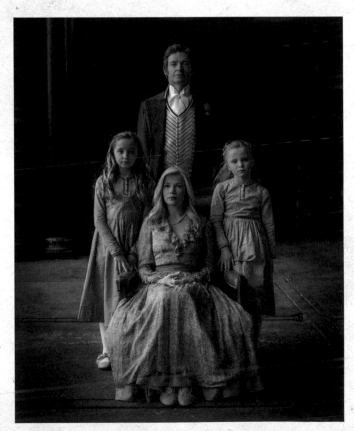

ABOVE: *Barnum and family* • OPPOSITE: *Barnum and Charity on the rooftop celebrating their daughter's birthday* • OVERLEAF: *Concept art by Jamie Jones of Barnum arriving at his daughter's ballet recital*

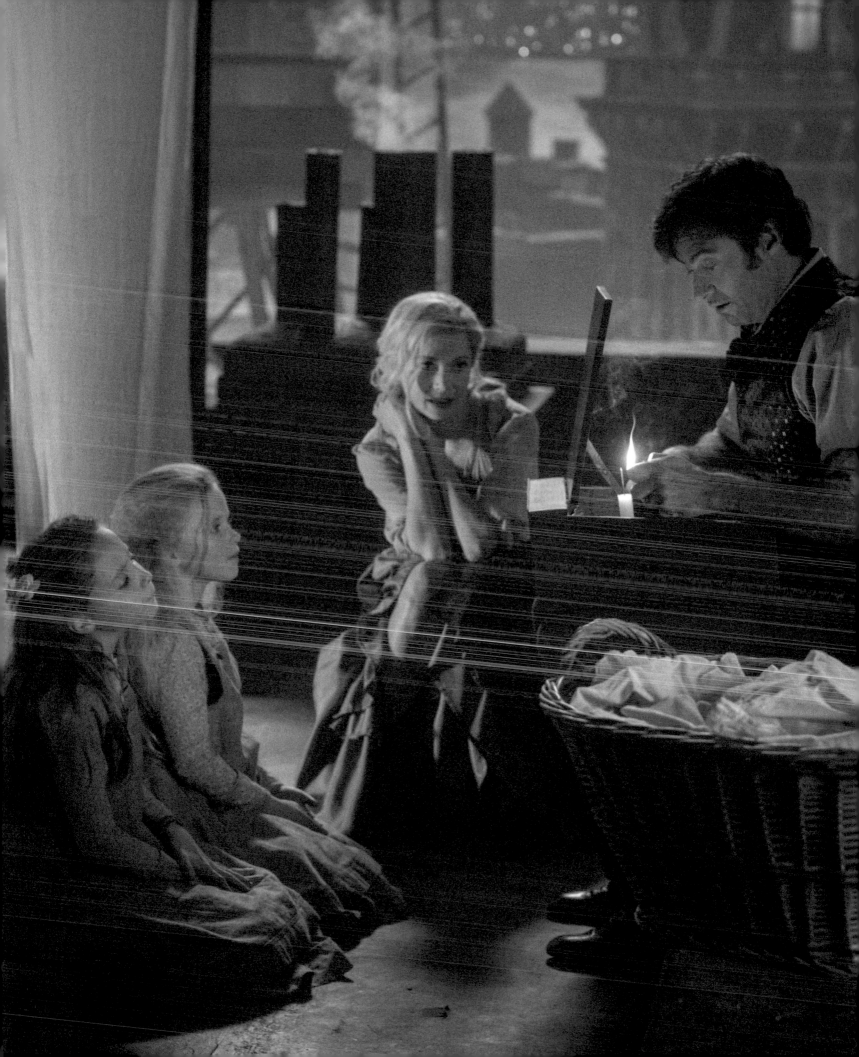

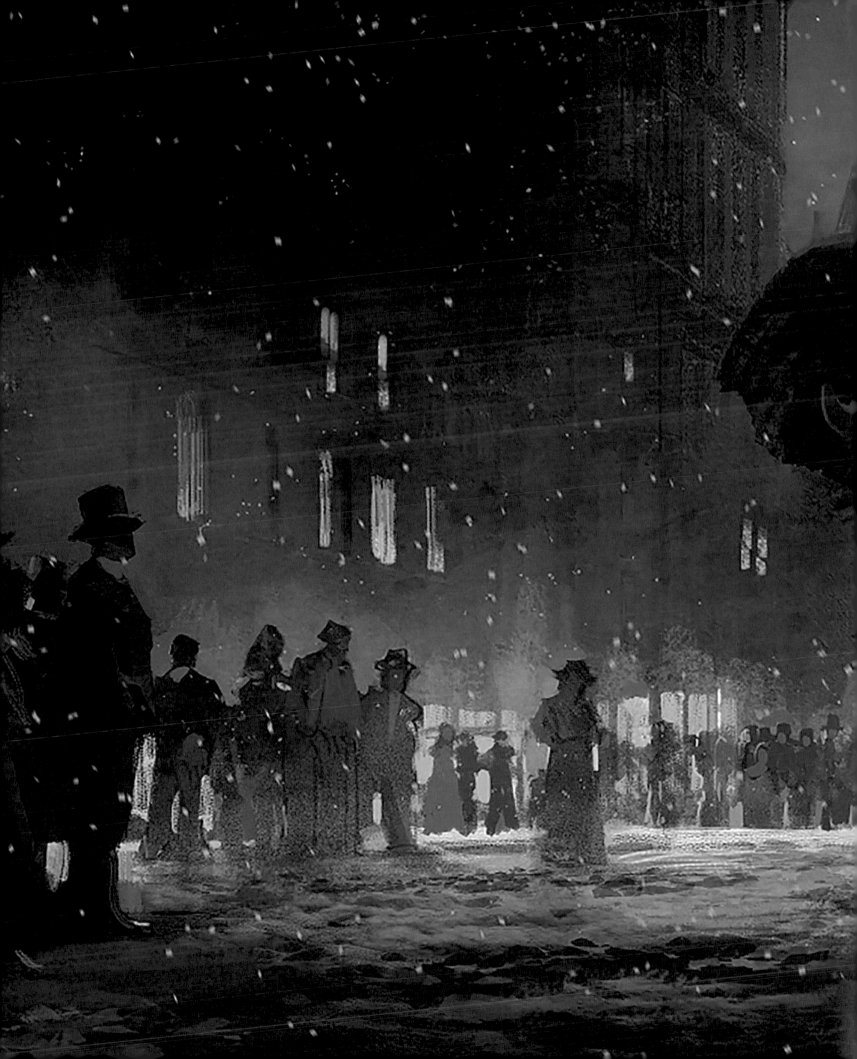

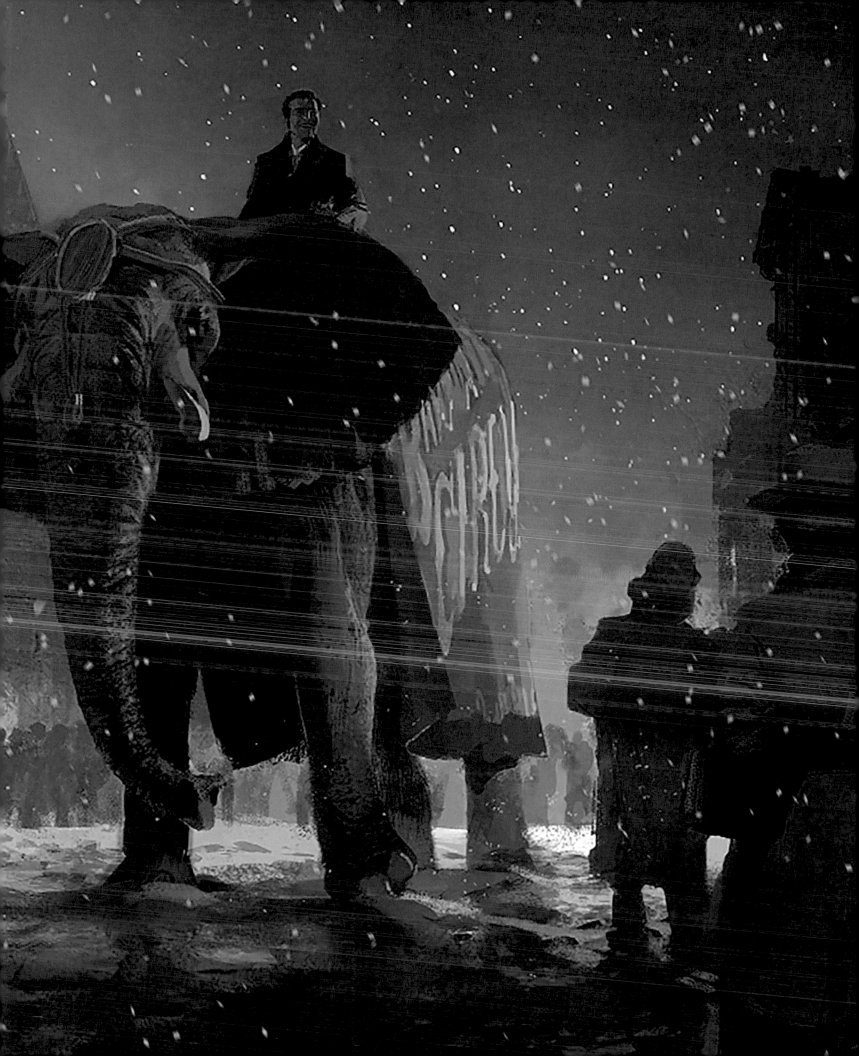

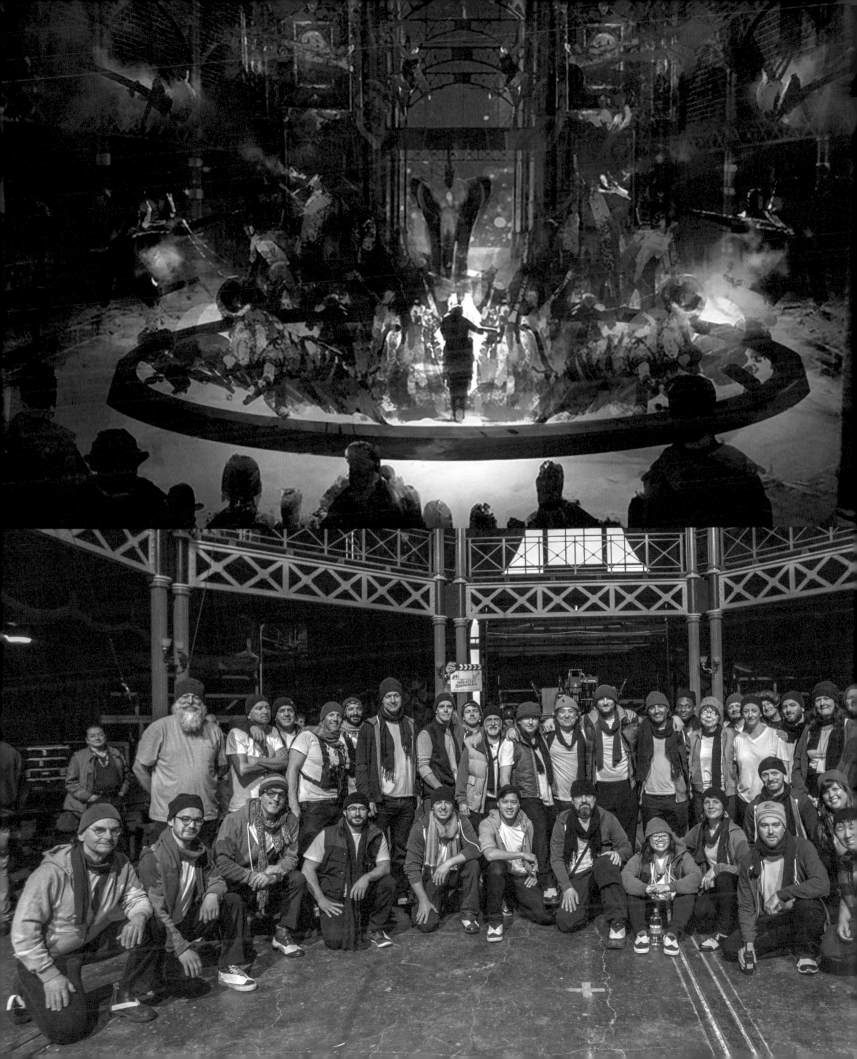

CAST & CREW

"You've got to understand that the excitement I had for the cast is only matched by the excitement I had for the crew that was assembled to make this film."
—DIRECTOR MICHAEL GRACEY

It's not unusual for the cast and crew of films to become tight-knit: Long hours and the intensity of performing can bring a group of strangers together in the most uplifting and powerful way. The constant pressure, driving expectations, and demanding schedules, however, can also pull people apart. The cast and crew of *The Greatest Showman* were fortunate to find a sense of camaraderie amid the circus of production. For Gracey, a first-time movie director, it was a dream come true. He says, "These people are legends, and I got to amass all of them for this special moment in time. The people who signed up for it, for this impossible dream, believed in it, and brought it to life." Jackman, too, got a chance to partner with Gracey, a director he long admired, as well as other legendary crew members, including Production Director Nathan Crowley. He says, "I worked with Nathan on *The Prestige* eleven years ago, and I have tried to get him to work on every single movie of mine since."

For a film that celebrates family in all its different incarnations, *The Greatest Showman* drew together a plethora of talented individuals from separate disciplines—everything from costume design and cinematography to acting, singing, and dancing to hair and makeup, and everything in between—to create a singular vision of P.T. Barnum's life and times. This newfound family gave its absolute maximum effort to create the movie. "Not just the performers," says Zac Efron. "I mean, every single person. . . .We ended up making something that's truly going to be magical."

187

OPPOSITE (TOP): *Concept art by Joel Chang* • OPPOSITE (BOTTOM): *Set photography of the crew* • OVERLEAF: *Concept art by Jamie Jones of the big top at the end of the movie*

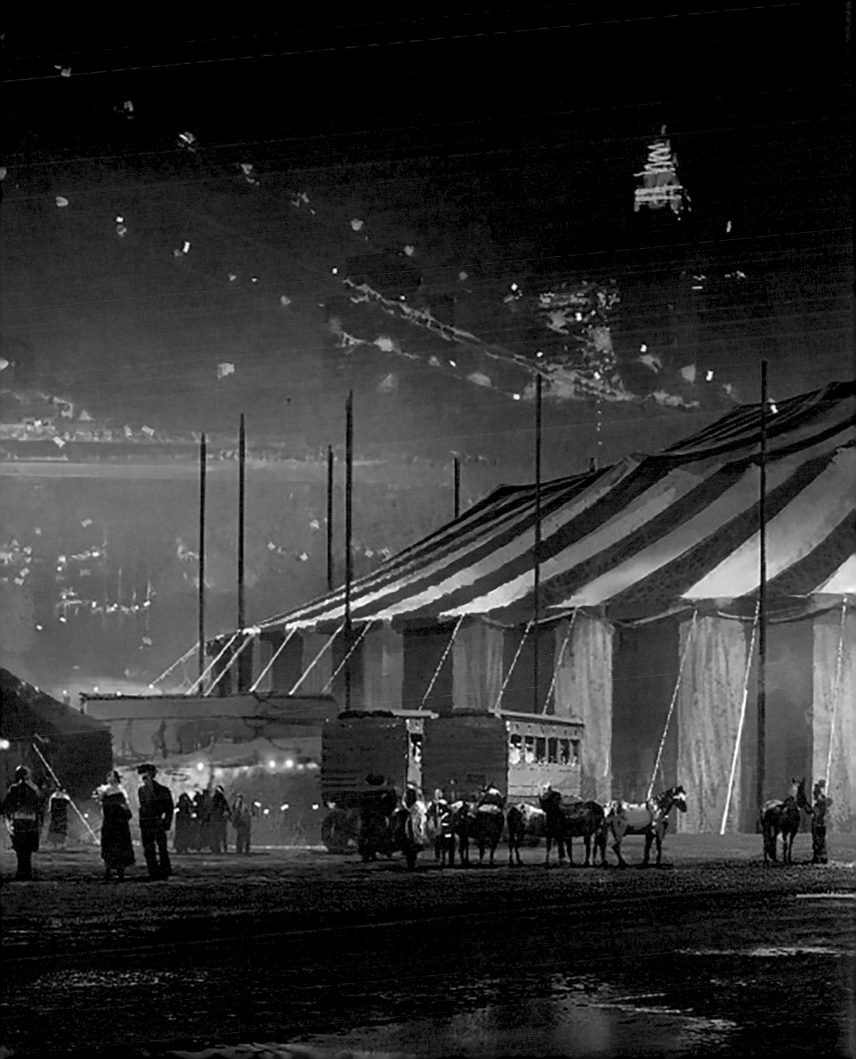

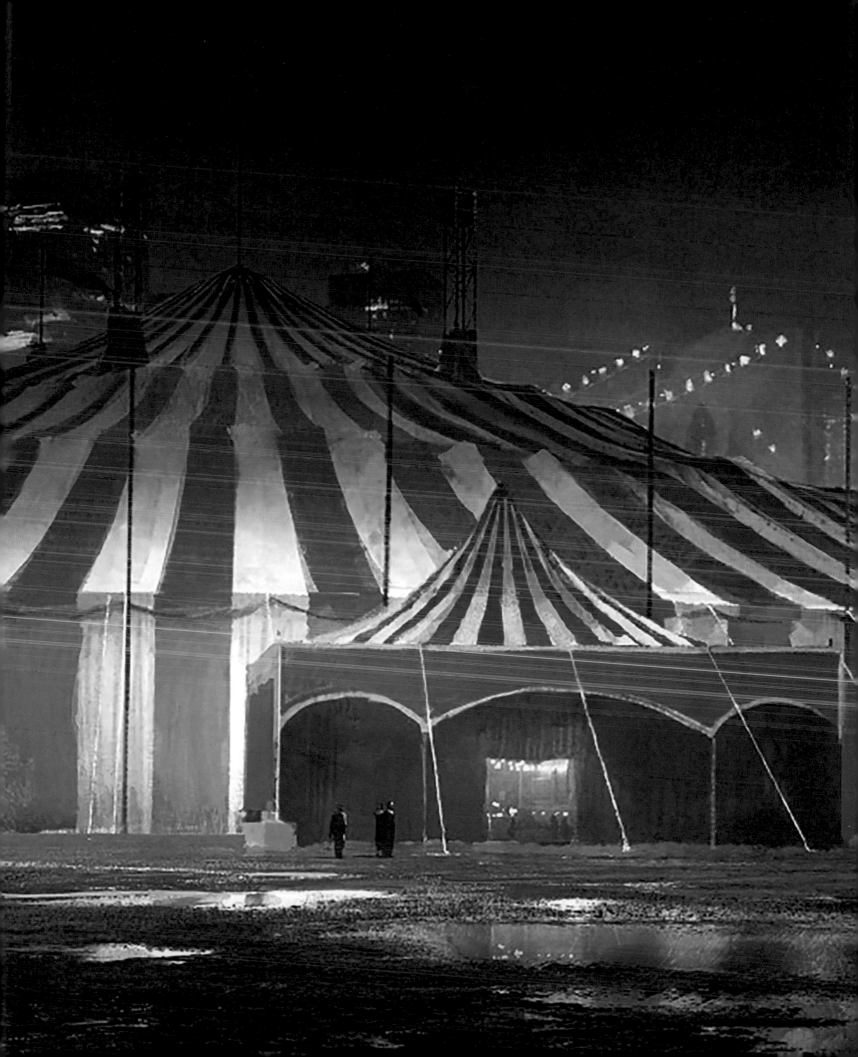

"This film reminds you of two things. One: Your differences are what make you special. Two: Real wealth is the love of friends and family."
—MICHAEL GRACEY

ACKNOWLEDGMENTS

FROM THE PUBLISHER

First and foremost we would like to thank the outstanding cast and crew of *The Greatest Showman* and, in addition, all those who helped make this book possible, including Steve Tzirlin, Beth Goss, and Nicole Perez from the Theatrical Franchise Team, Carol Roeder and Nicole Spiegel of Consumer Products, Ely Orias from Theatrical Creative Advertising, Michele Schweitzer, Tonia Davis and Jenno Topping of Chernin Entertainment, Kira Goldberg from Theatrical Production, and Bill Mona and Ariell Brown from the Theatrical Photo Department.

Additional thanks to Signe Bergstrom for her engaging narrative; Lucy Walker and Britt Bogan for editorial assistance; and Noah Kay and Regina Shklovsky for their design help.

FROM THE AUTHOR

A very special thanks to the talented publishing crew of Cameron + Company: Chris Gruener, Jan Hughes, Iain R. Morris; and to Mariah Bear of Weldon Owen, without whom this book would not have been possible. And to the spectacular staff of Fox, thank you. Hats off to the amazing cast and crew of *The Greatest Showman,* who inspired audiences around the world to believe in the power of imagination.

Signe Bergstrom is a writer and editor of several illustrated books, including *Suicide Squad: Behind the Scenes with the Worst Heroes Ever*, *Wonder Woman: Ambassador of Truth*, and *Harry Potter: Film Wizardry*. She lives in the Hudson Valley.

THIS PAGE: *Concept art by Brian Estanislao* • OPPOSITE: *Set photography of P.T. Barnum* • OVERLEAF: *Production image* • BACK ENDPAPERS: *Concept art by Joel Chang*

190

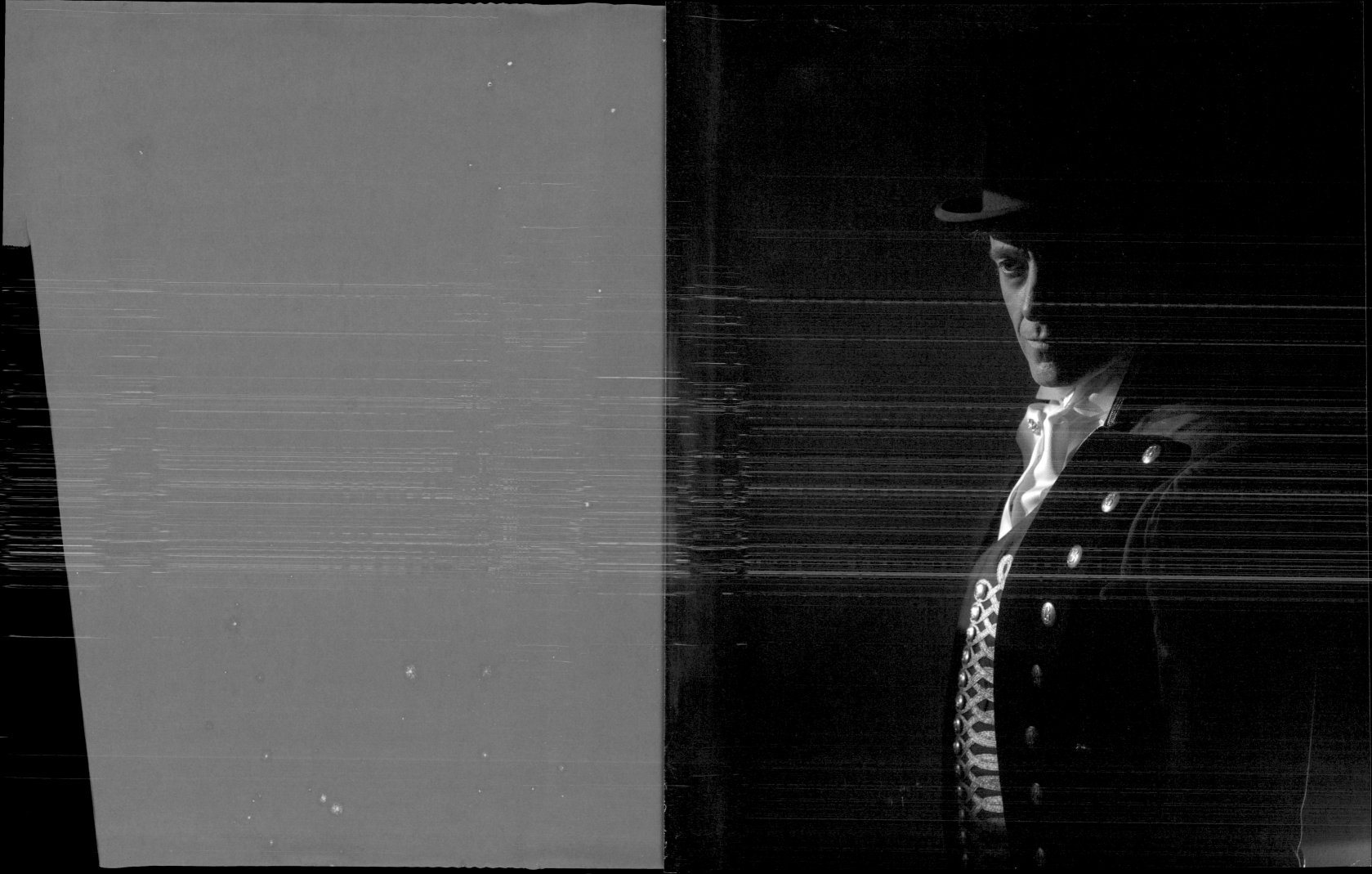

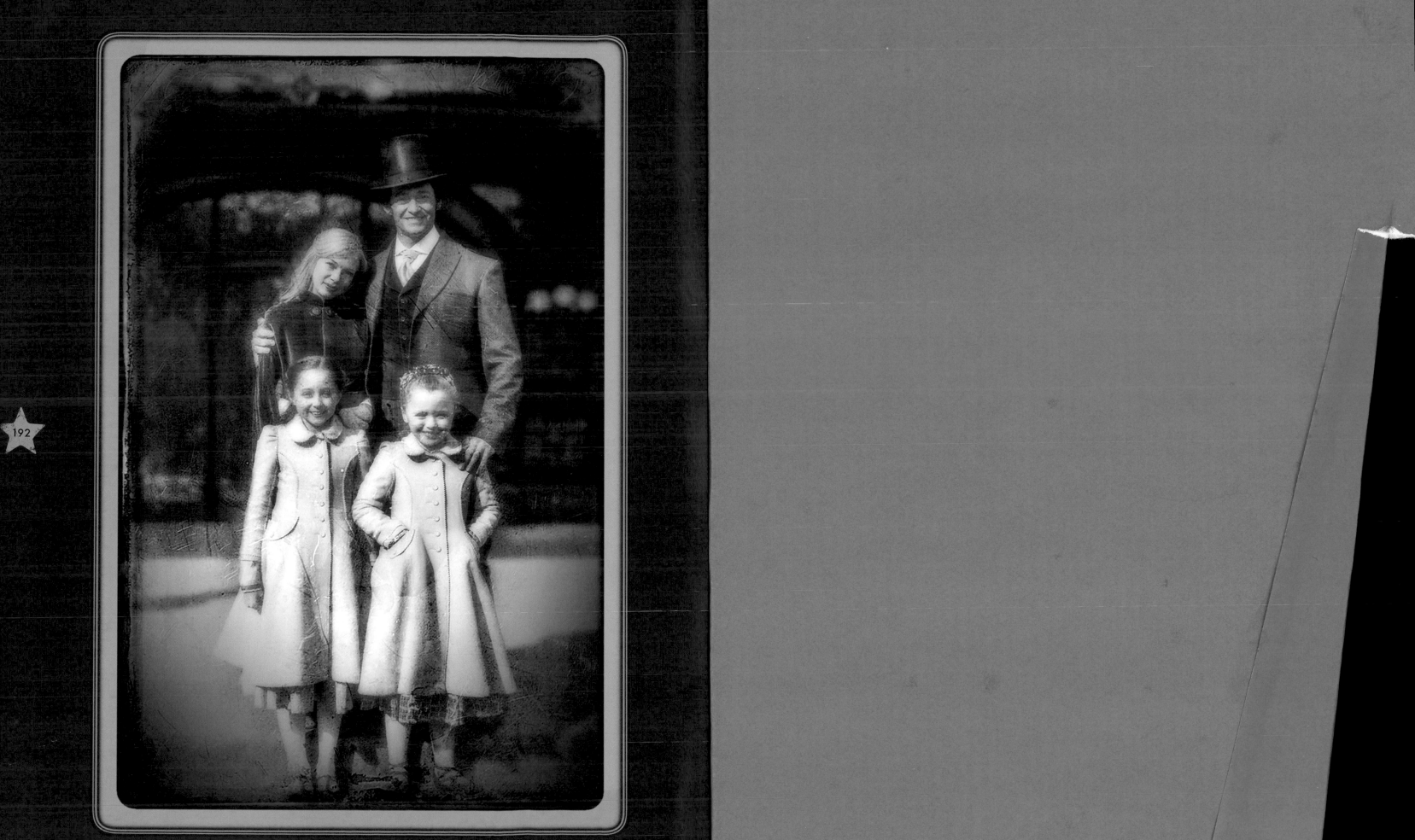